MADONNA
CONFESSIONS

PHOTOGRAPHY BY GUY OSEARY

This book is dedicated to my son, Oliver Oseary.
Even though you were born on November 17, 2006, two months after
the tour ended, your mamma brought you to many shows in her belly.
That's why you can outdance all the others!

MADONNA
CONFESSIONS
PHOTOGRAPHY BY GUY OSEARY

powerHouse Books Brooklyn, NY

INTRODUCTION

I have a confession of my own to make. Like most people, I've taken thousands of photos over the years on your standard, basic little camera. I've always been a fan and collector of photos—I started in my teens with photographs of artists like the Sex Pistols and the Clash, and iconic shots by rock photographer Bob Gruen. Somehow, various stars aligned as I was about to begin my journey with Madonna on the Confessions Tour that led to this book.

First, I was given a professional camera by Michelle, the love of my life, a few days before I was scheduled to go on the road. My passion for photography, my new professional camera, and the opportunity to photograph Madonna night after night amounted to a chance I could not pass up. With just a few days to master the equipment, I immediately called up Kevin Mazur, who hooked me up with Lester Cohen. I got a 30-minute lesson with Lester at my home.

Rehearsals for the show were spectacular, and with a passion to capture it on film, off I went on tour with my new cool camera. I initially envisioned shooting a show here and there; I had no idea that I would end up shooting the entire 60 shows on the tour as we traveled around the world. I ended up shooting well over 50,000 photographs. I have much more appreciation today for what photographers do.

The magic for me was that every single night I would notice something new in the show, something enthralling that I hadn't noticed before. The chance to capture the nonstop movement of Madonna singing and dancing across the stages of the world every night was the best education I could get as a photographer. It was an incredible experience and a labor of love.

Thank you Madonna, for allowing me that privilege.

Guy Oseary, 2008

WHIP ME, MADONNA! LIKE IT OR NOT

WHIP ME, MADONNA! (EDUCATED HORSE)

WHIP ME, MADONNA! YOU THRILL ME!

WHIP ME, MADONNA! I'M COMING SOON!

DUSSELDORF
8.20.06

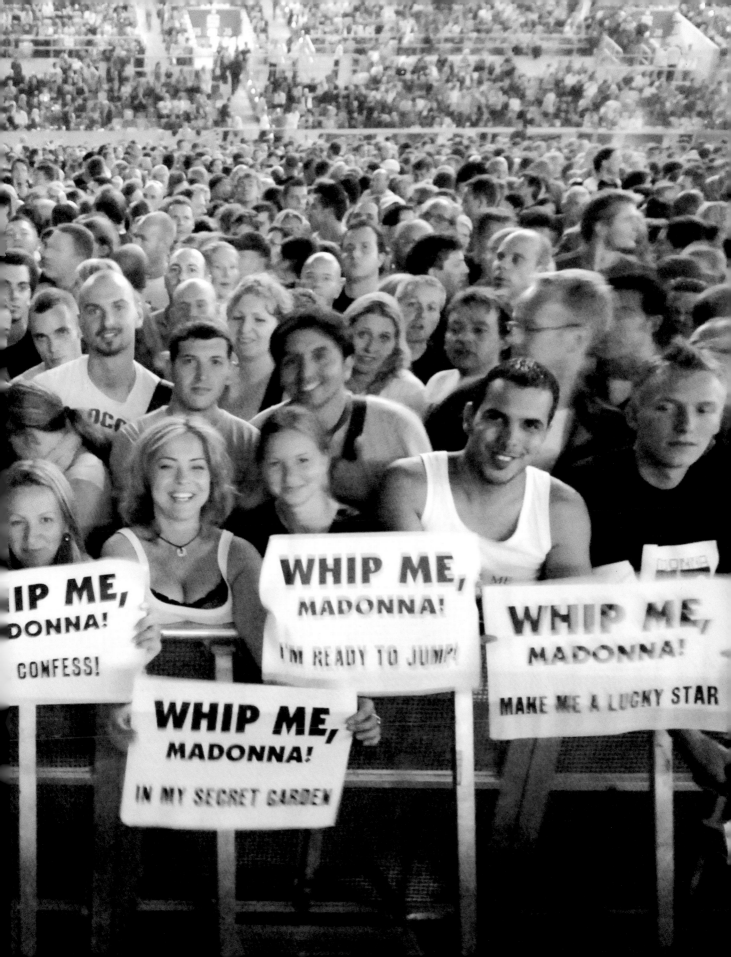

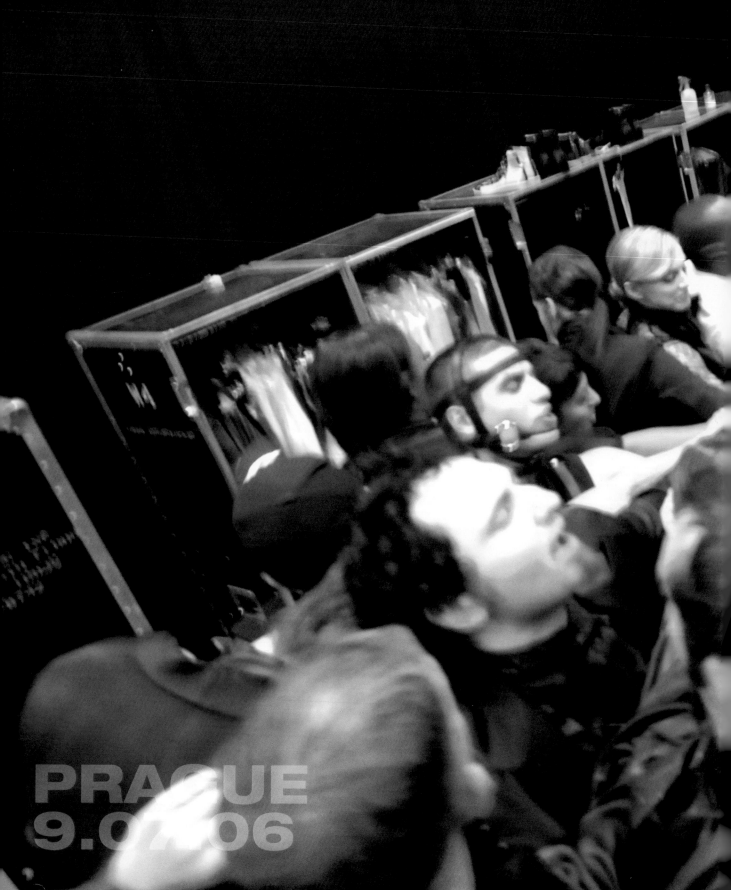

PRAGUE
9.07.06

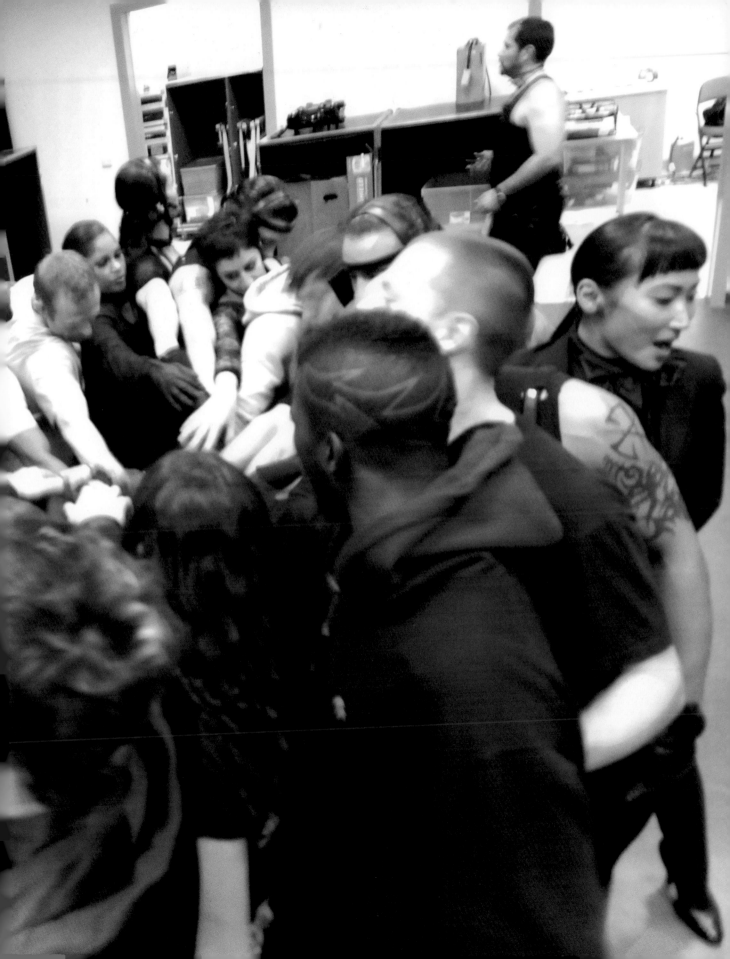

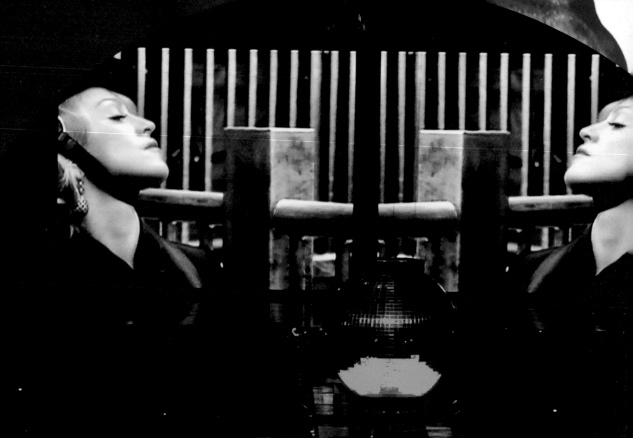

AMSTERDAM
9.03.06

AMSTERDAM
9.03.06

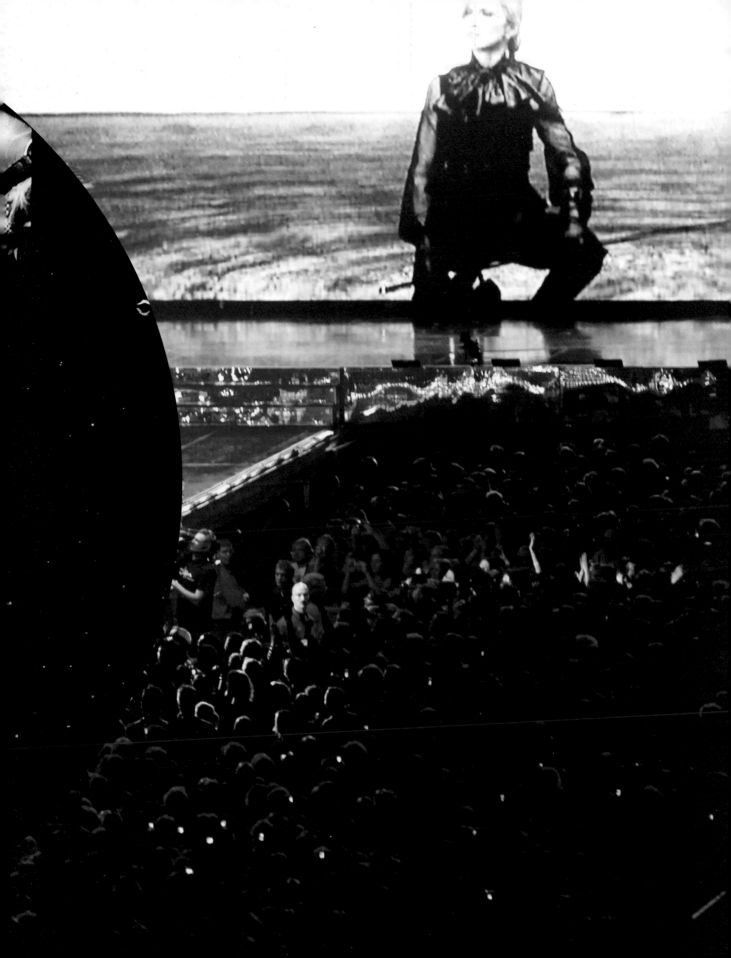

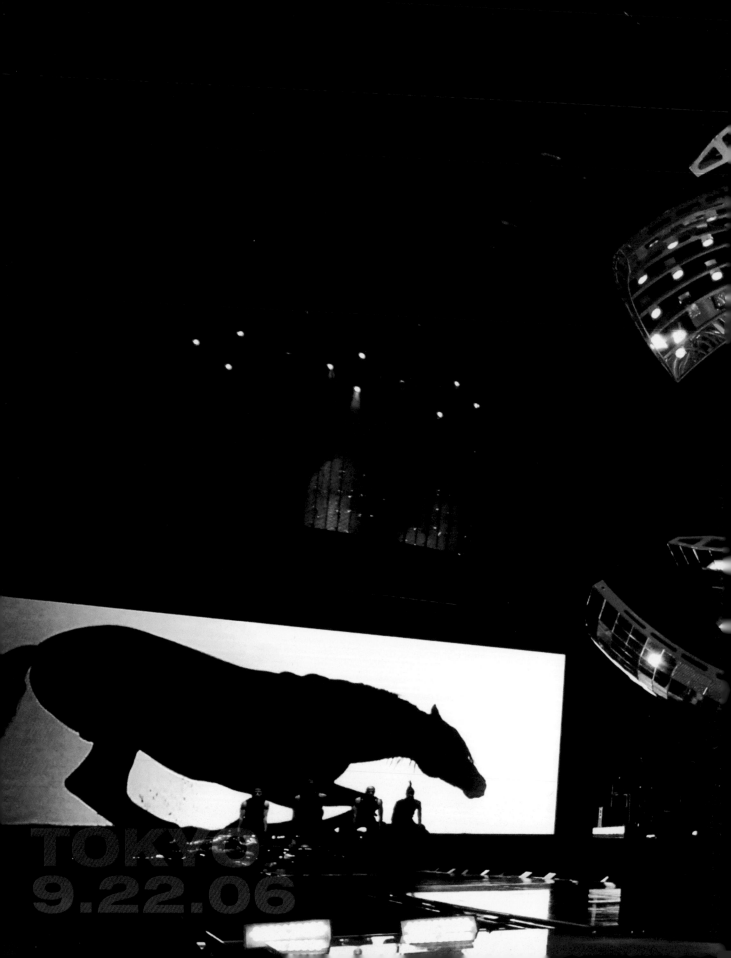

TOKYO
9.22.06

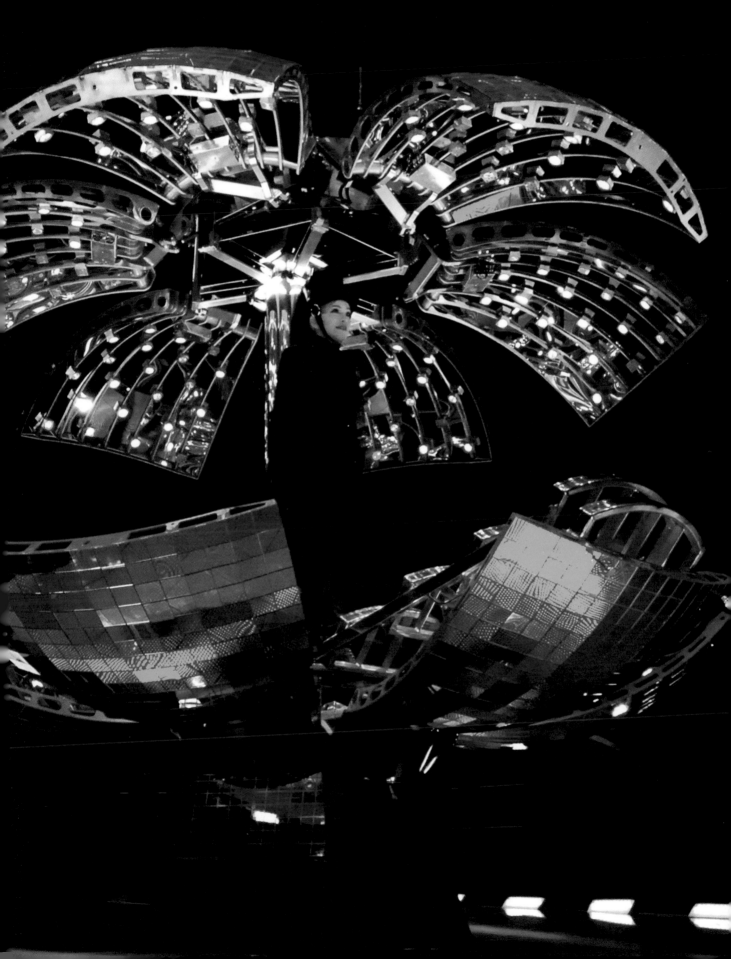

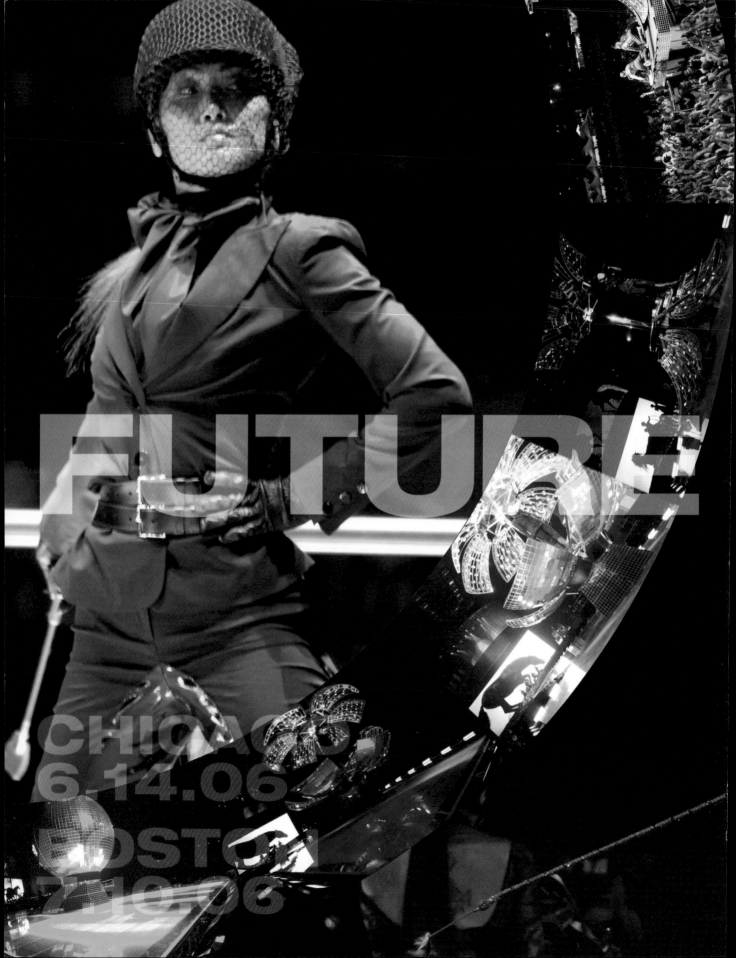

FUTURE

CHICAGO
6.14.06
BOSTON
7.10.06

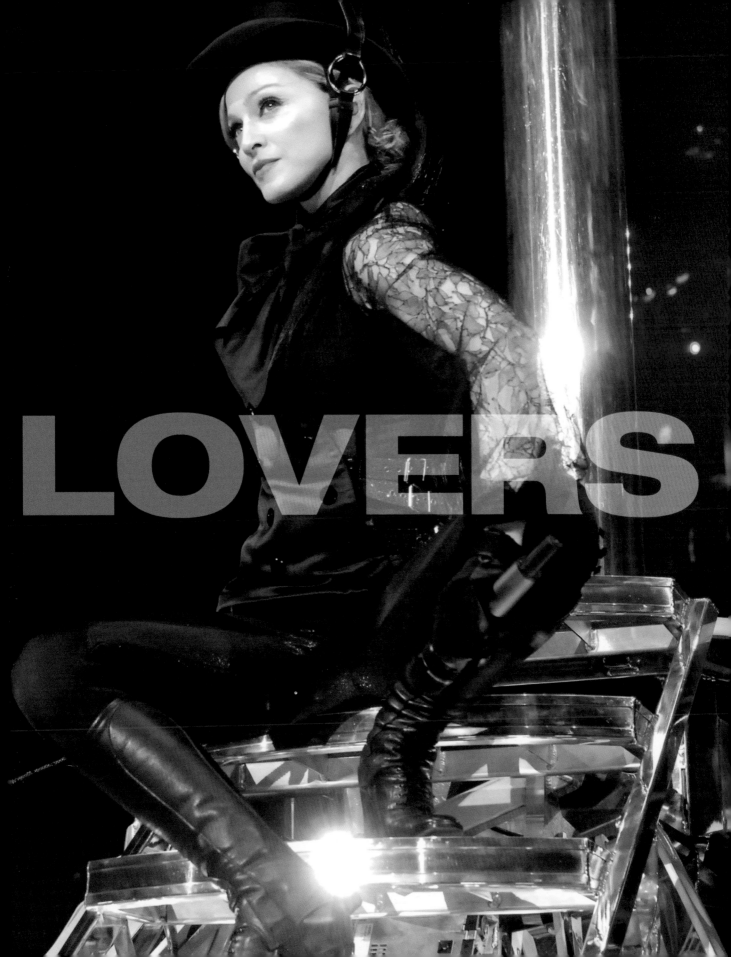

LOVERS

ARE YOU READY TO RIDE WITH ME?

HORSENS
8.24.06

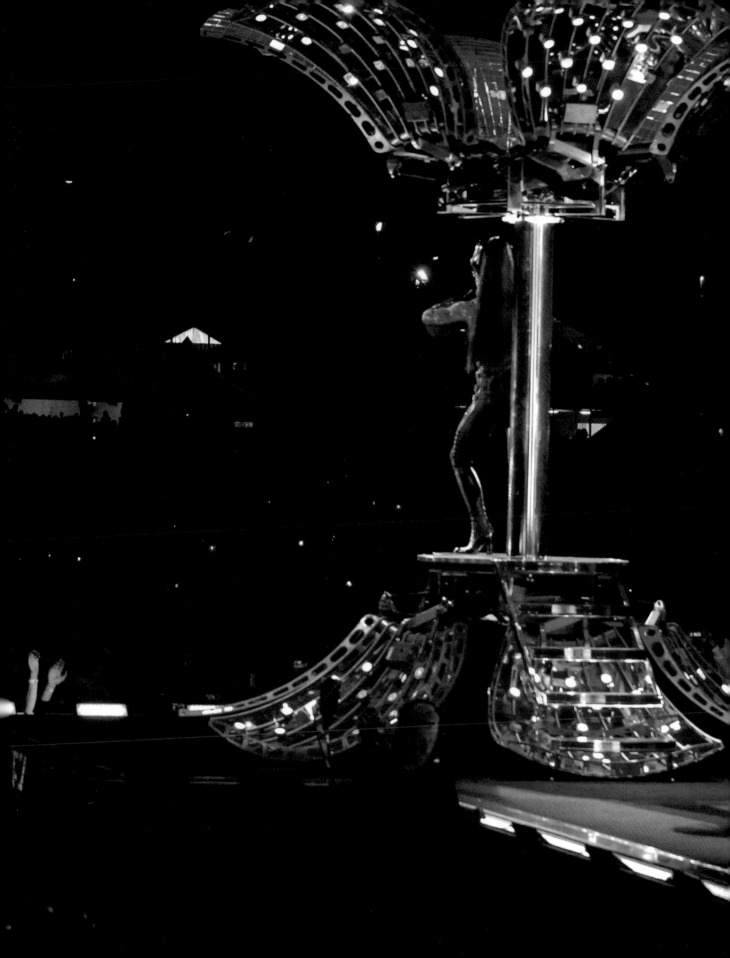

DUSSELDORF
8.20.06
DUSSELDORF
8.20.06

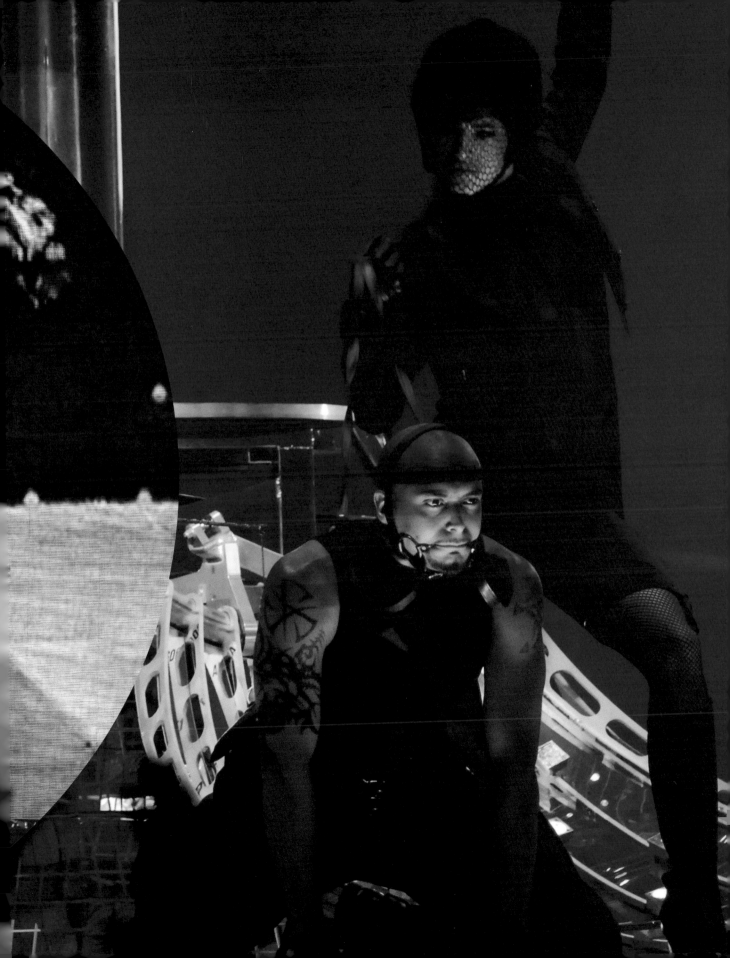

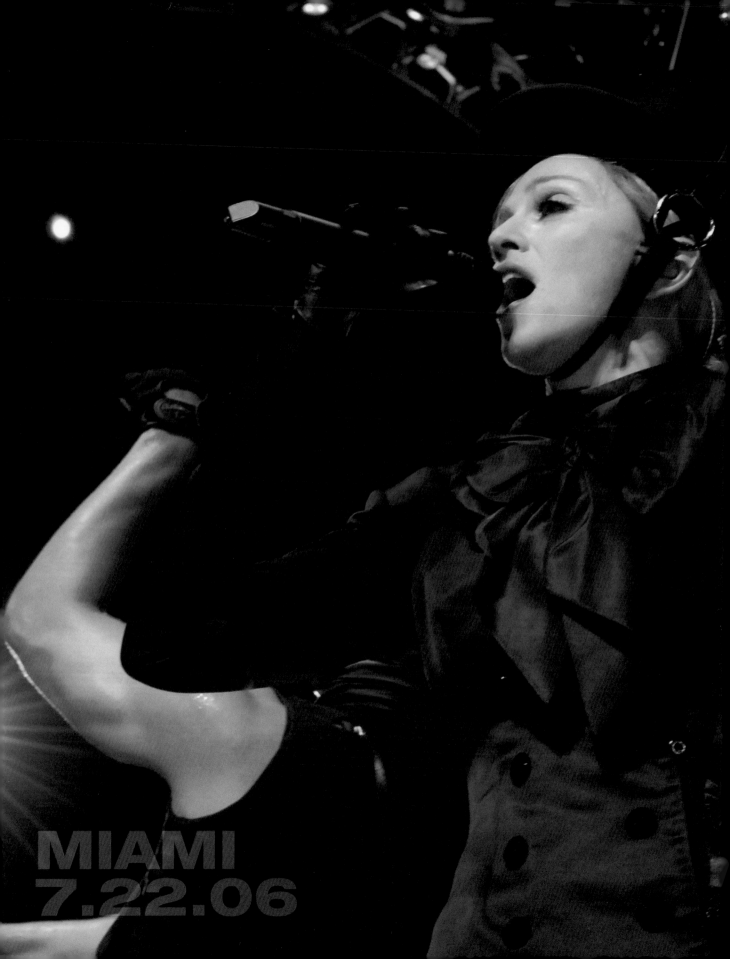

MIAMI
7.22.06

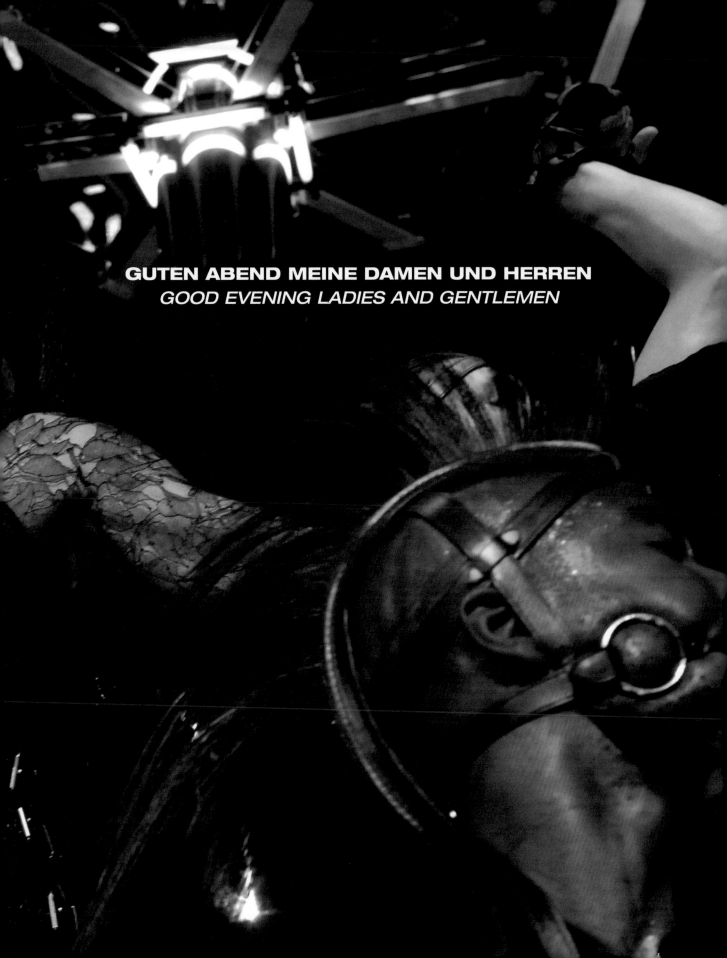

GUTEN ABEND MEINE DAMEN UND HERREN
GOOD EVENING LADIES AND GENTLEMEN

LONDON
8.09.06

BOSTON
7.10.06

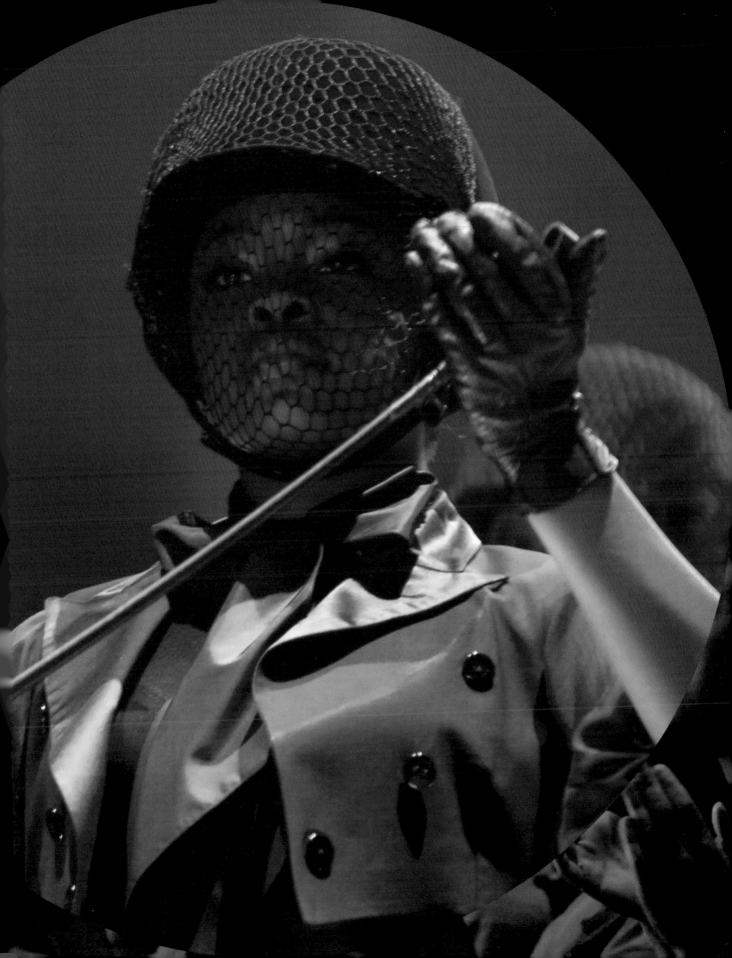

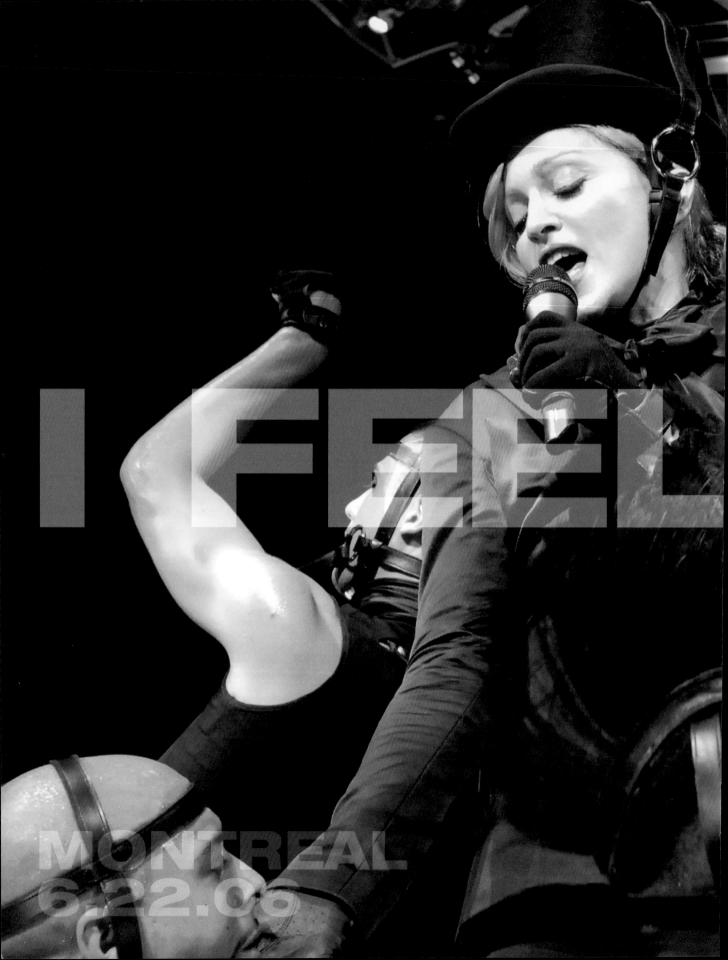

I FEEL

MONTREAL
6.22.06

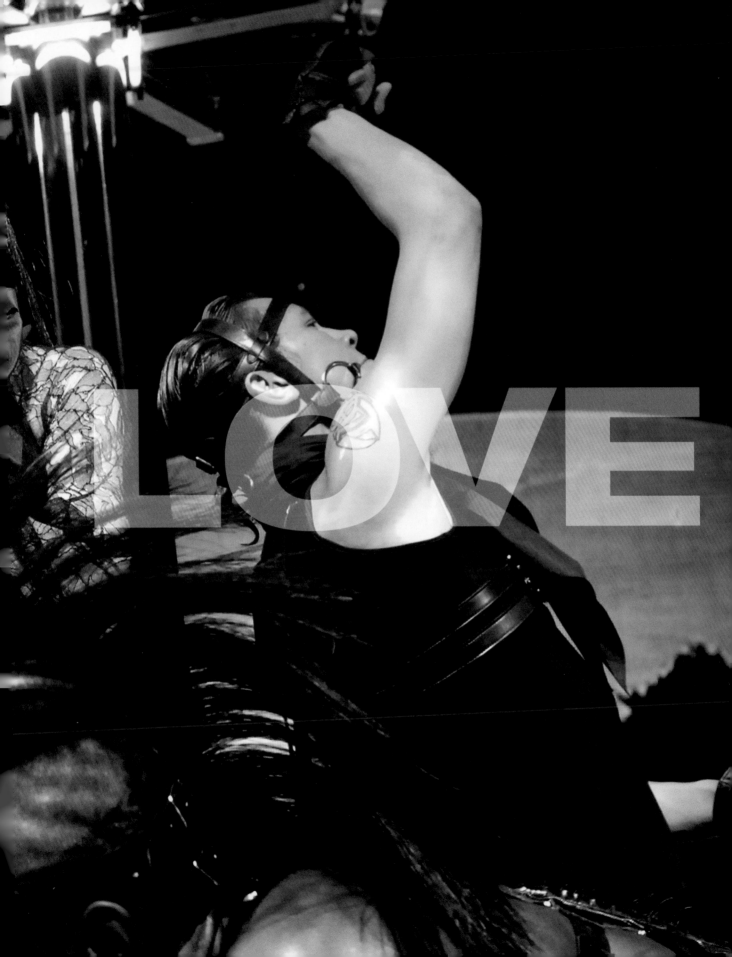

TOKYO
9.22.06
BOSTON
7.10.06

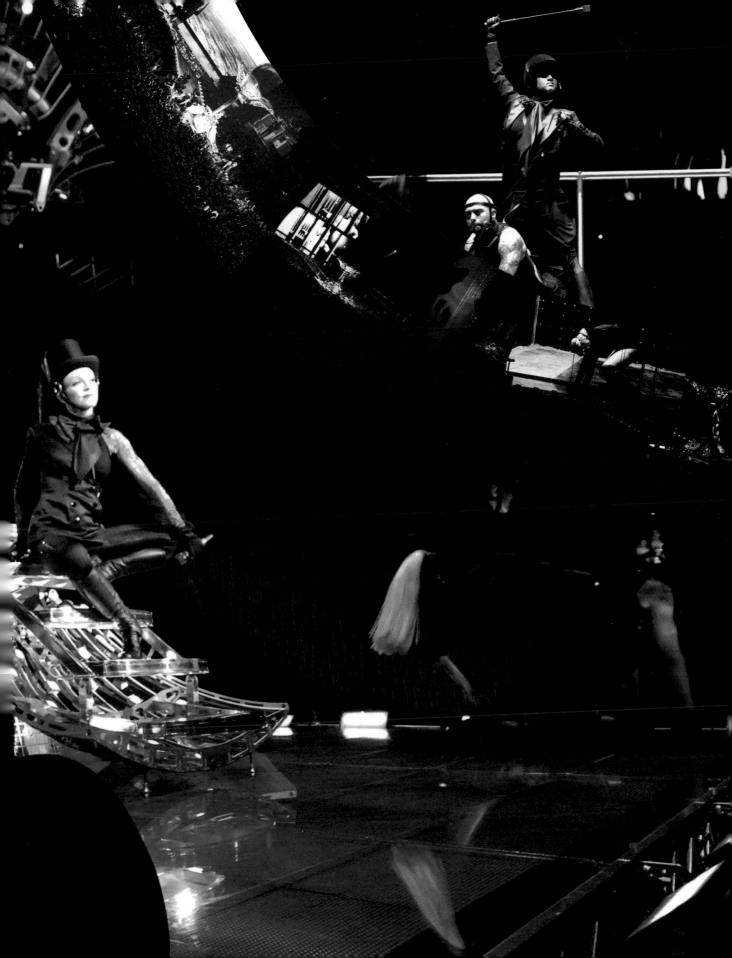

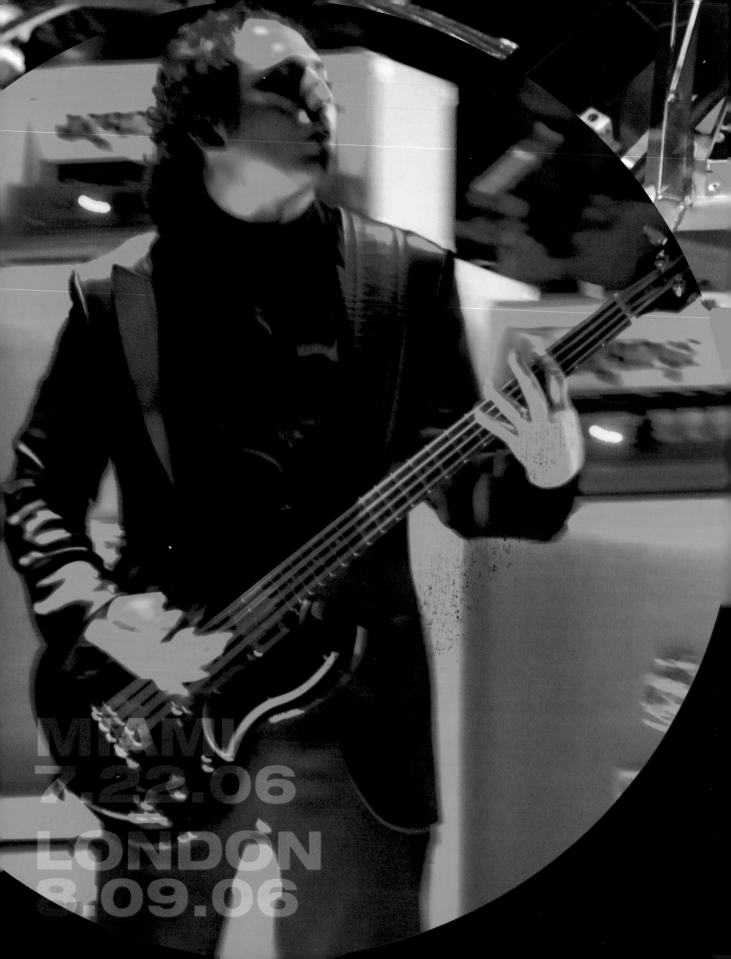

MIAMI
7.22.06
LONDON
8.09.06

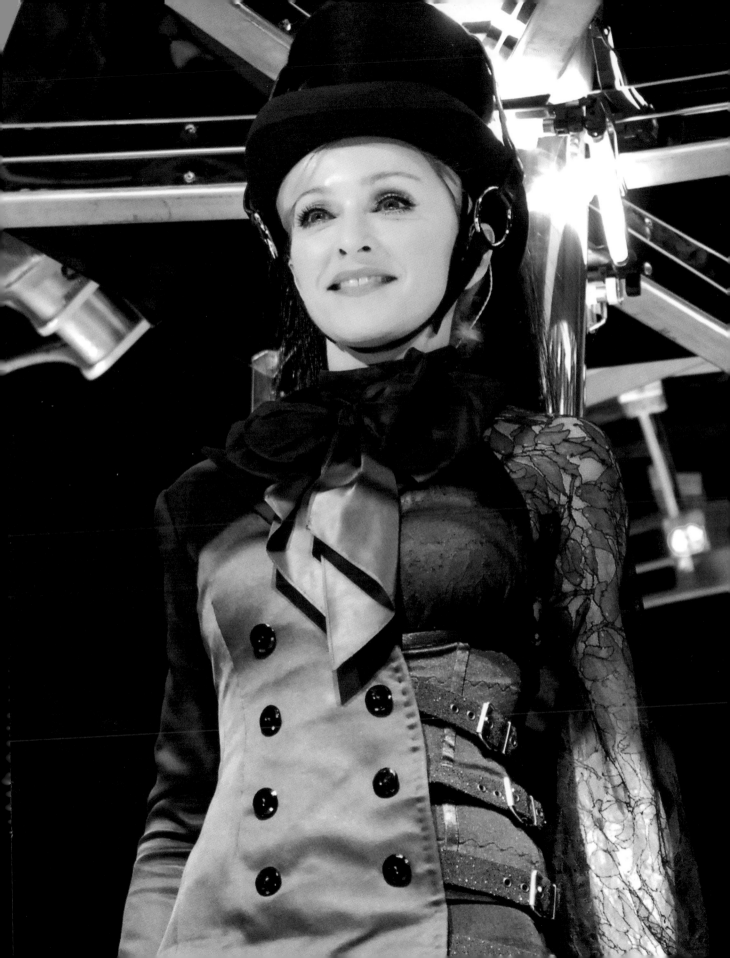

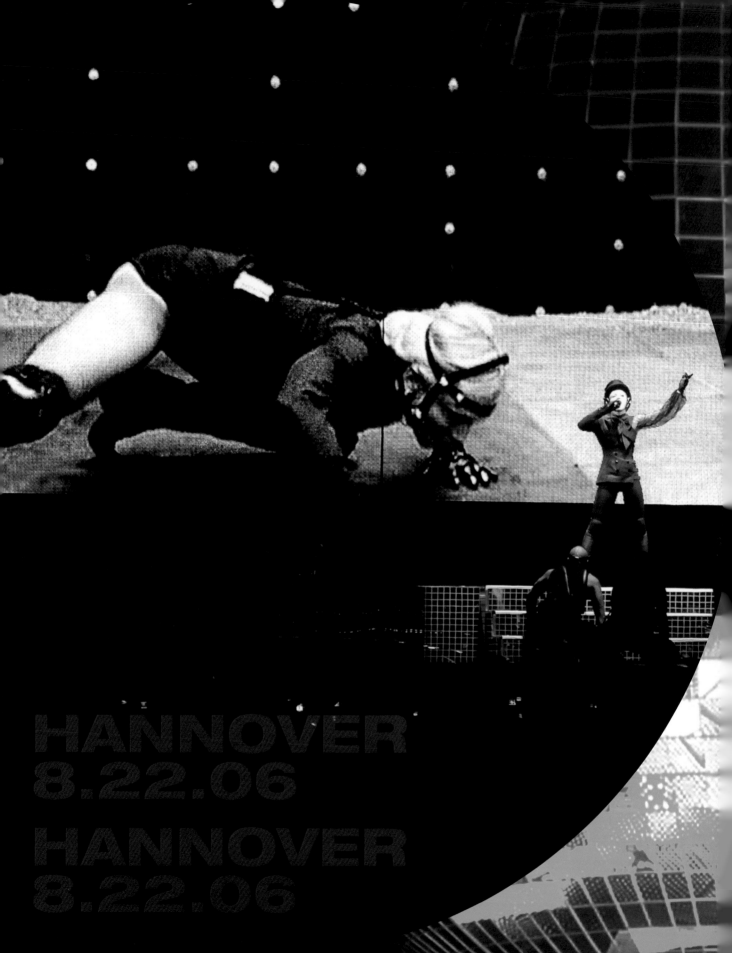

HANNOVER
8.22.06
HANNOVER
8.22.06

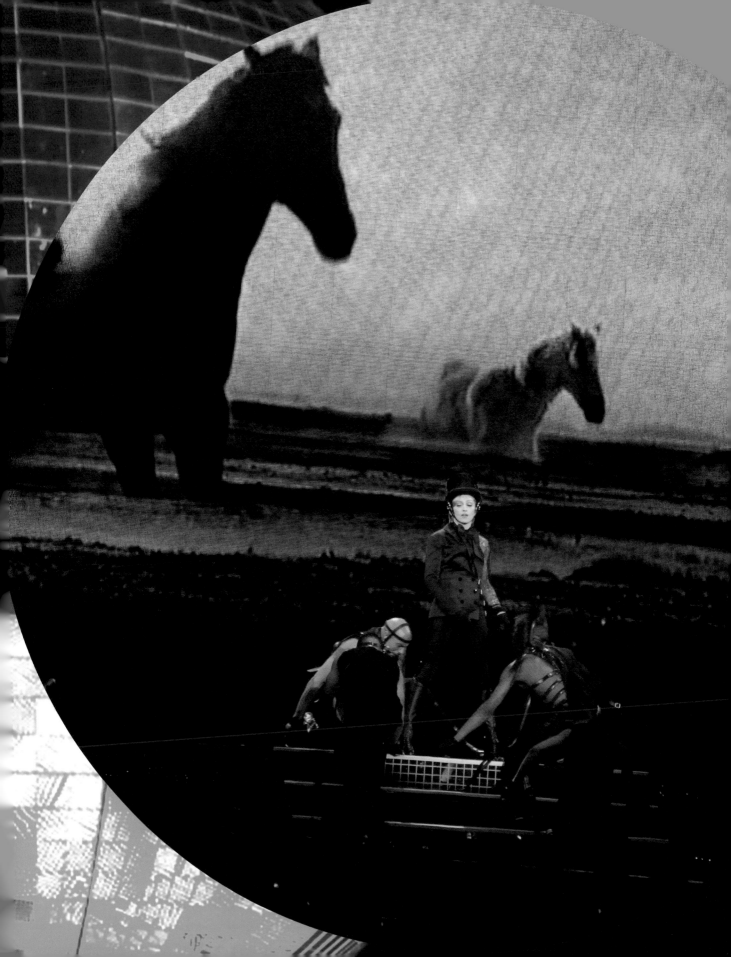

GET TOG

CARDIFF
7.29.06
LONDON
8.09.06

GETHER

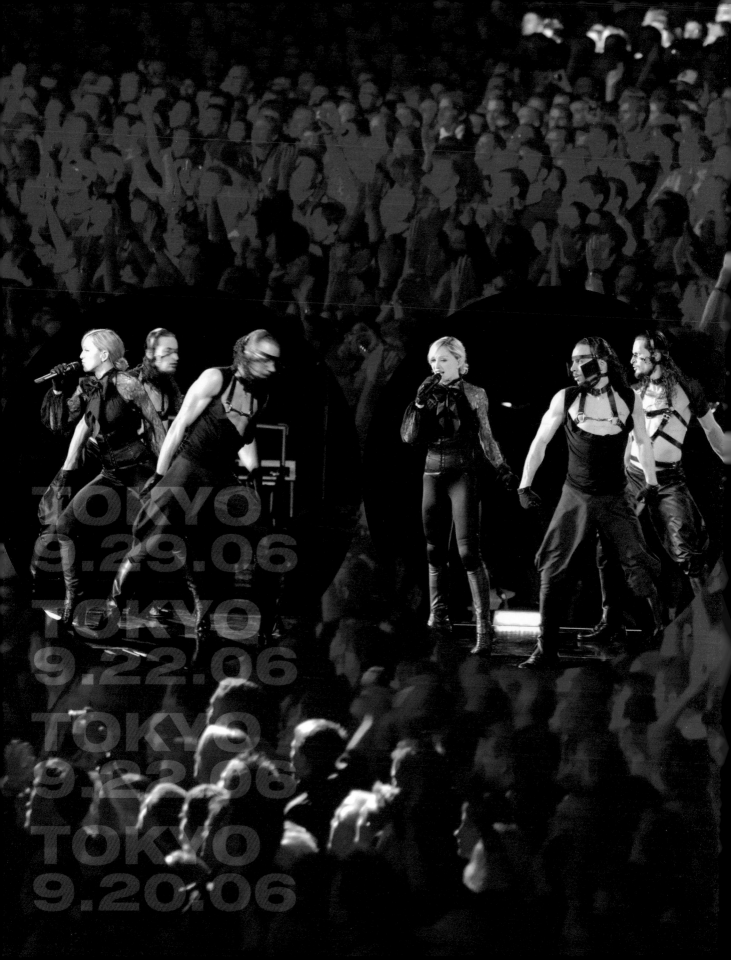

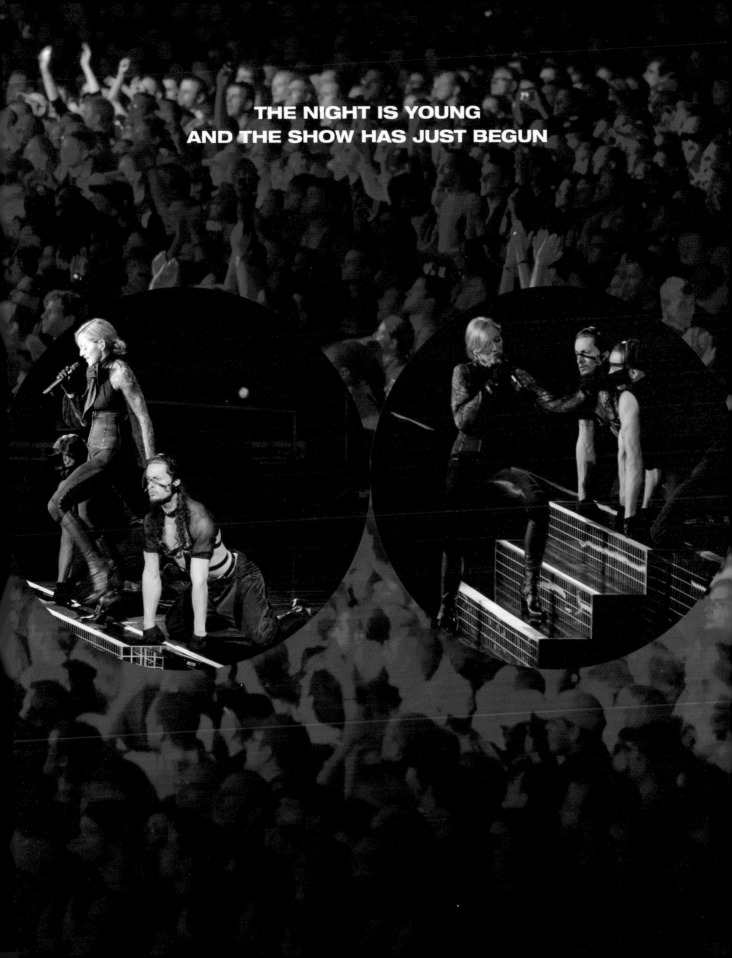

THE NIGHT IS YOUNG
AND THE SHOW HAS JUST BEGUN

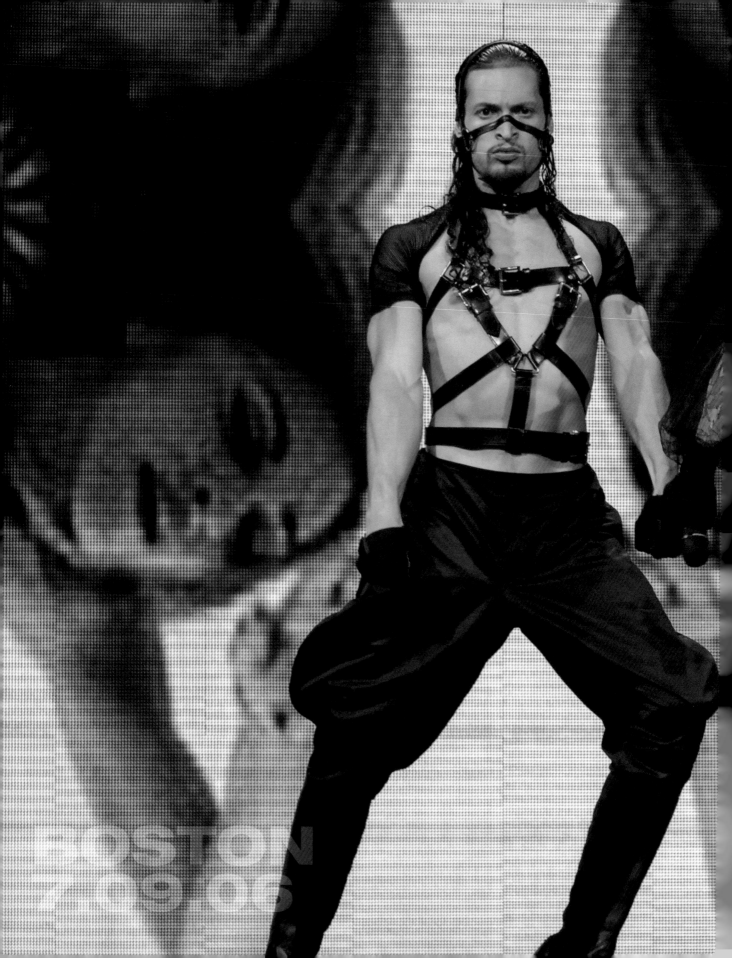

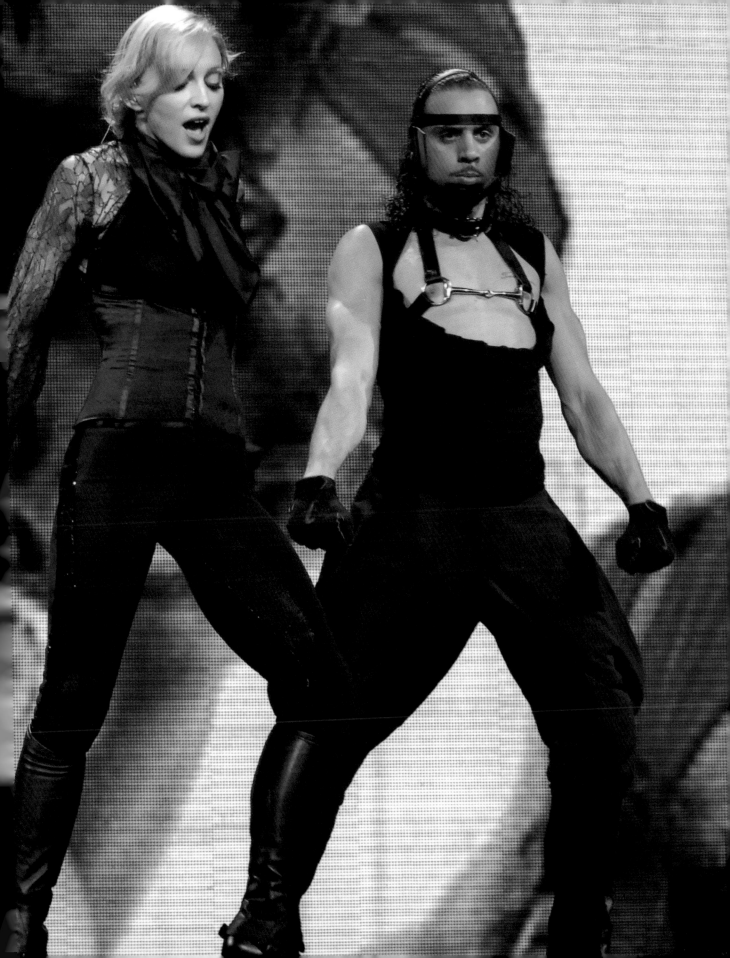

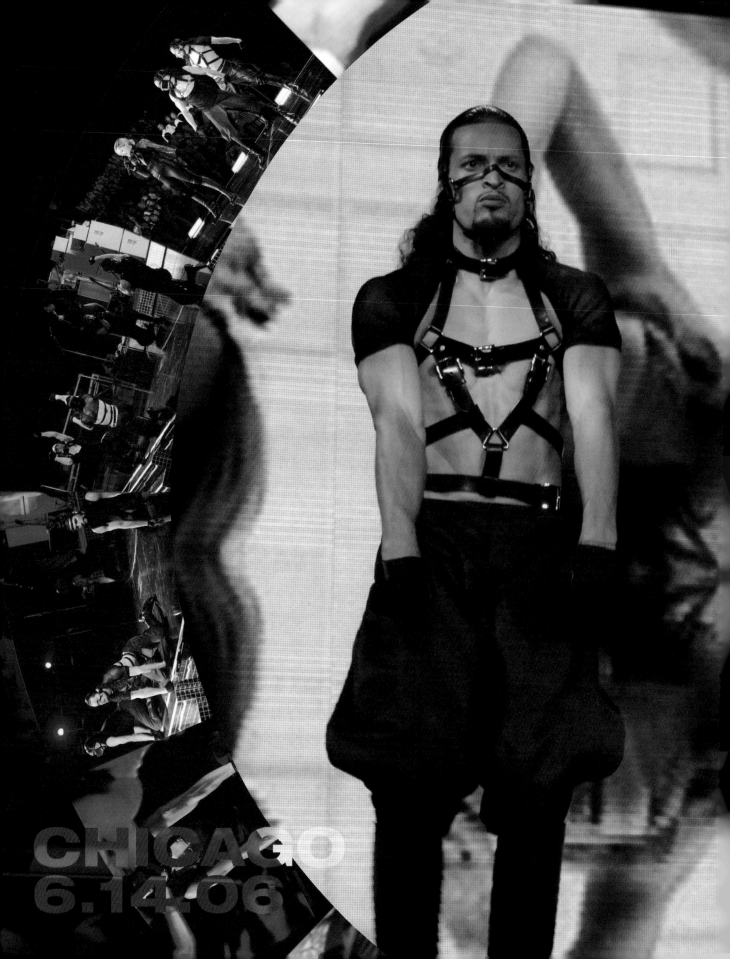

CHICAGO
6.14.06

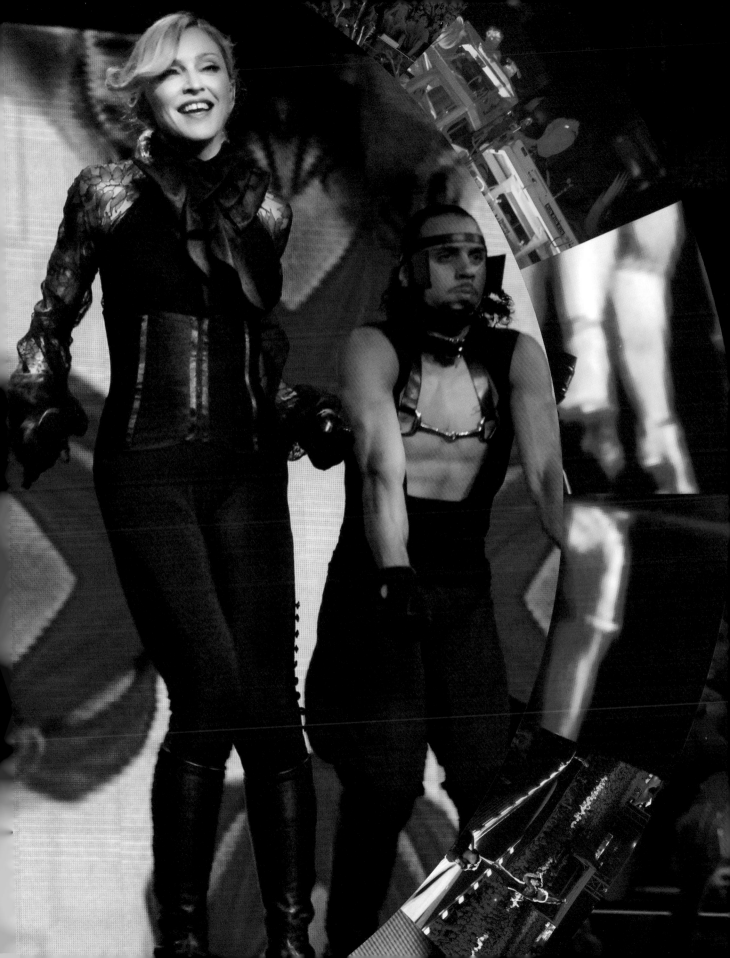

PRAGUE
9.06.06

CARDIFF
7.29.06

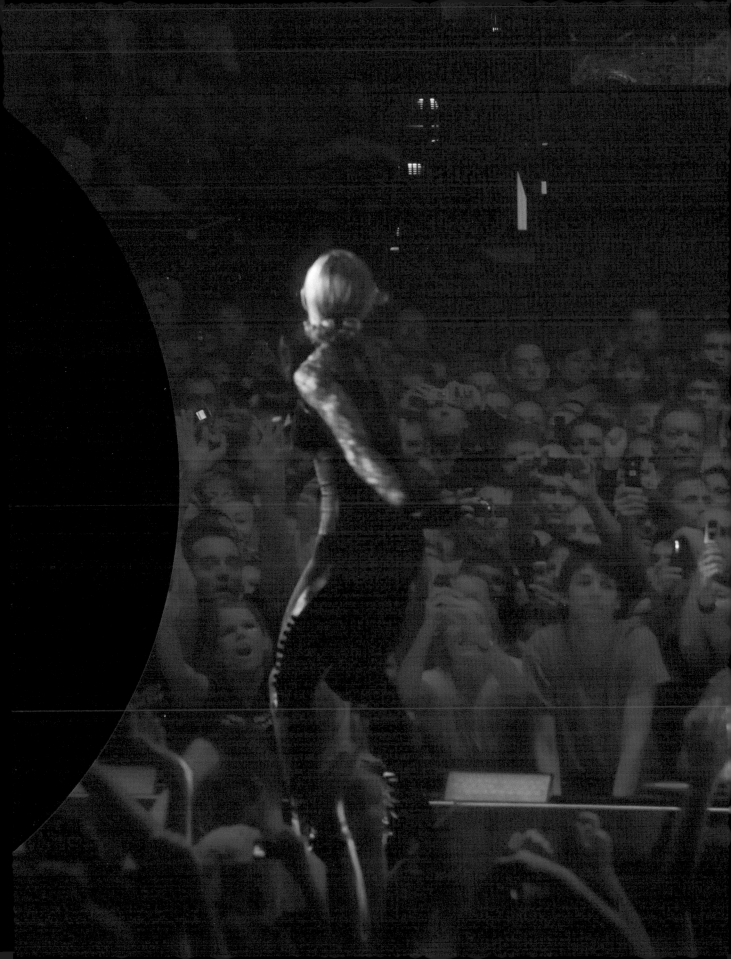

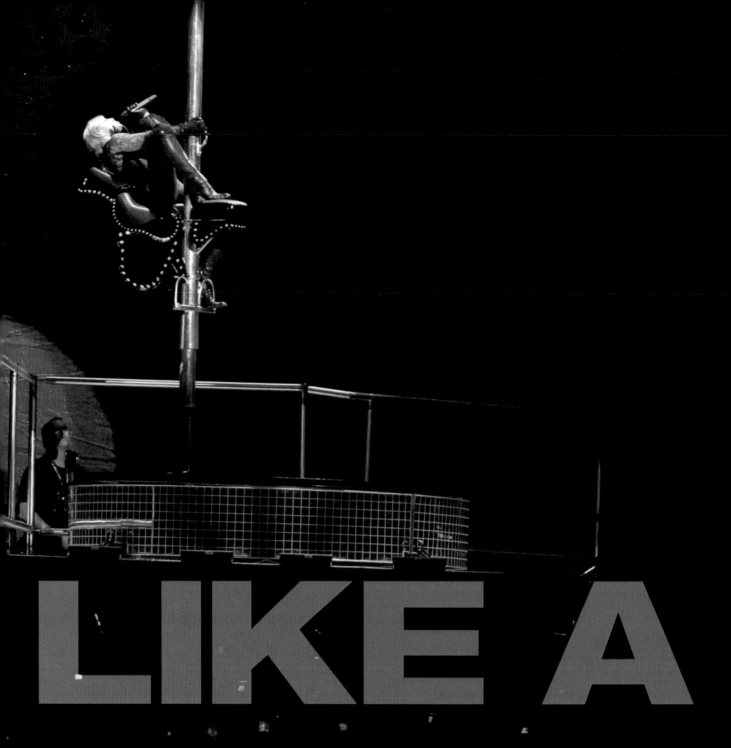

LIKE A

DUSSELDORF
8.20.06

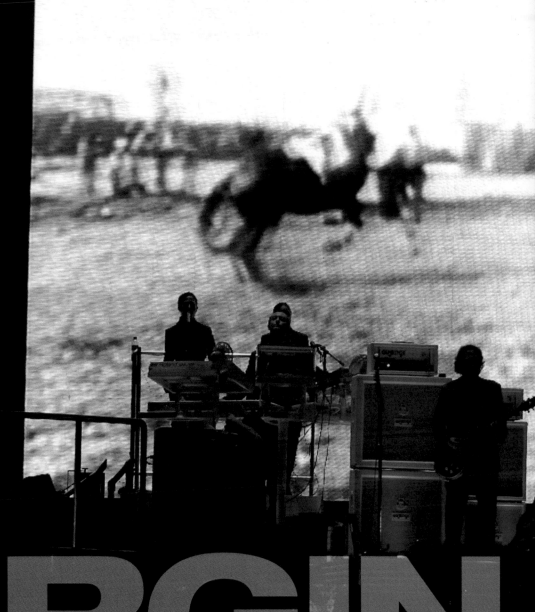

VIRGIN

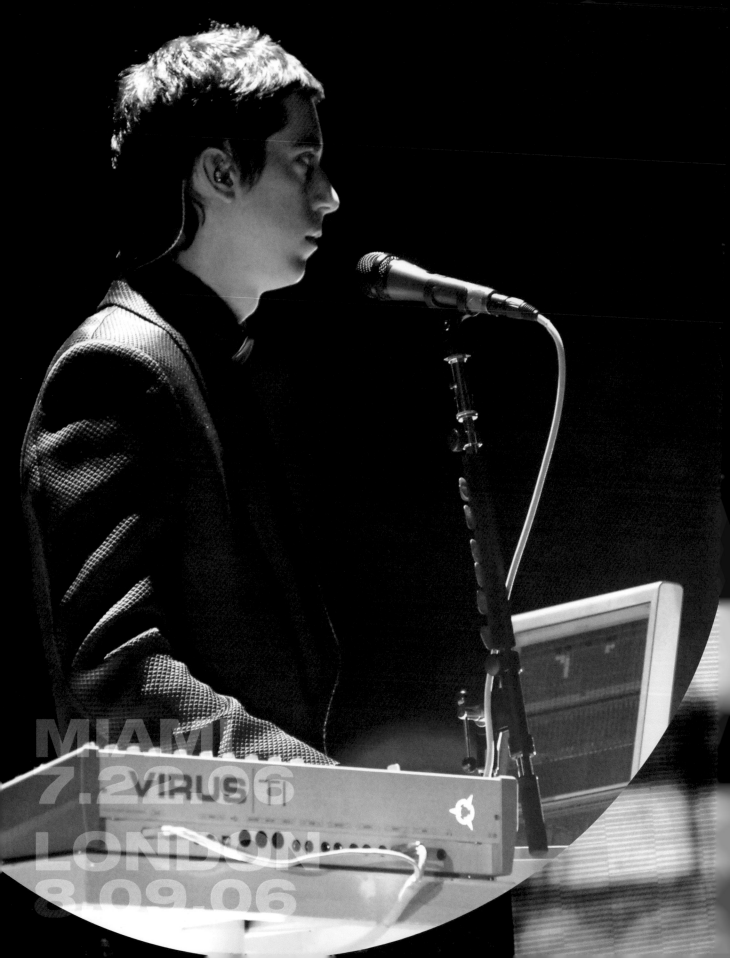

MIAMI
7.22.06
LONDON
8.09.06

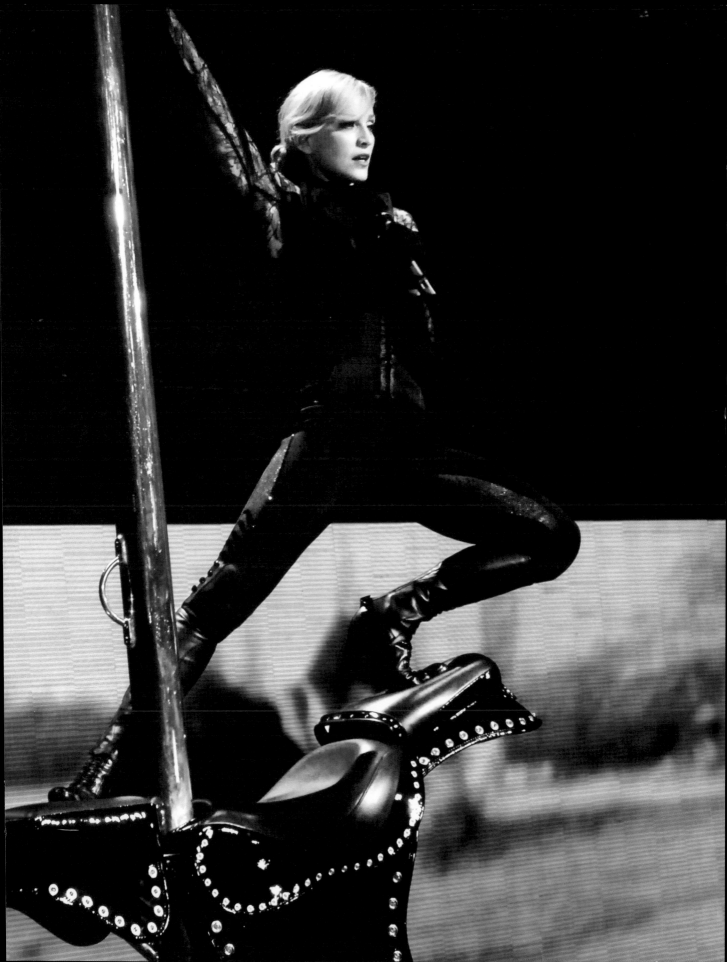

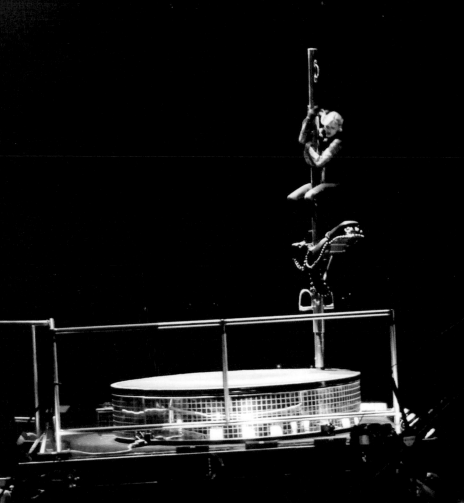

HANNOVER
8.22.06

LONDON
8.10.06

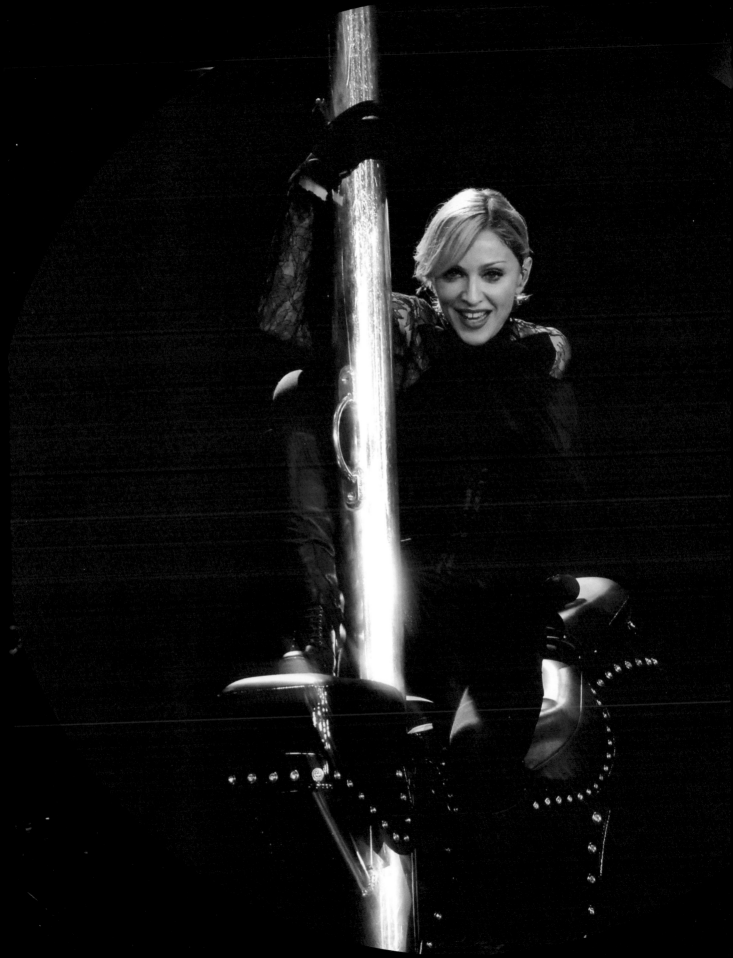

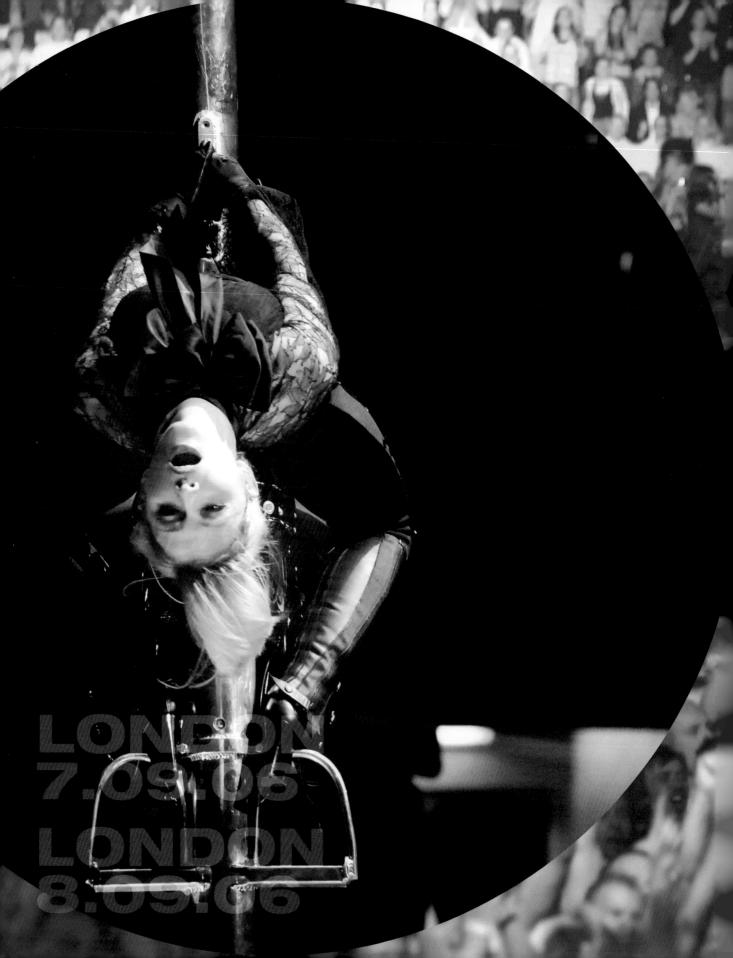

LONDON
7.09.06
LONDON
8.09.06

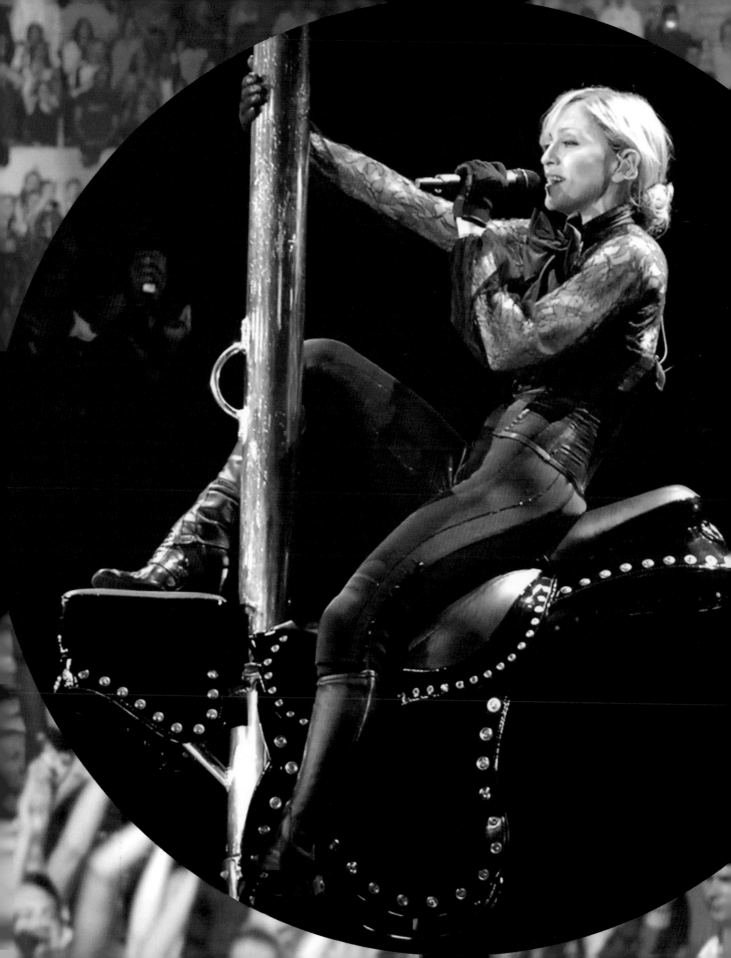

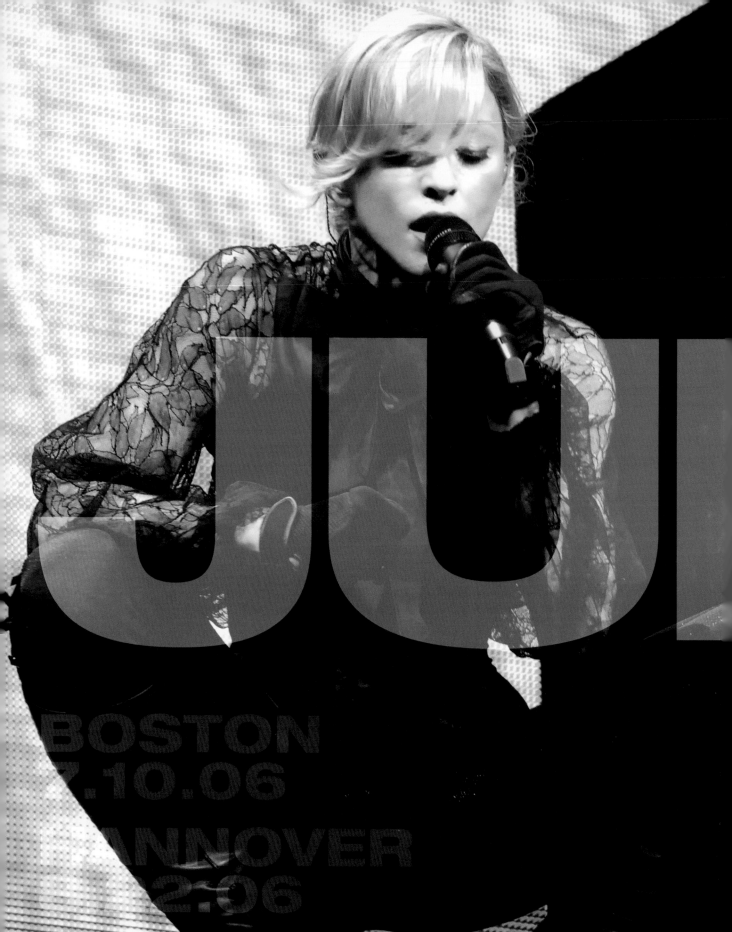

JUL

BOSTON
7.10.06

ANNOVER
2.06

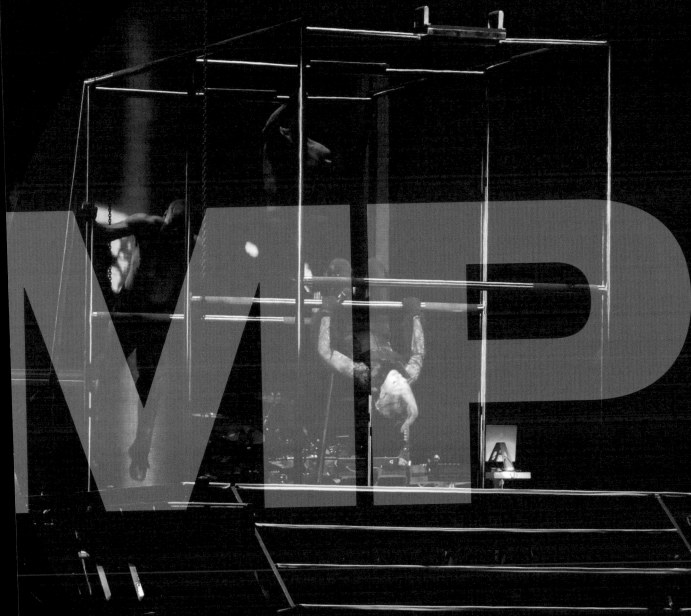

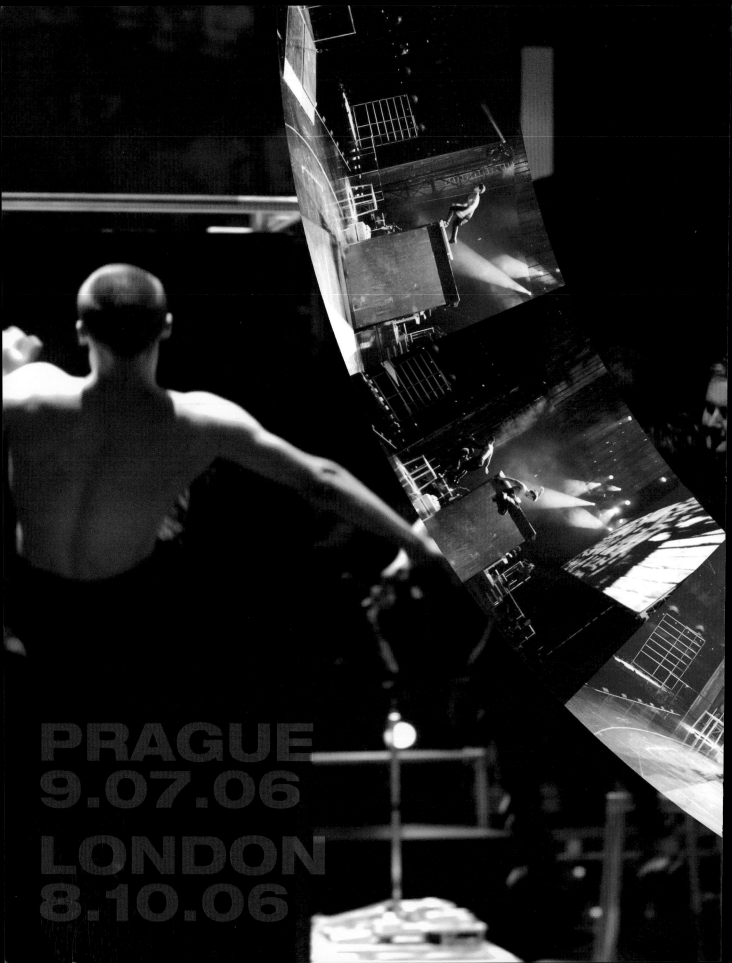

PRAGUE
9.07.06
LONDON
8.10.06

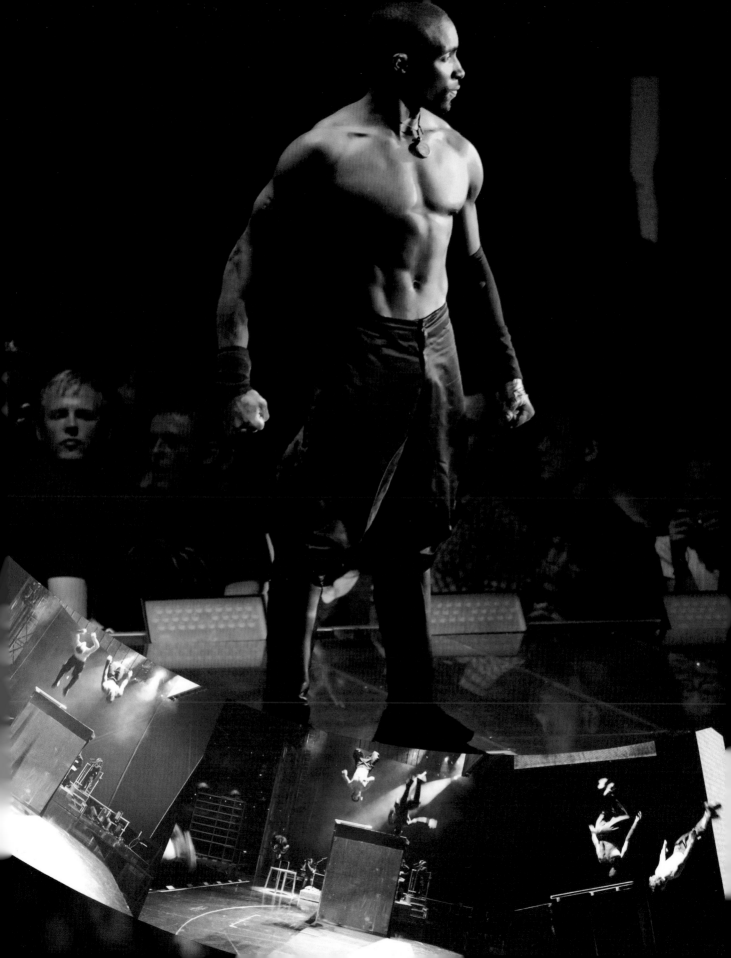

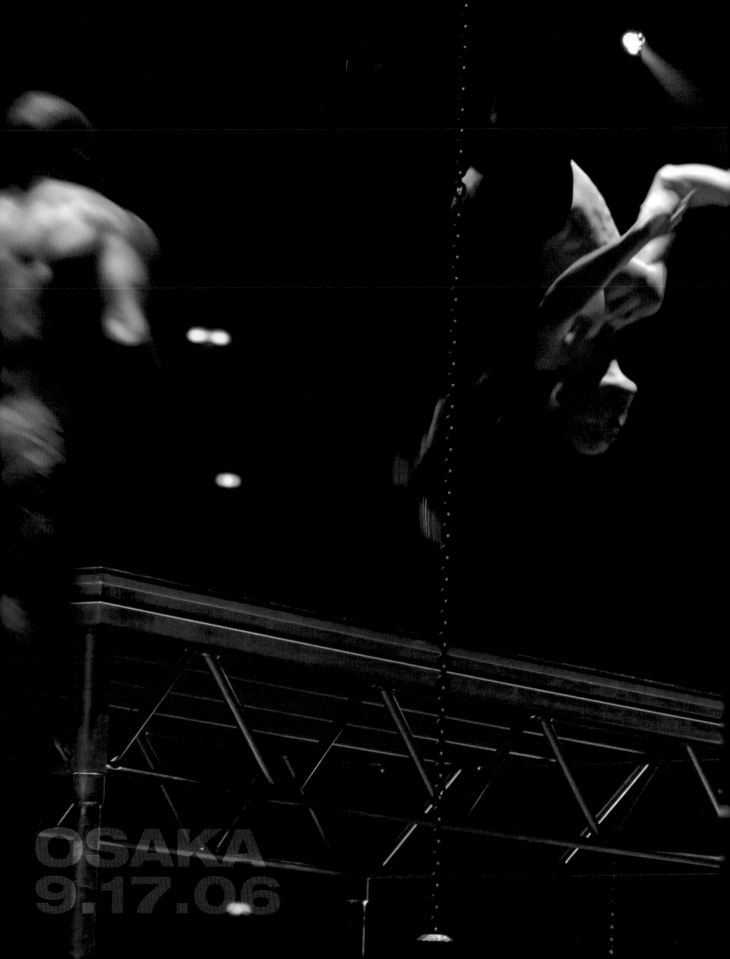

OSAKA
9.17.06

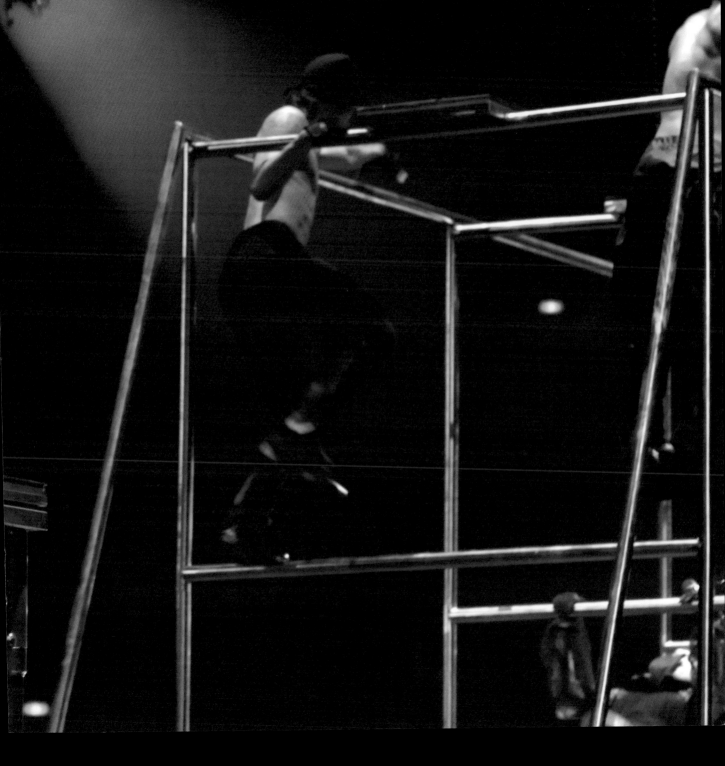

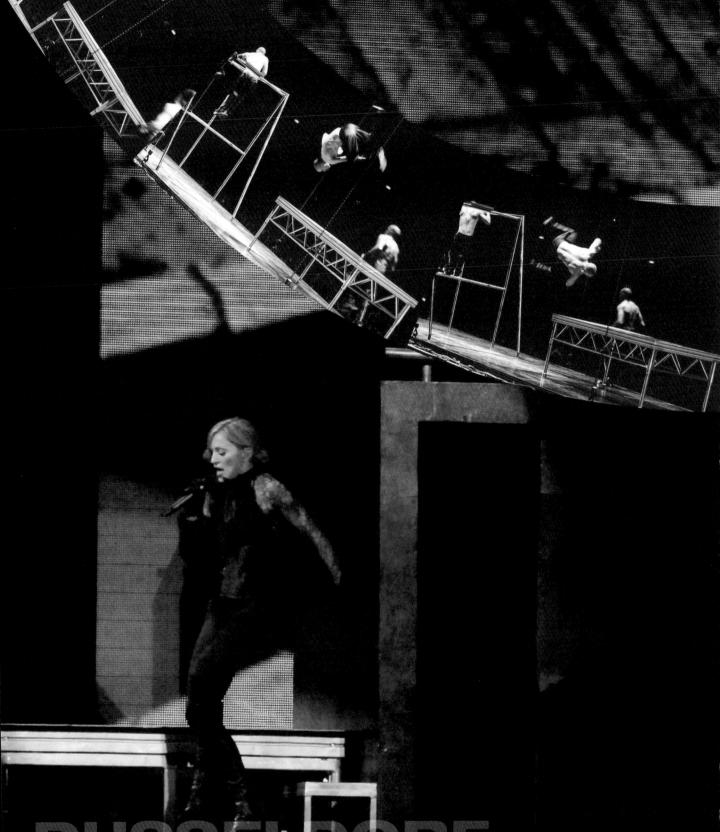

DUSSELDORF
8.20.06

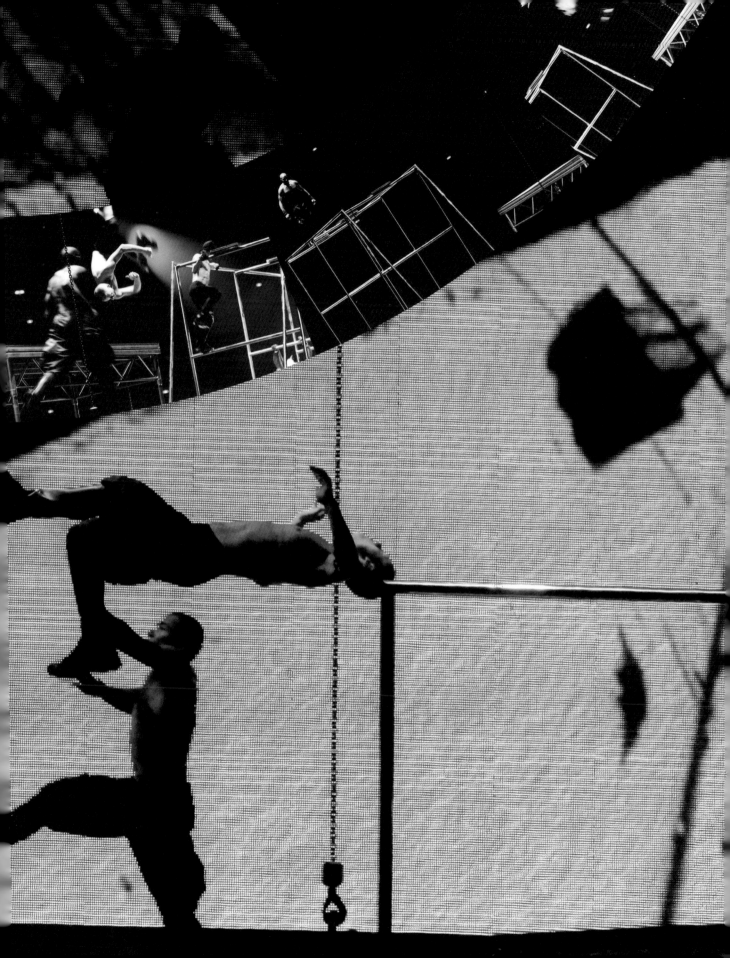

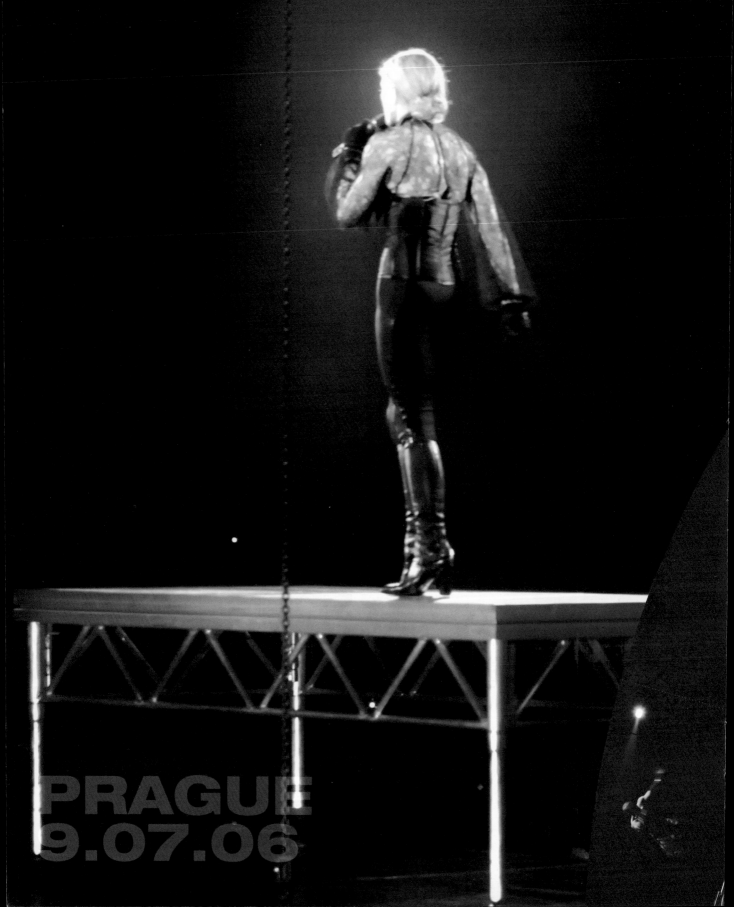

PRAGUE
9.07.06

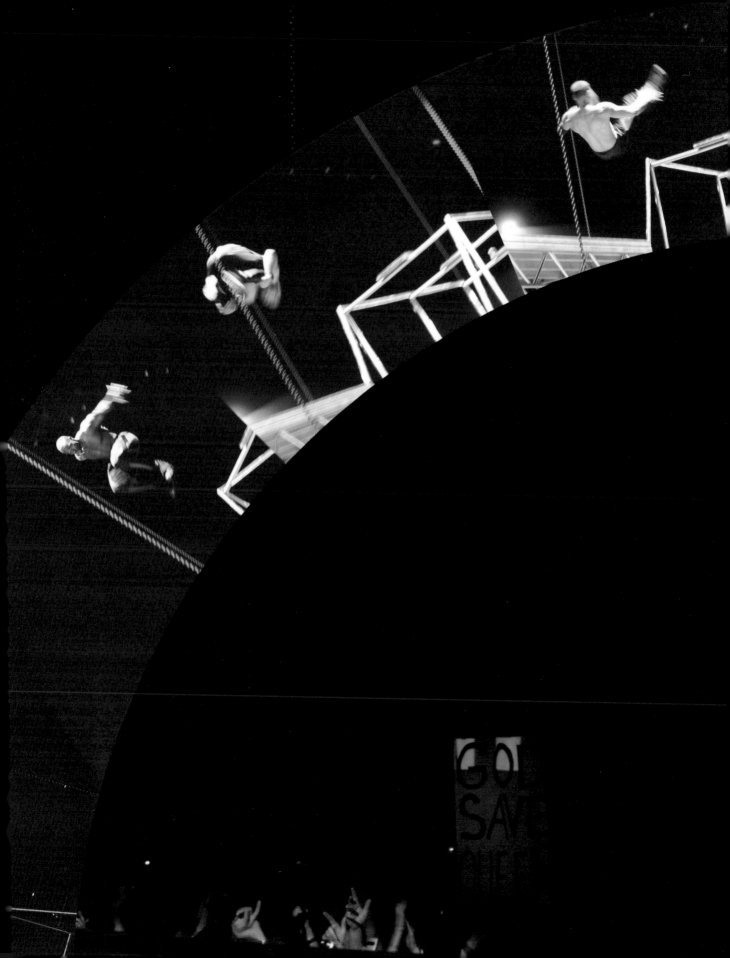

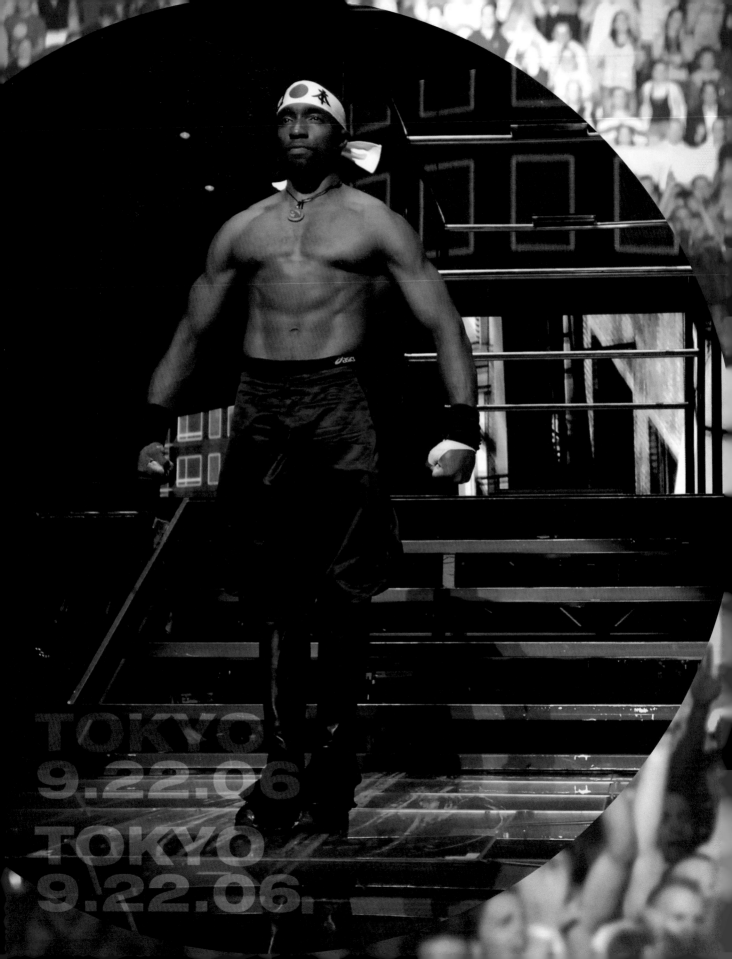

TOKYO
9.22.06
TOKYO
9.22.06

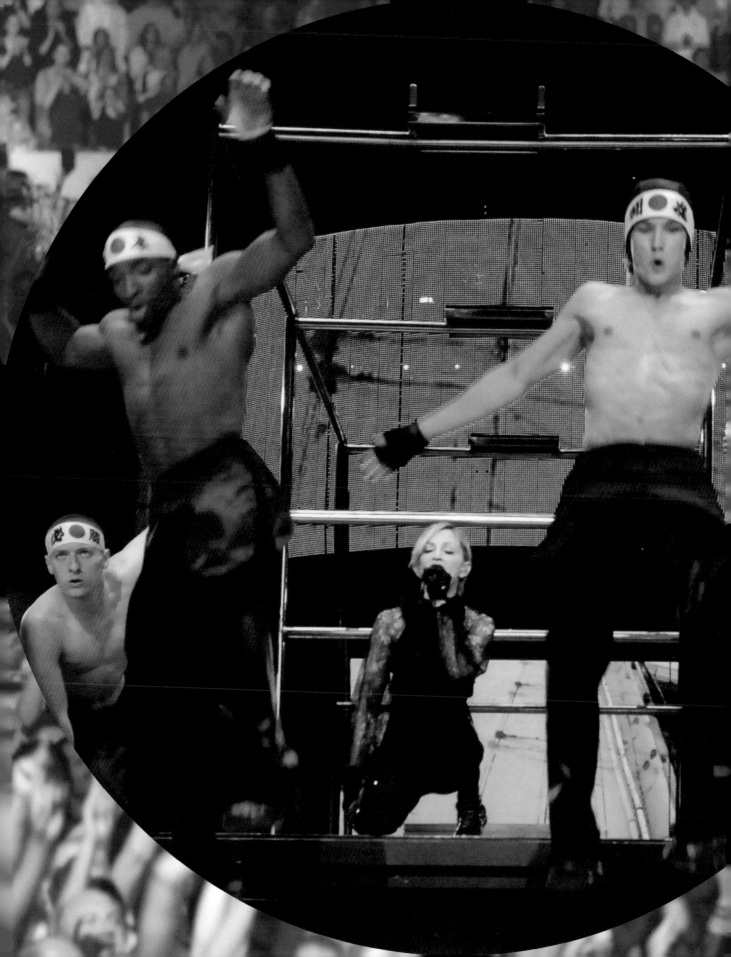

t to kill anybody

CONFES

TOKYO
9.22.06

SSIONS

TOKYO
9.22.06

LONDON
8.09.06

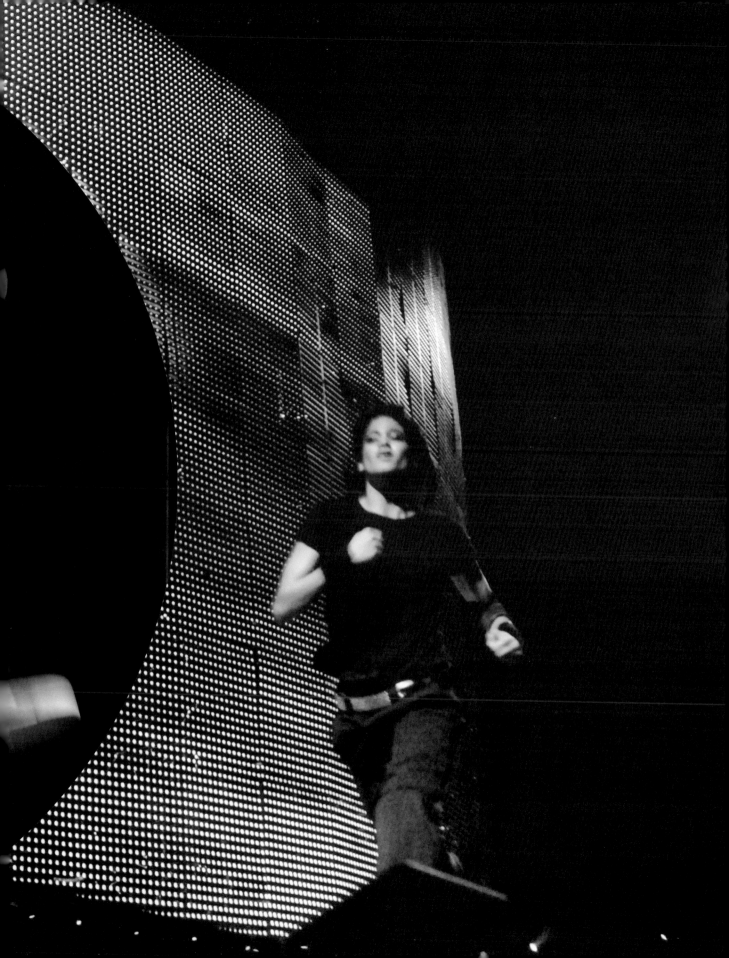

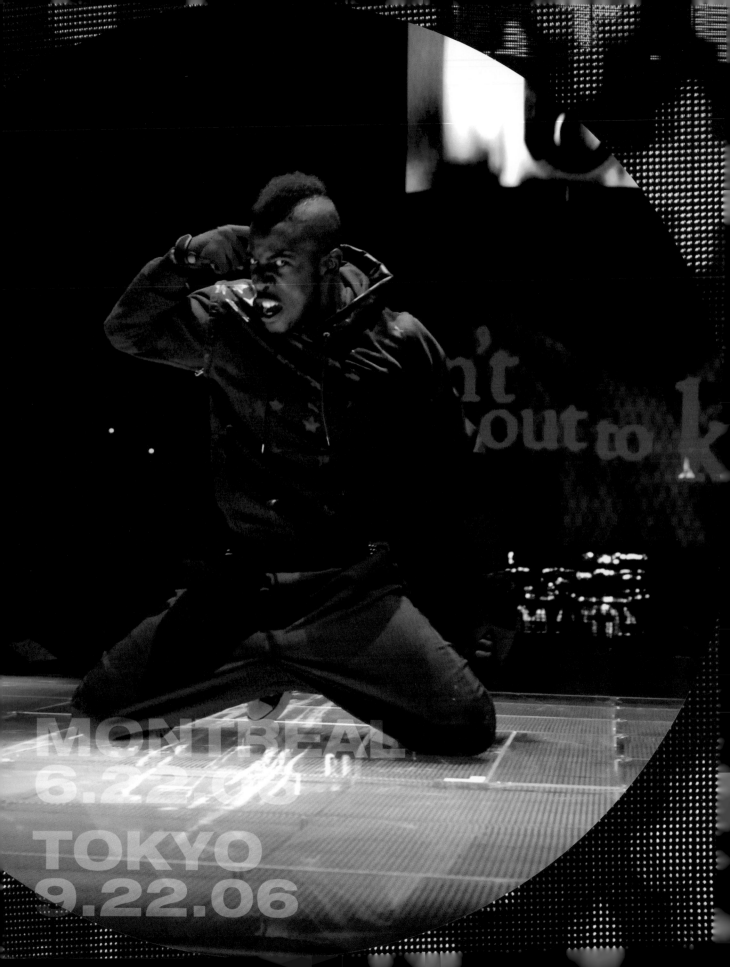

MONTREAL
6.22.06

TOKYO
9.22.06

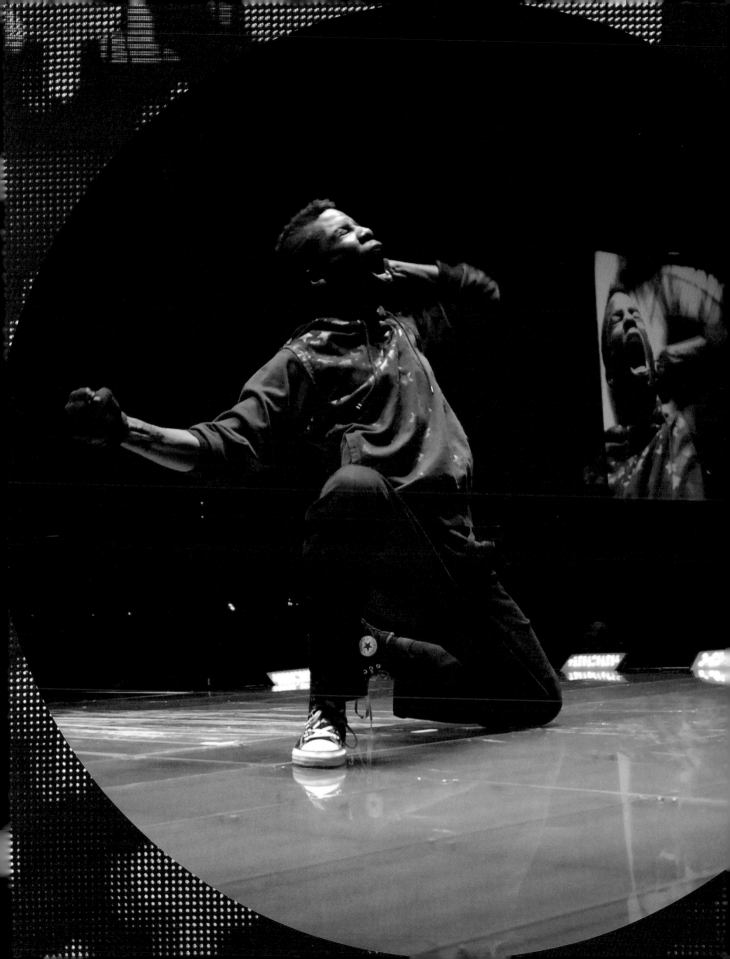

BOSTON
7.09.06
CARDIFF
7.29.06
ONTREAL
.22.06

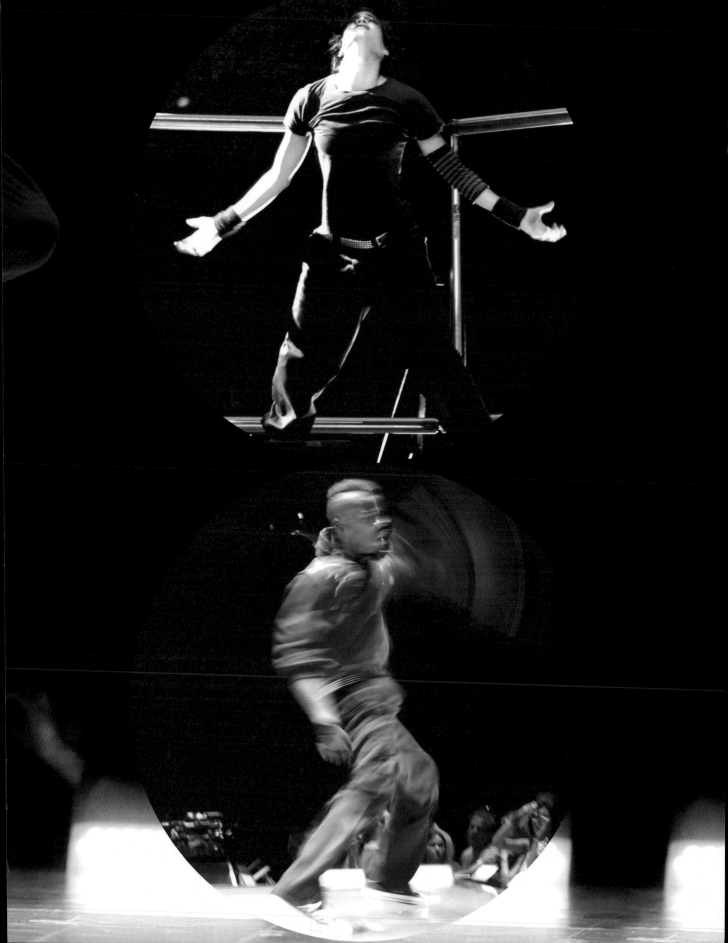

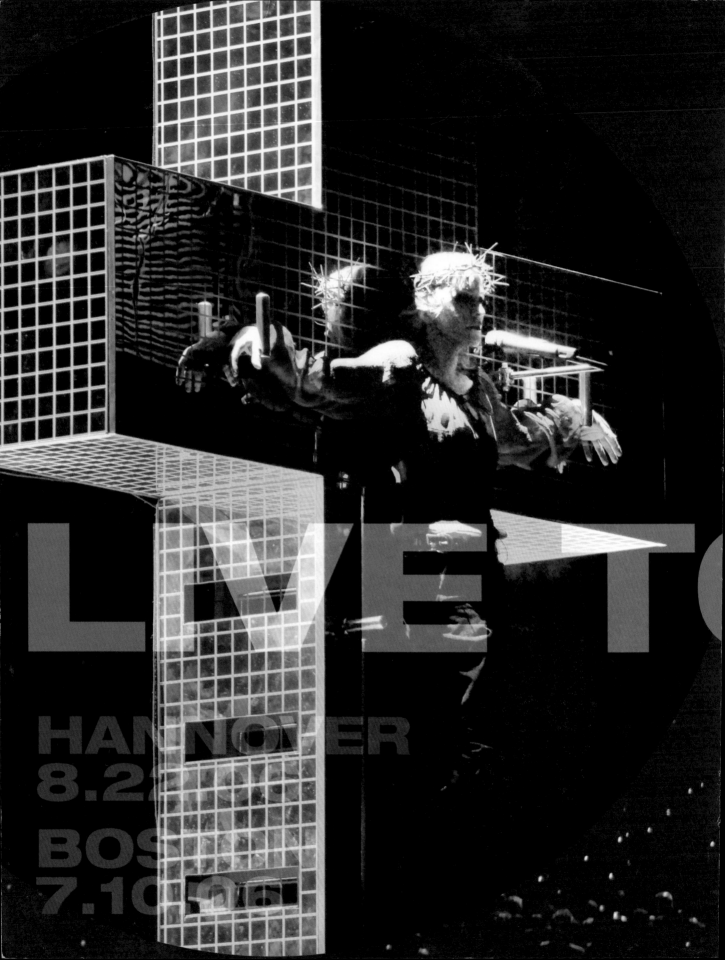

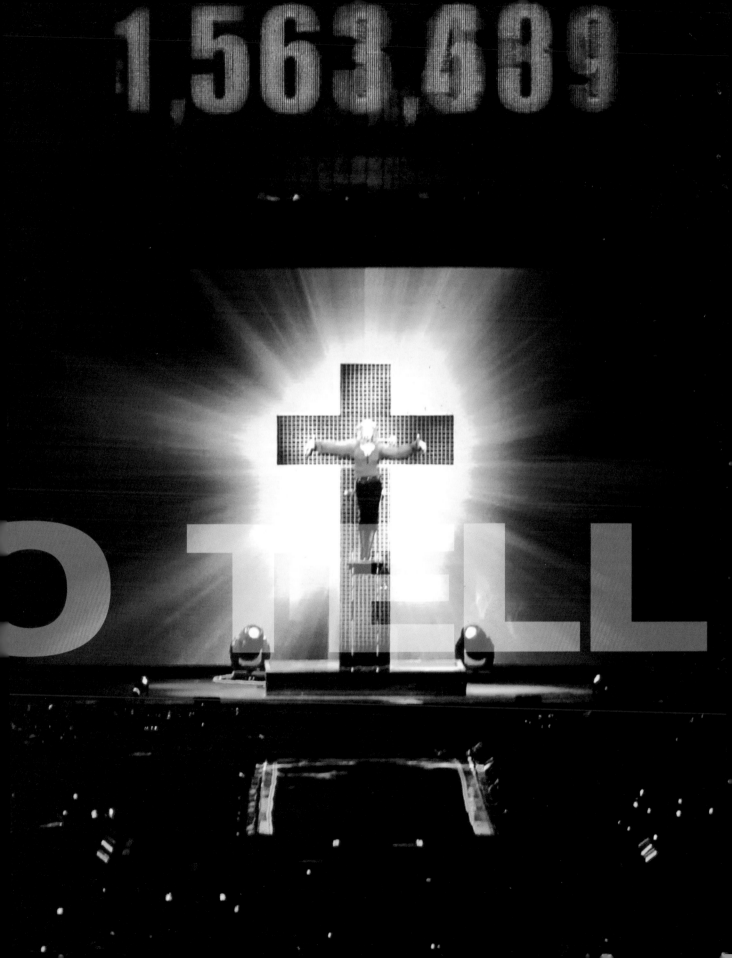

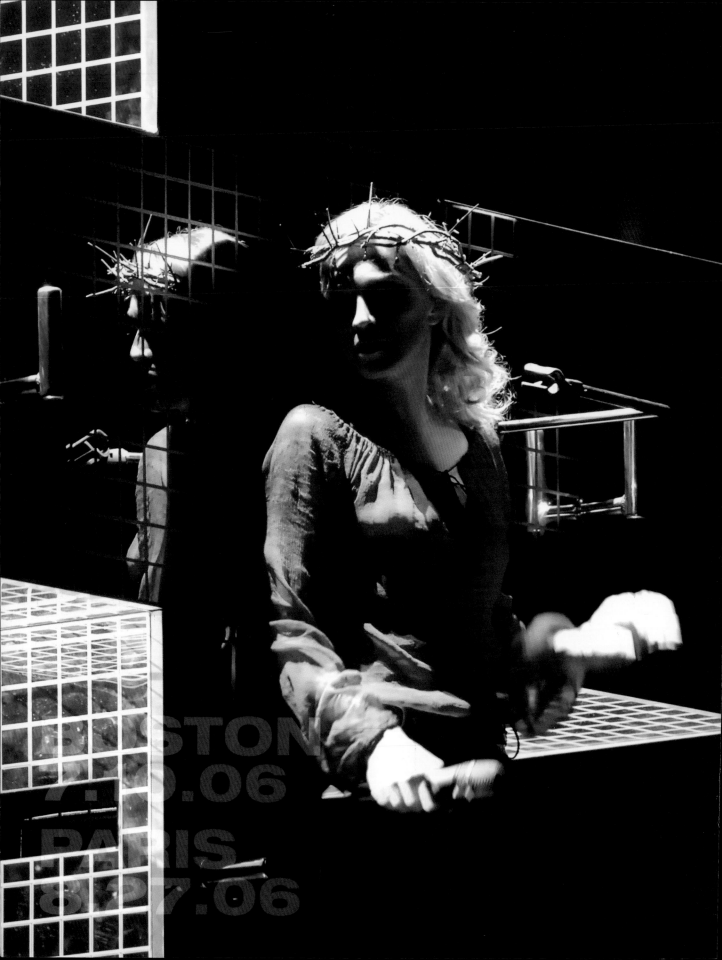

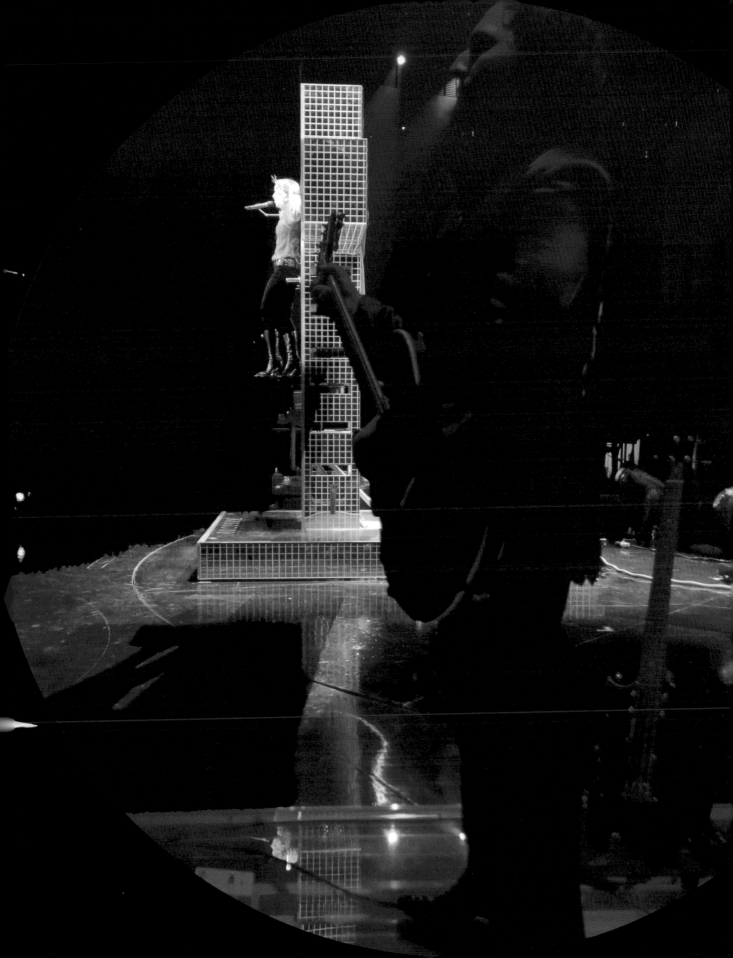

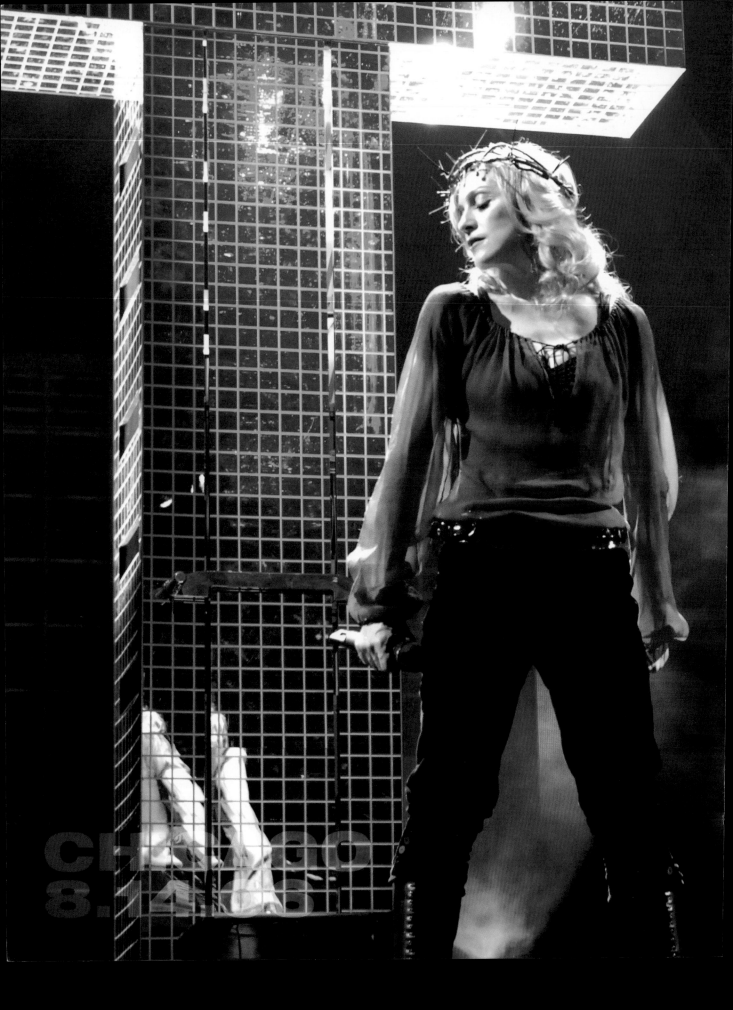

TOKYO
9.22.06

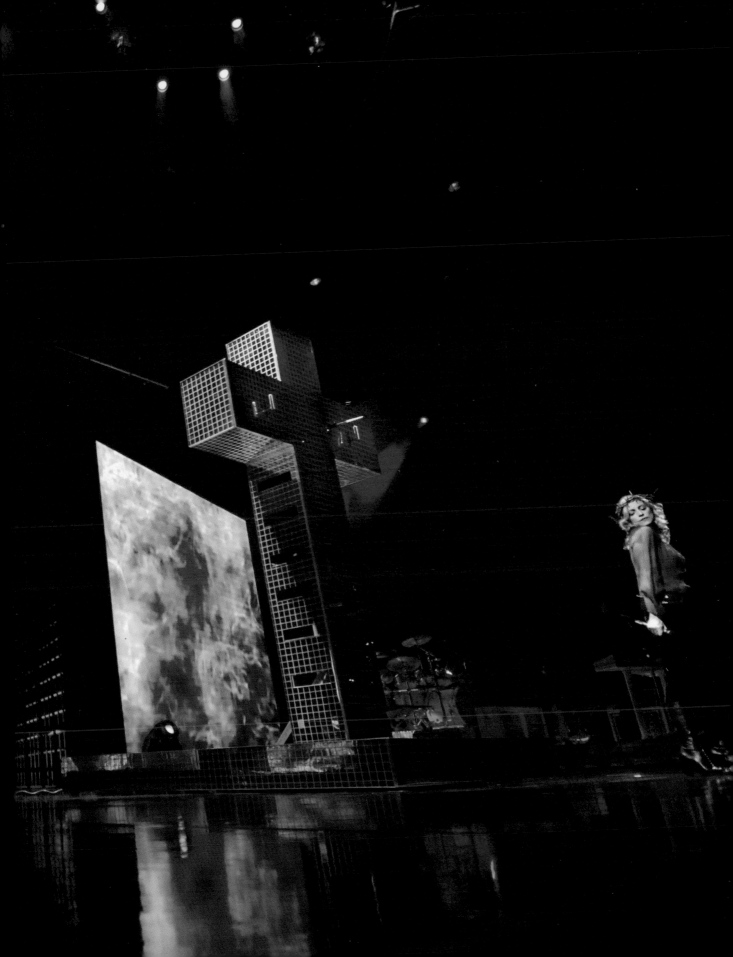

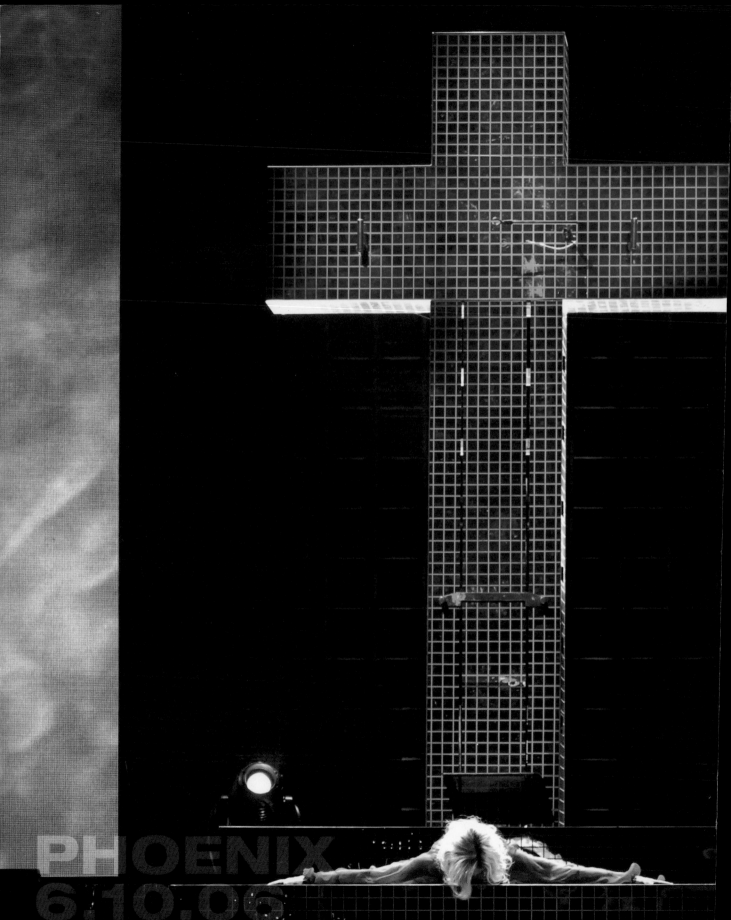

PHOENIX
6.10.06

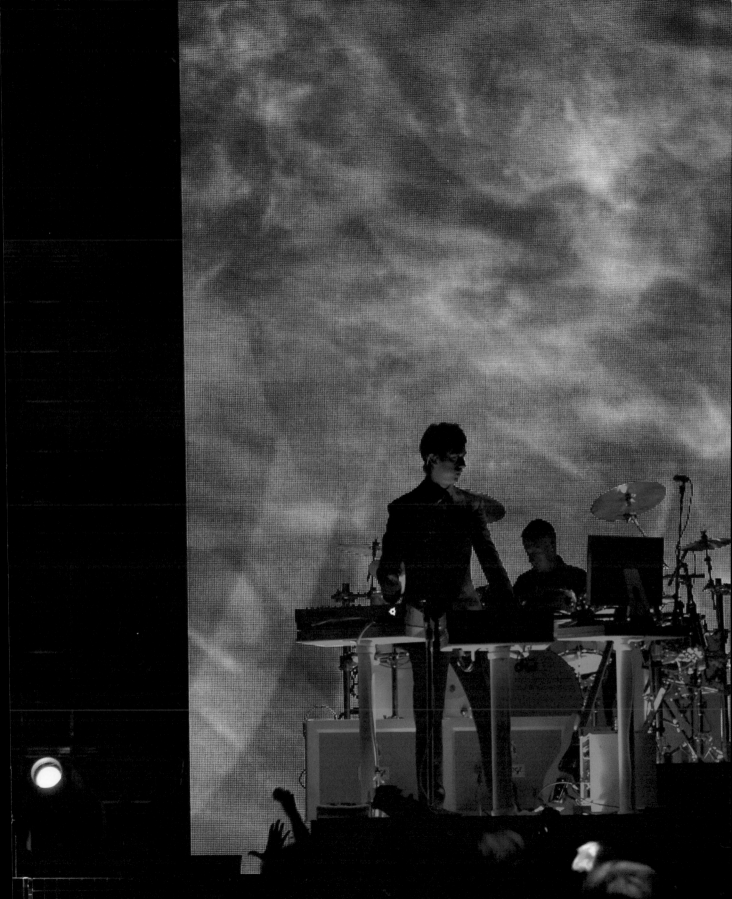

FORBIDD

BOSTON
7.10.06

CHICAGO
6.14.06

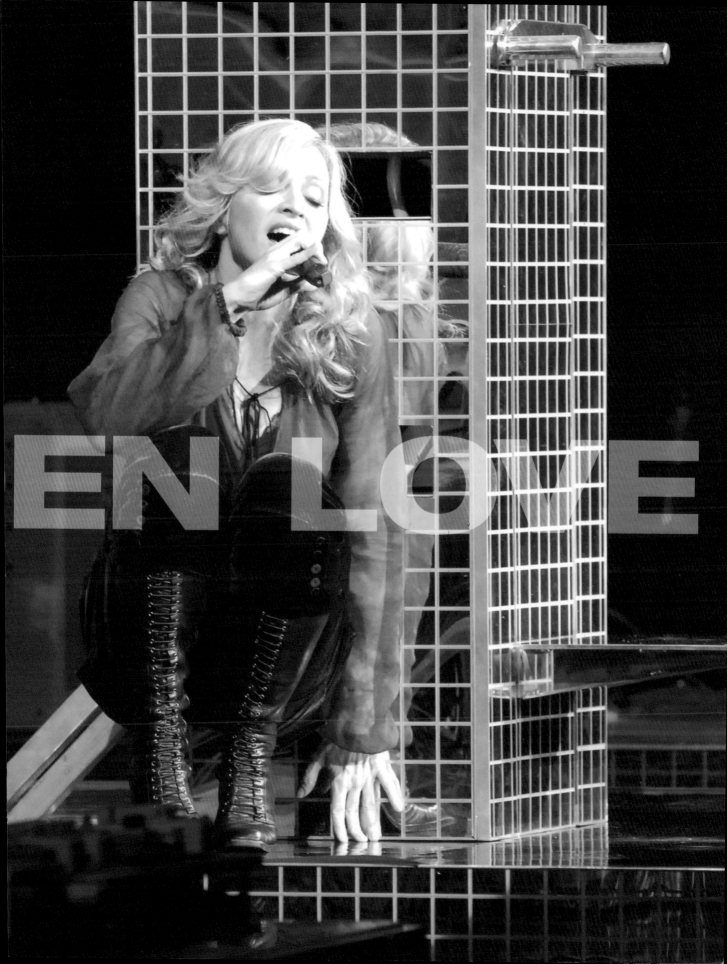

LONDON
8.10.06
BOSTON
7.10.06

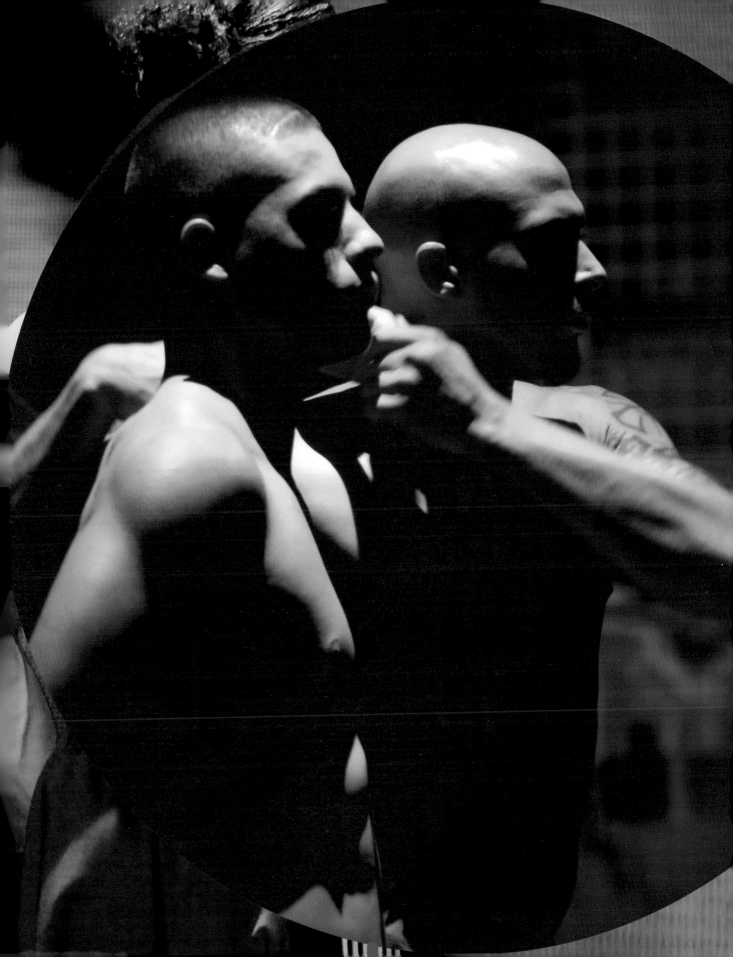

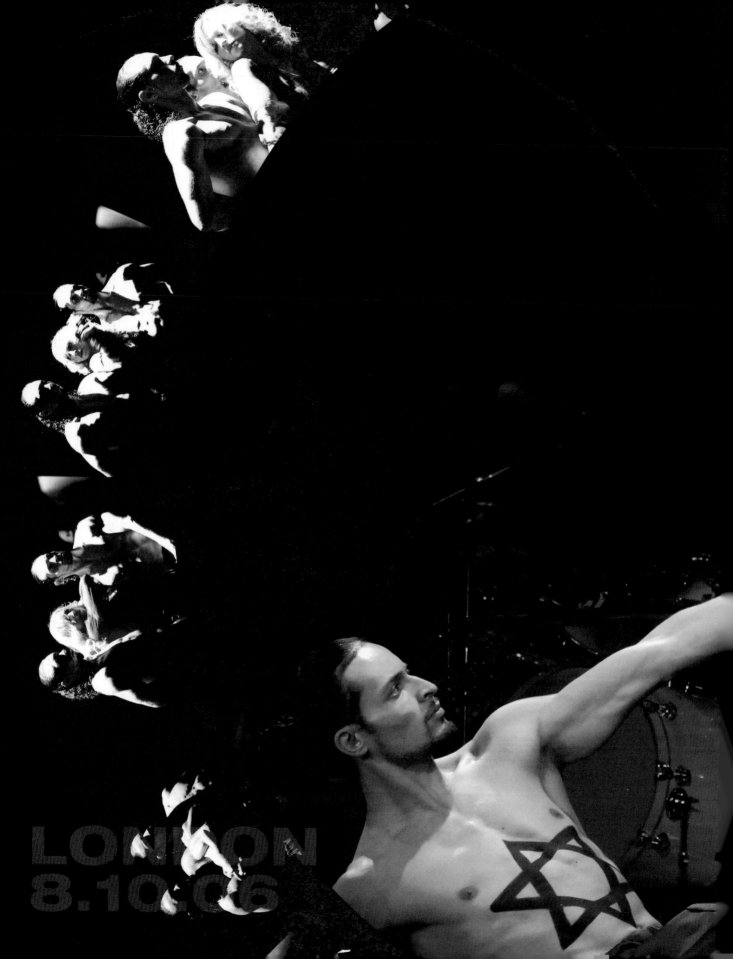

LONDON
8.10.06

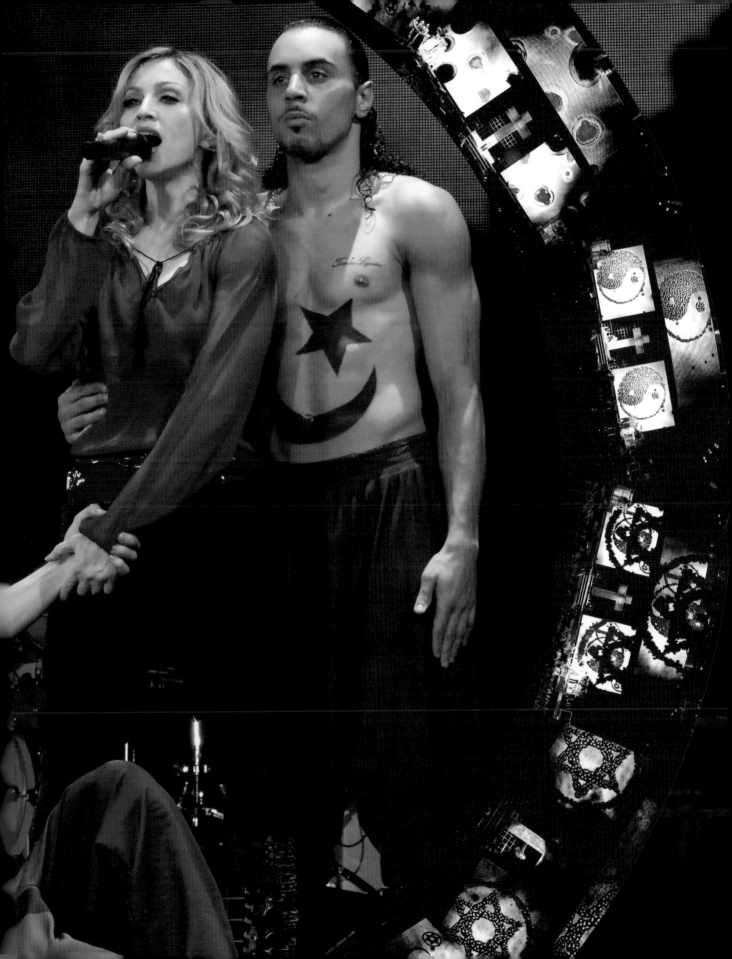

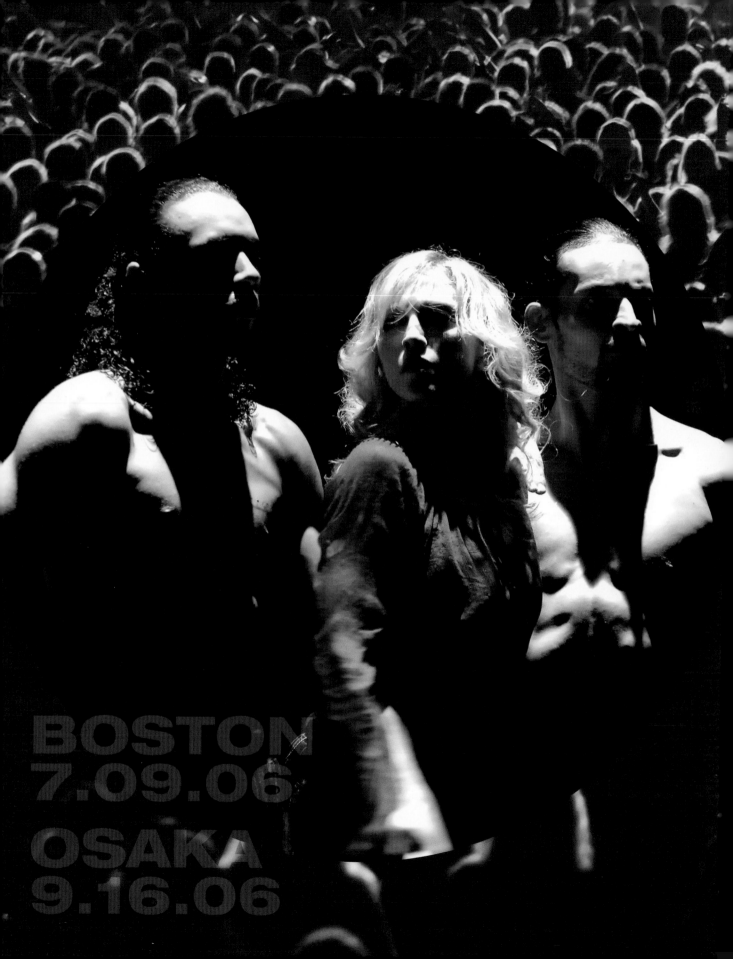

BOSTON
7.09.06
OSAKA
9.16.06

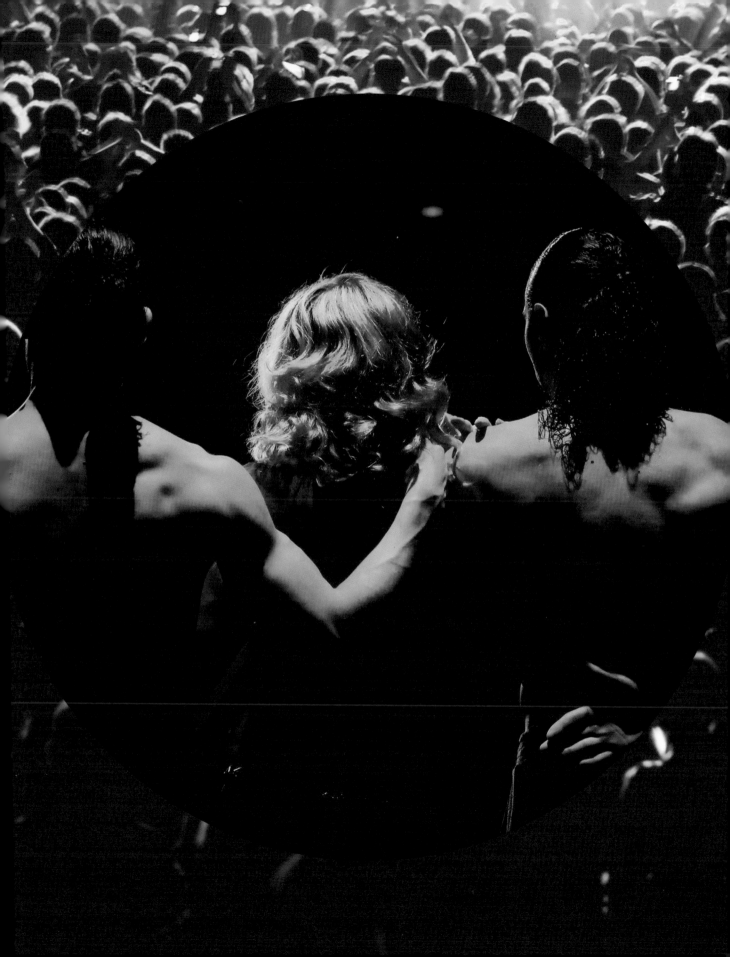

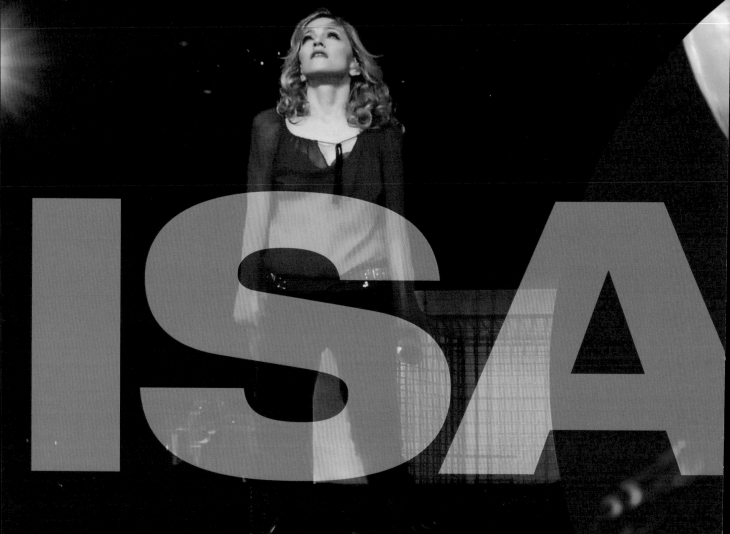

ISA

TOKYO
9.22.06
NEW YORK CITY
7.19.06

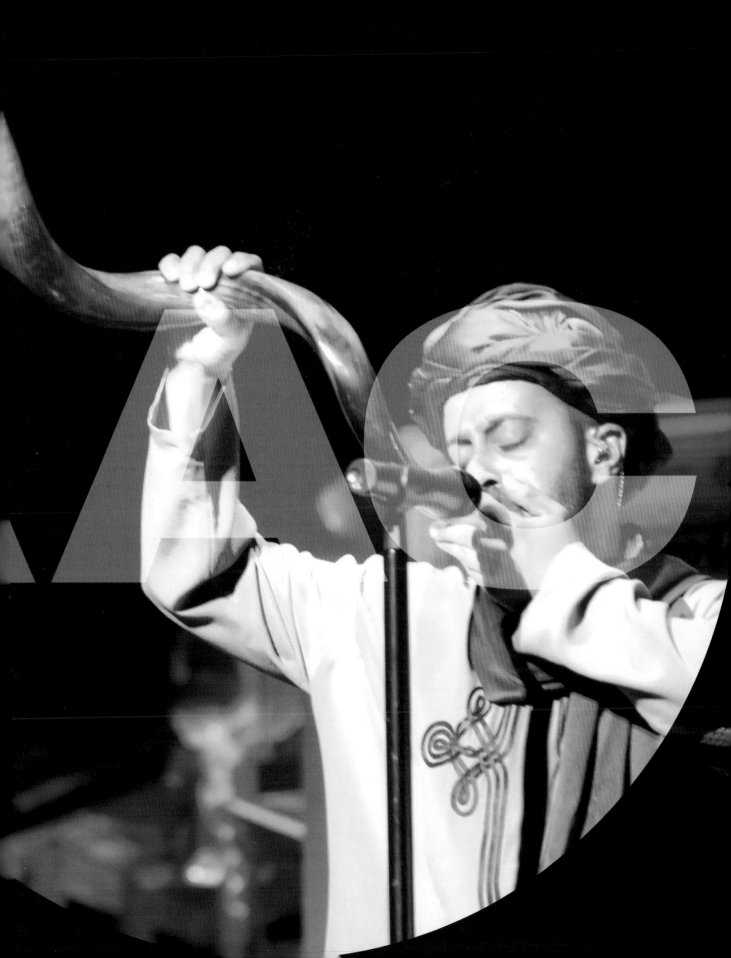

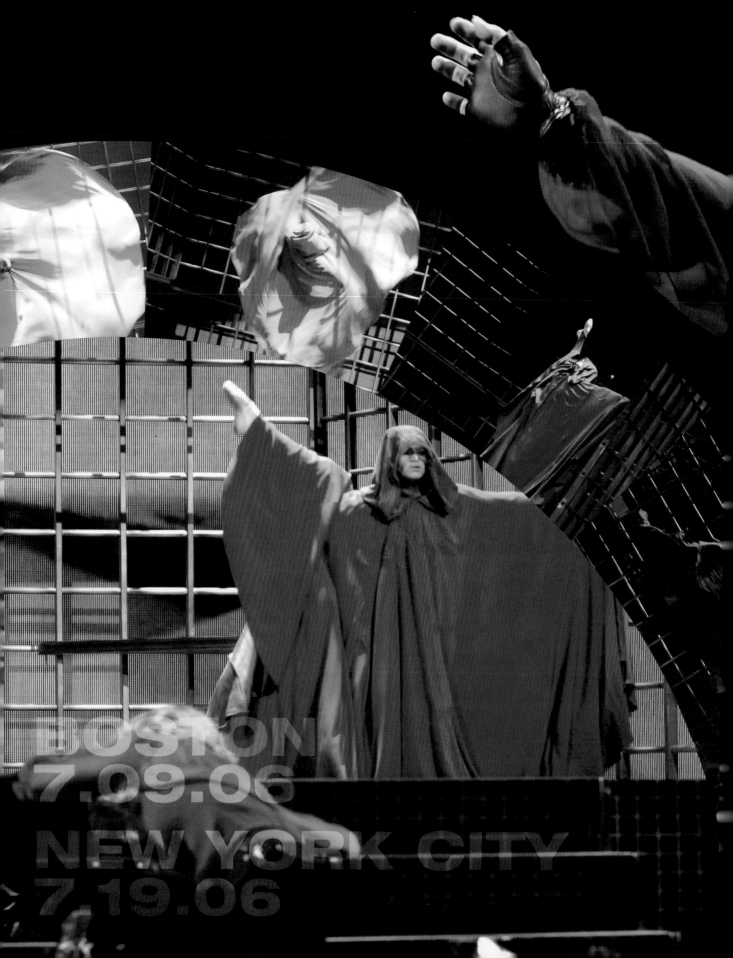

BOSTON
7.09.06
NEW YORK CITY
7.19.06

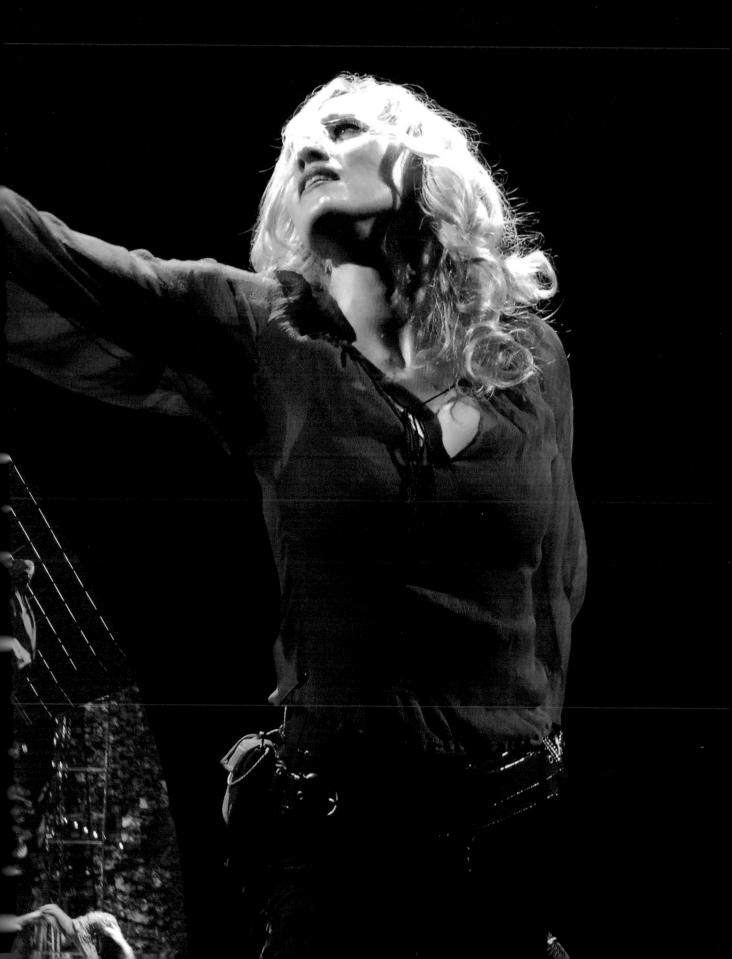

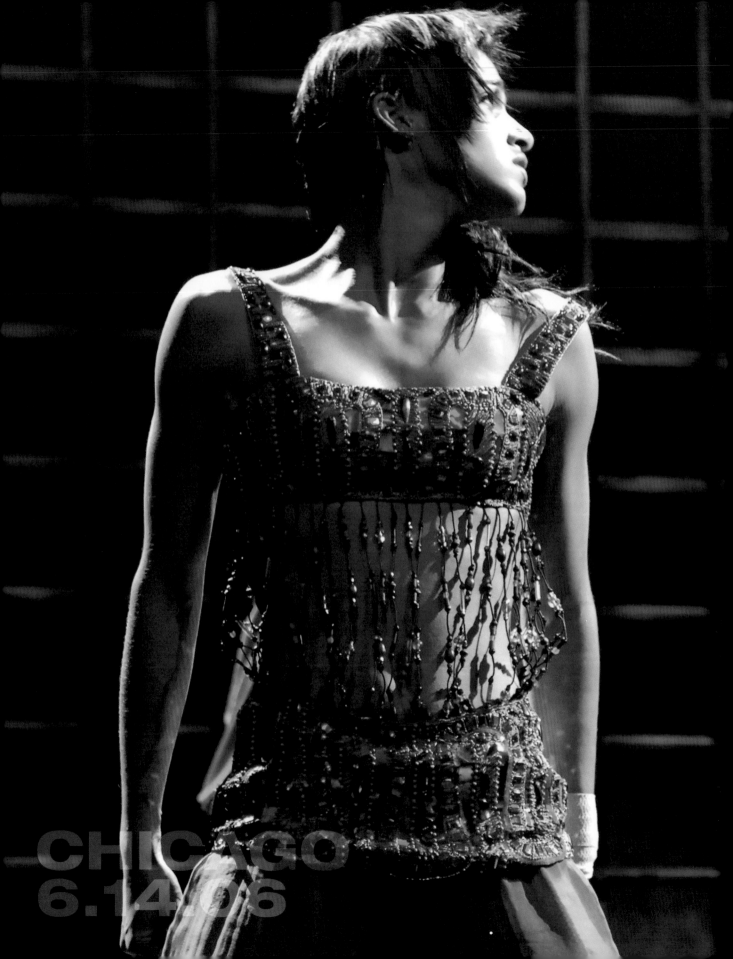

CHICAGO
6.14.06

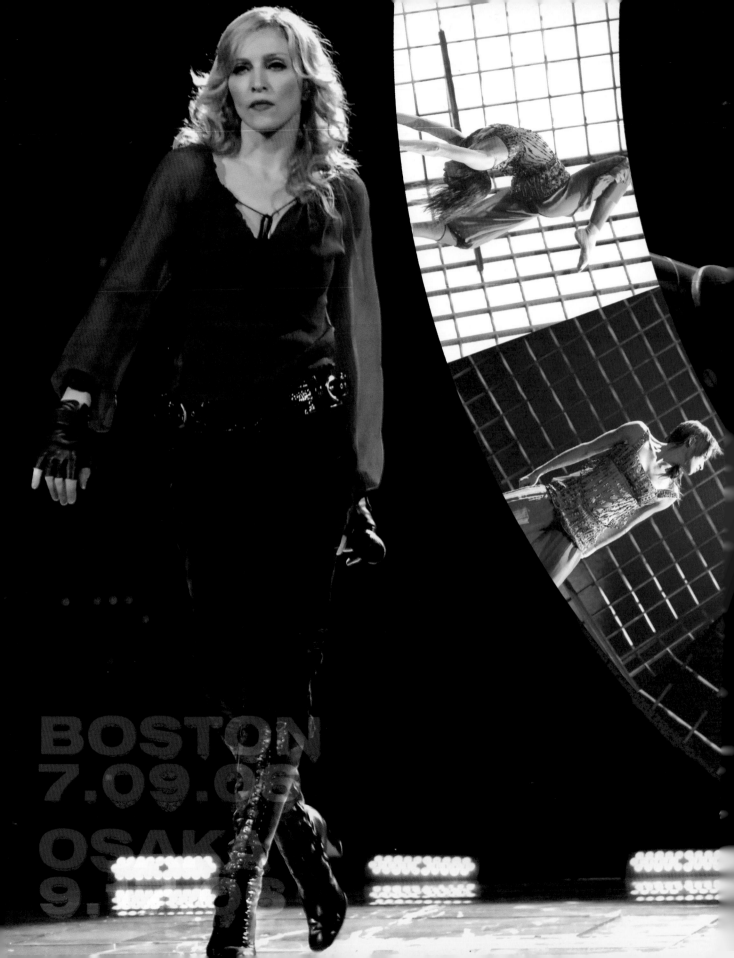

BOSTON
7.09.0
OSAK
9.

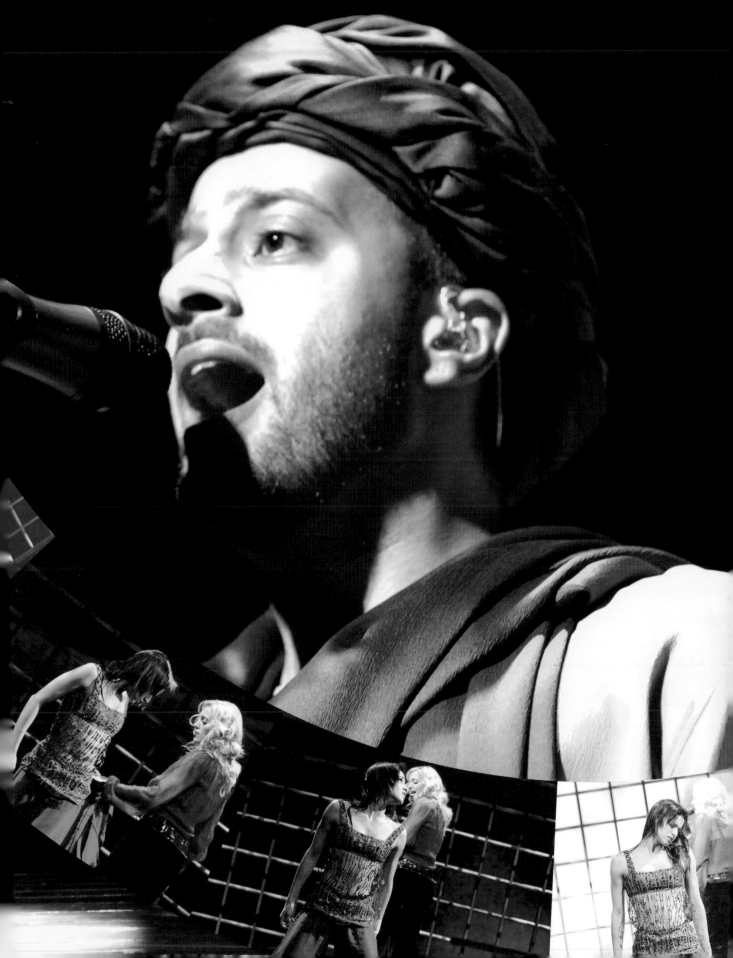

AMSTERDAM
9.03.06

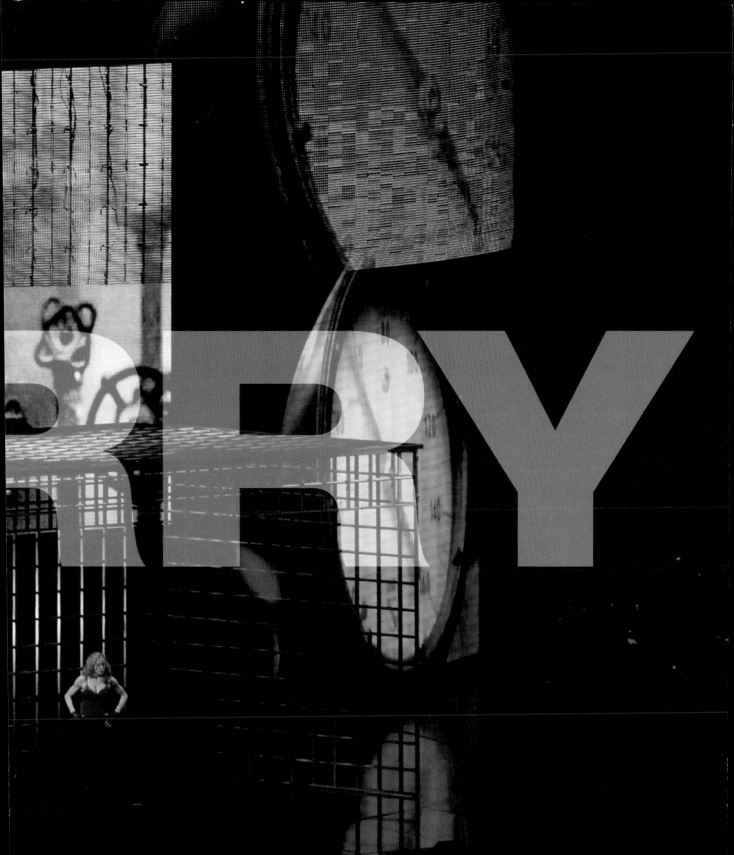

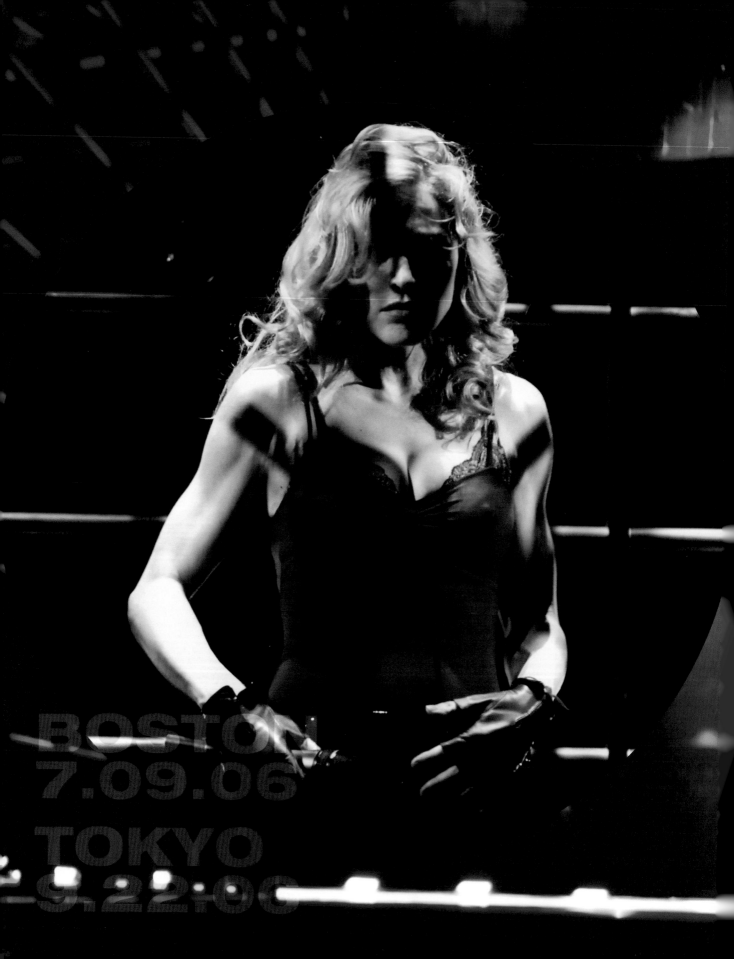

BOSTON
7.09.06

TOKYO
9.22.06

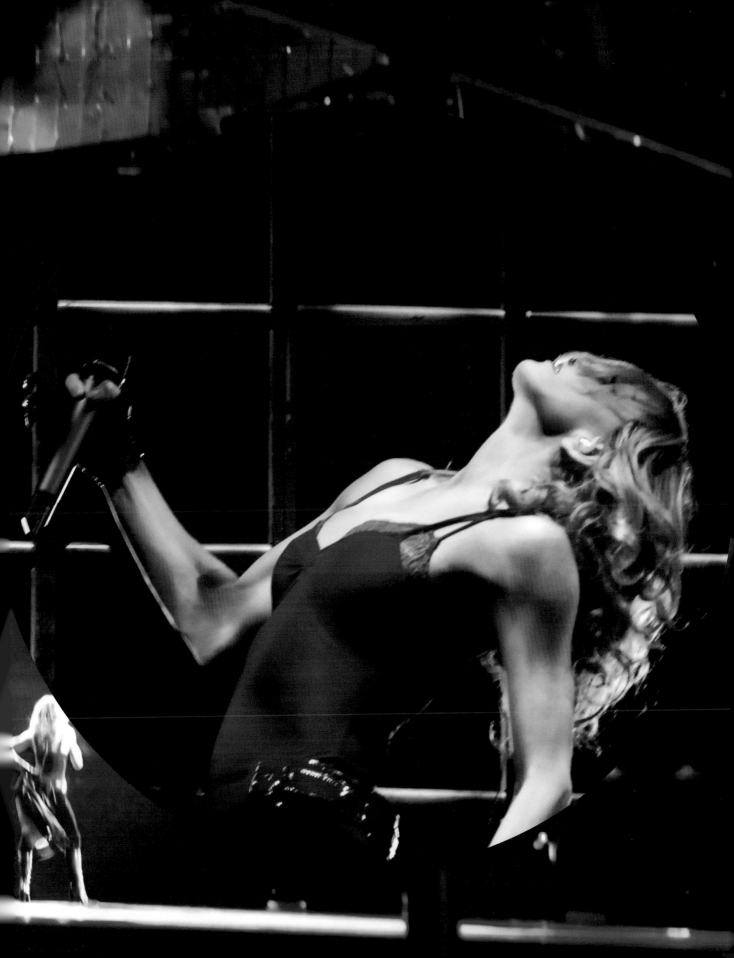

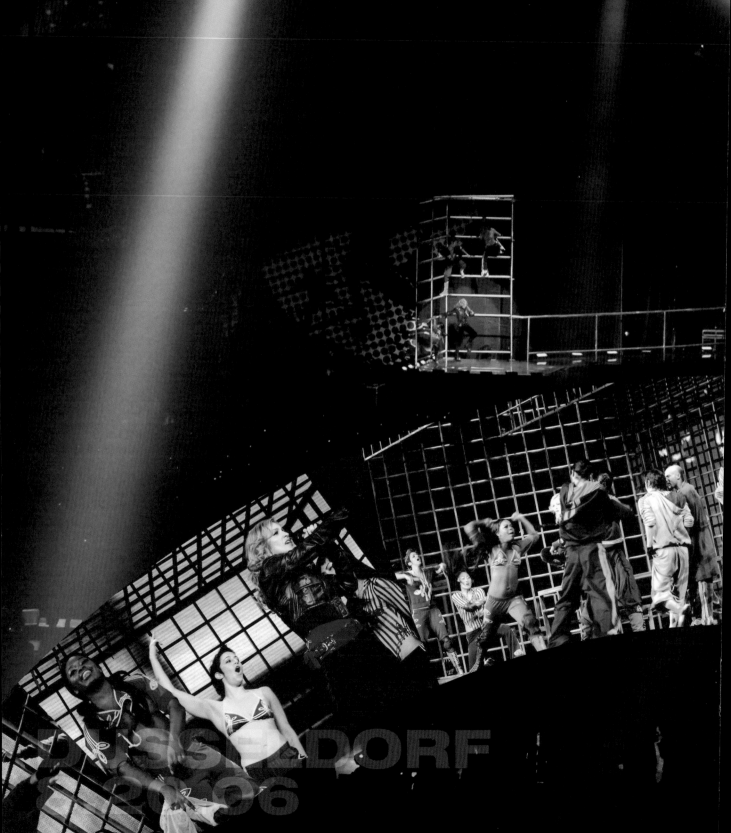

DÜSSELDORF 8.20.06

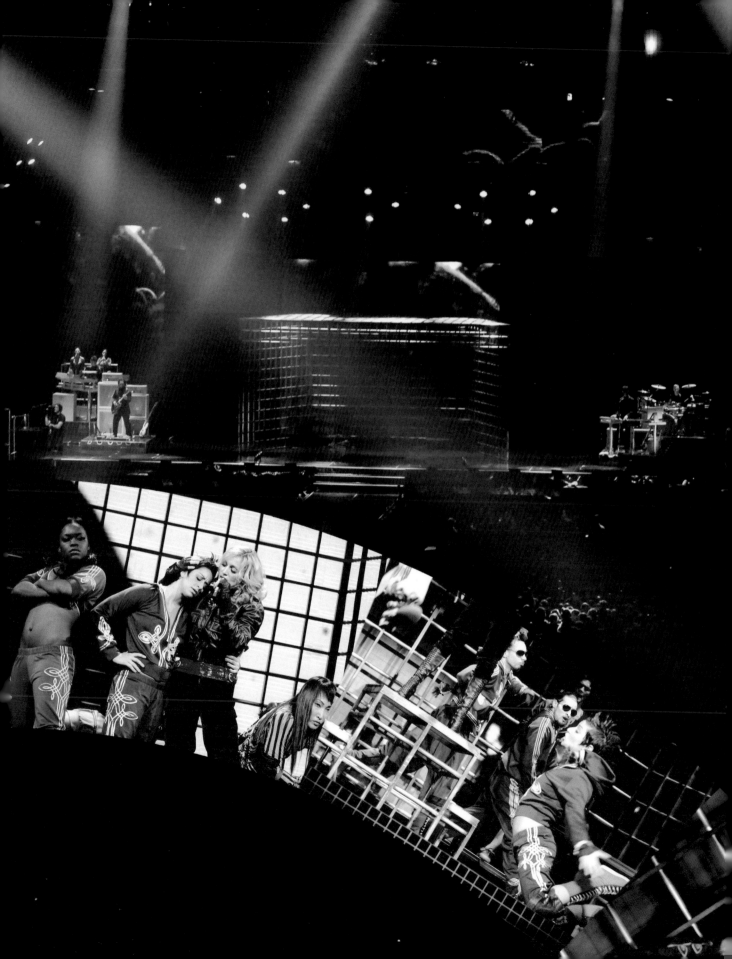

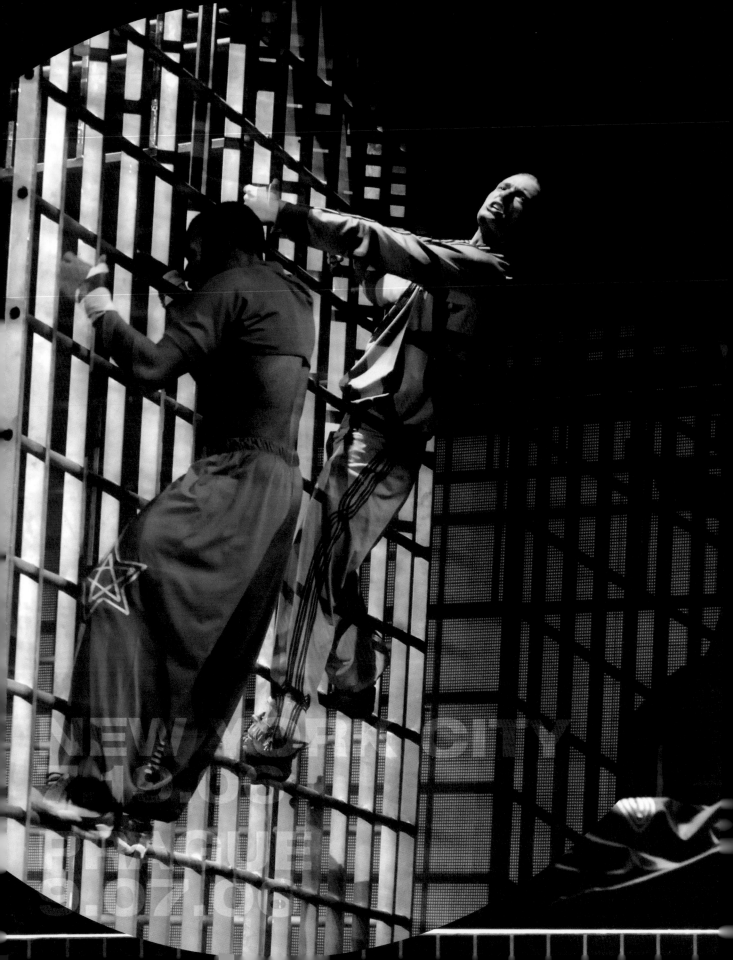

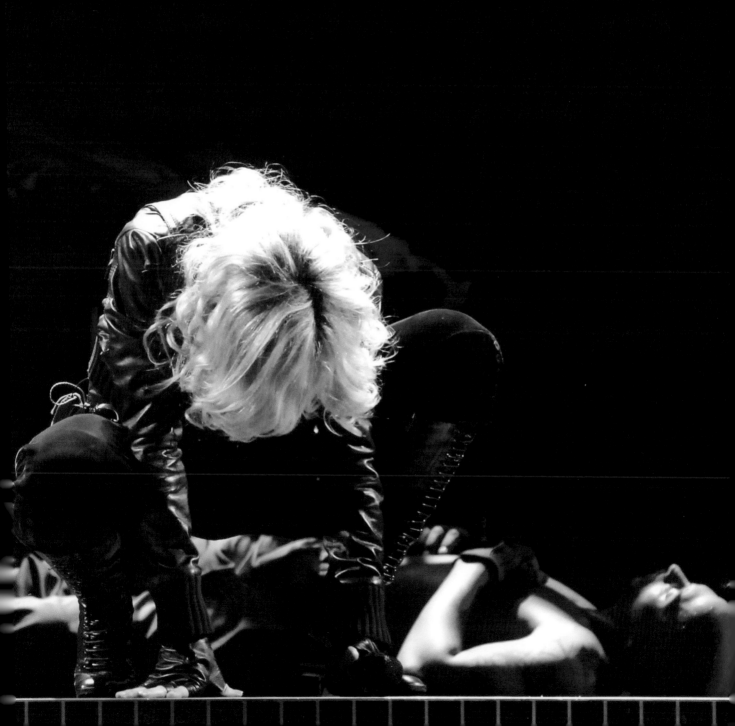

EVERY TIME I DO A SHOW, I DIE A LITTLE BIT,
BUT NO SHIT IS WORTH DOING UNLESS
YOU'RE WILLING TO DIE FOR IT. YOU GUYS CAN
UNDERSTAND THAT, YOU'RE NEW YORKERS.
YOU'RE WILLING TO DIE FOR A TAXI CAB!

LIKE IT

PRAGUE
9.07.06

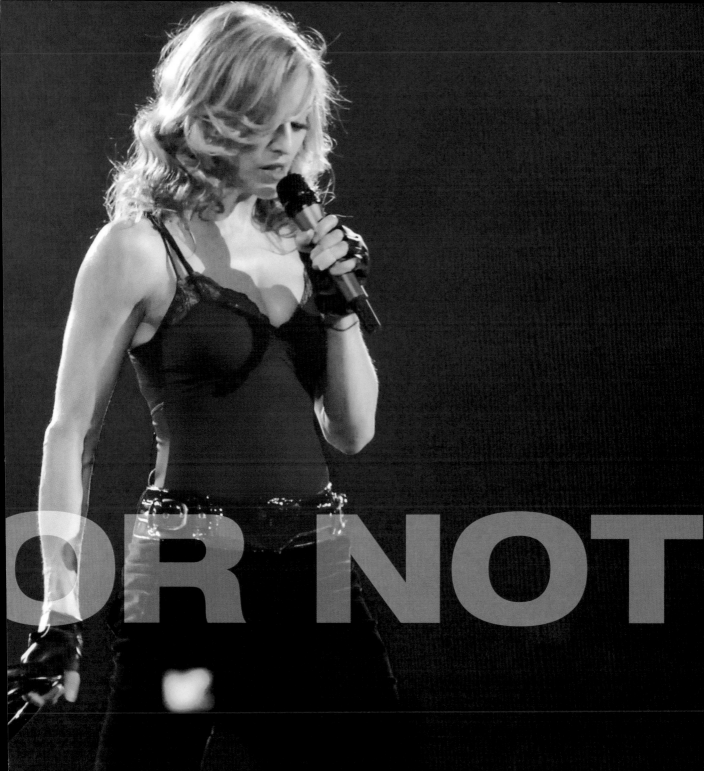

OR NOT

PRAGUE
9.07.06
DUSSELDORF
8.20.06

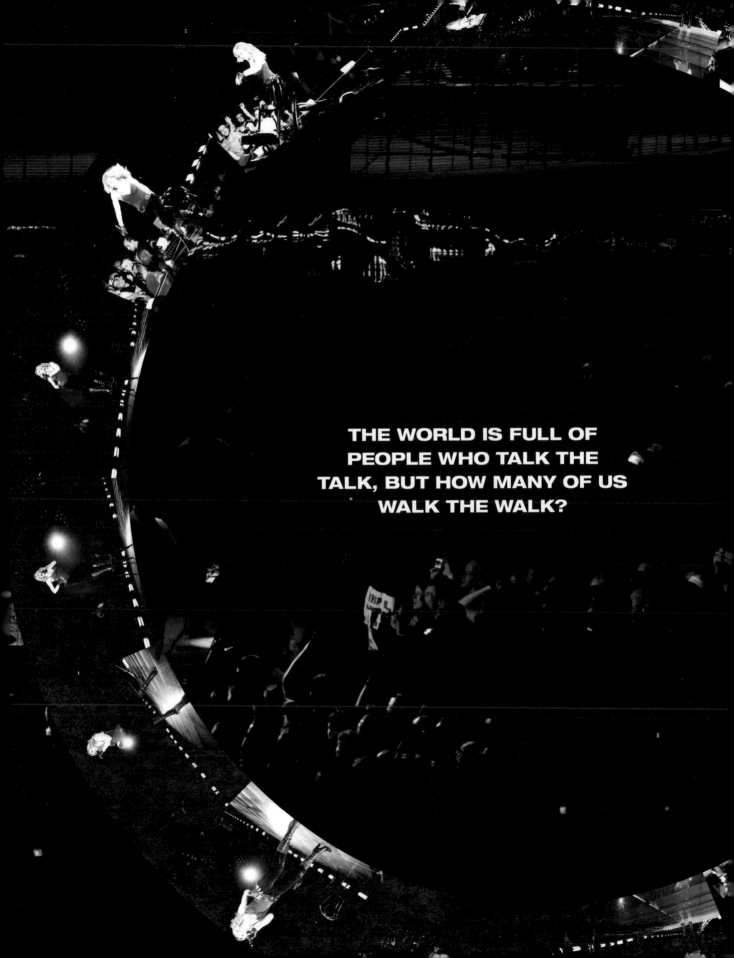

THE WORLD IS FULL OF
PEOPLE WHO TALK THE
TALK, BUT HOW MANY OF US
WALK THE WALK?

NEW YORK CITY
7.19.06

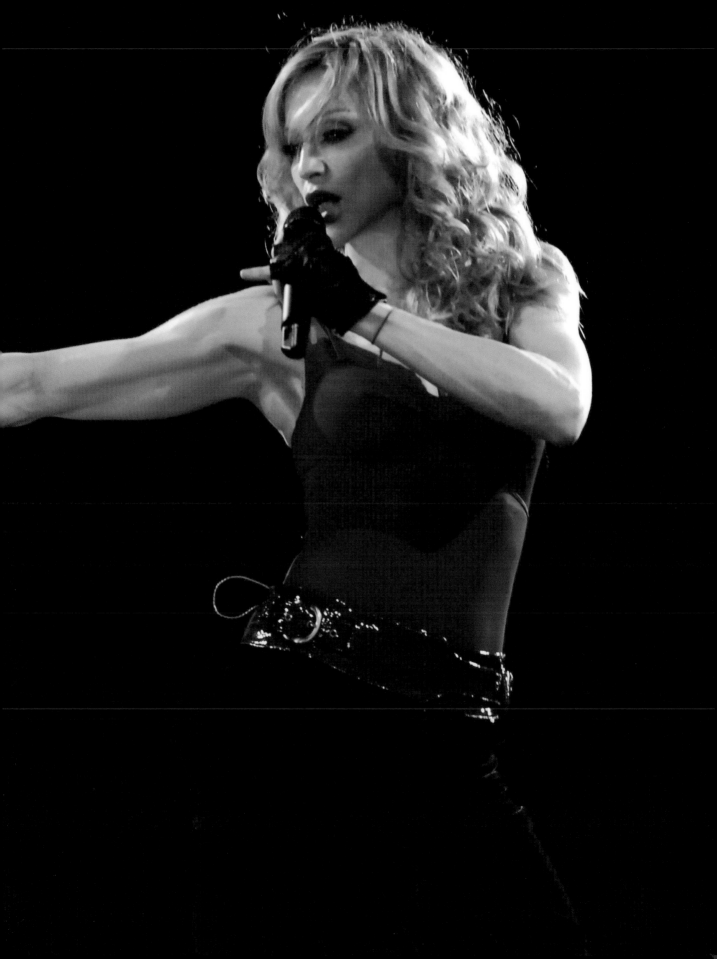

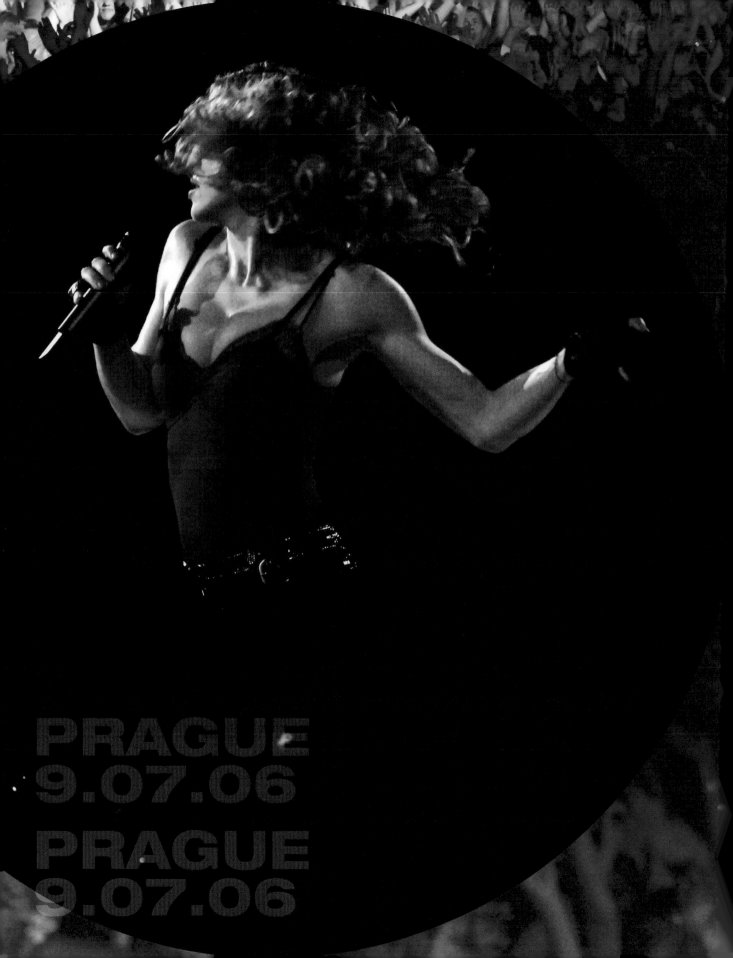

PRAGUE
9.07.06
PRAGUE
9.07.06

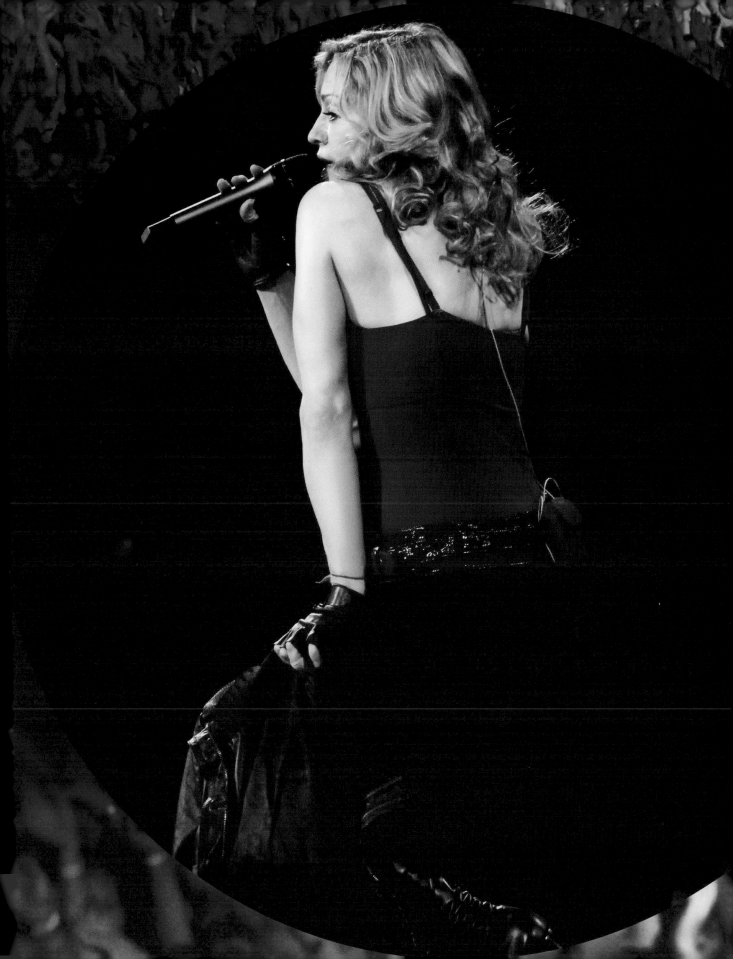

SORRY

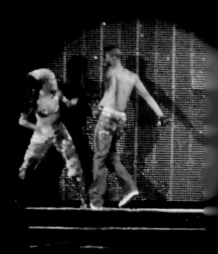

HANNOVER
9.22.06

REMIX

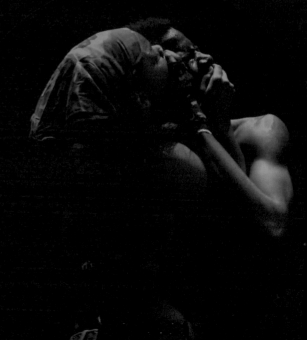

BOSTON
7.09.06
BOSTON
7.10.06
NEW YORK
7.19.06
BOSTON
7.19.06

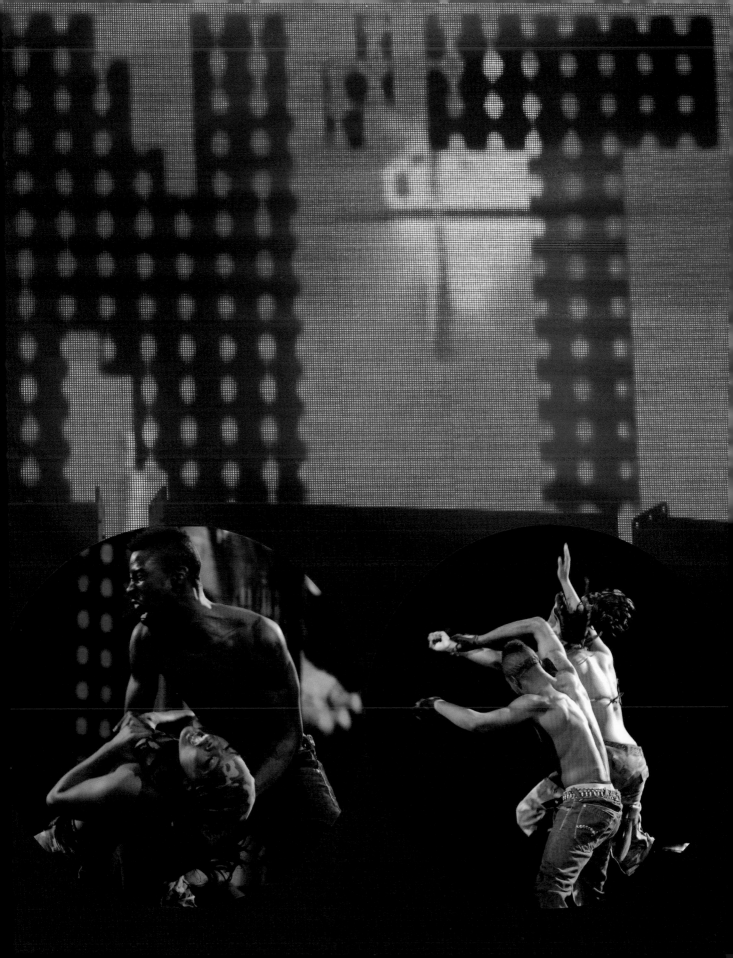

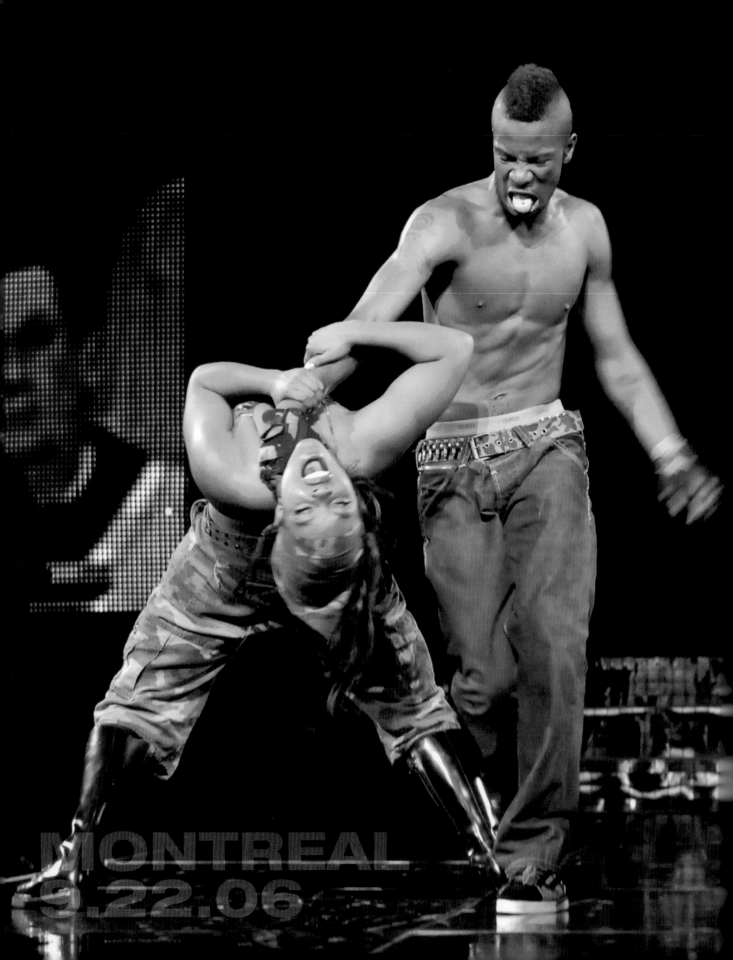

MONTREAL
9.22.06

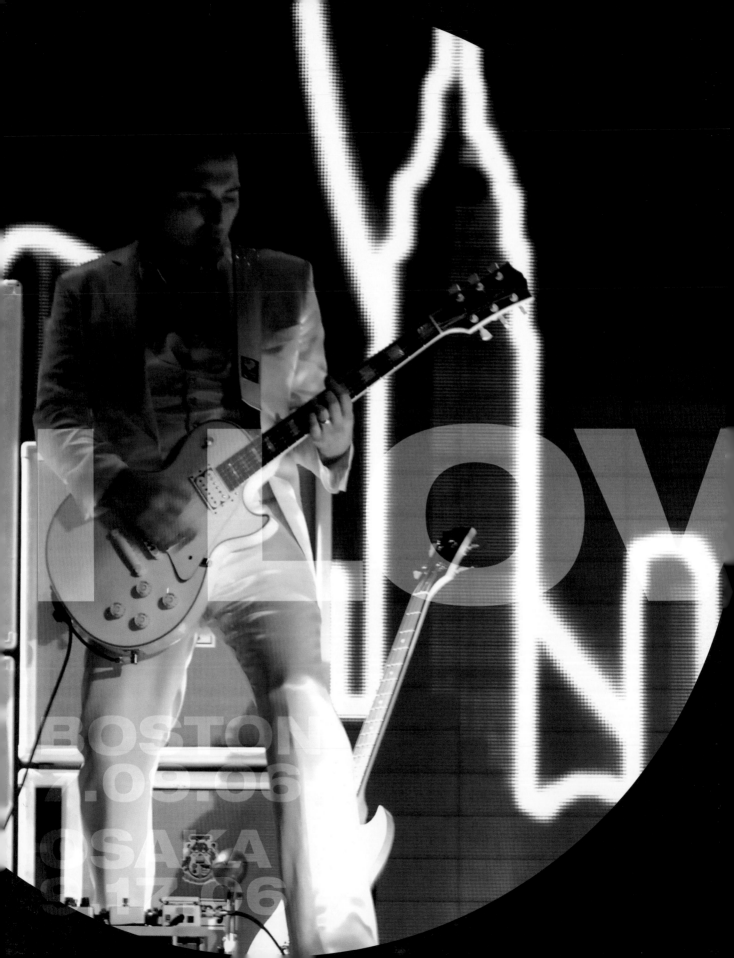

BOSTON
7.09.06

OSAKA
8.17.06

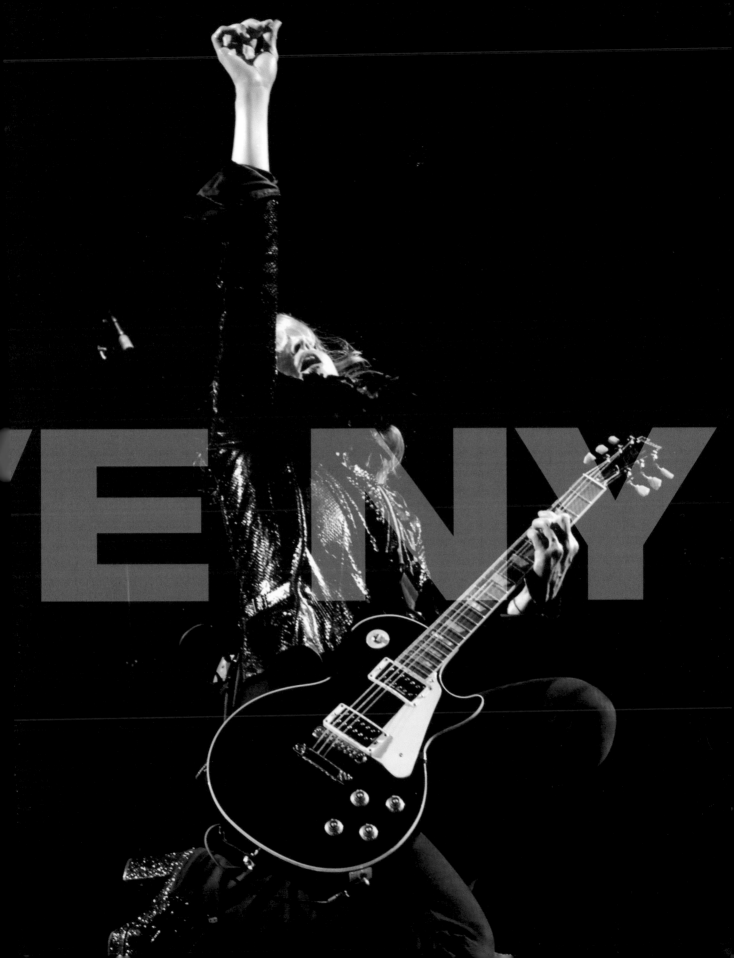

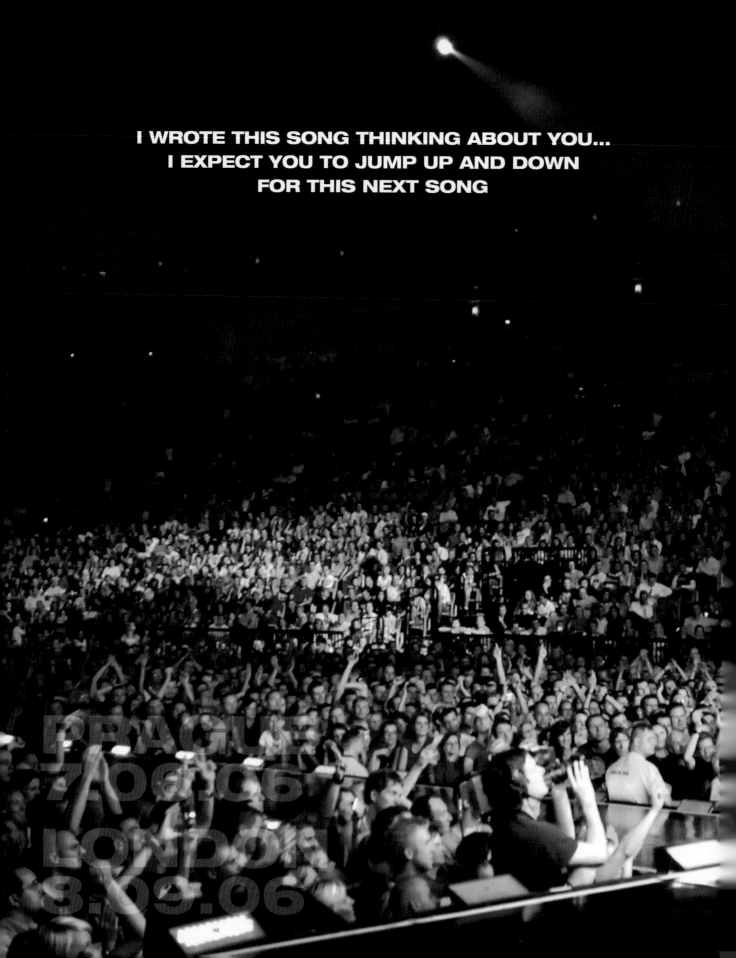

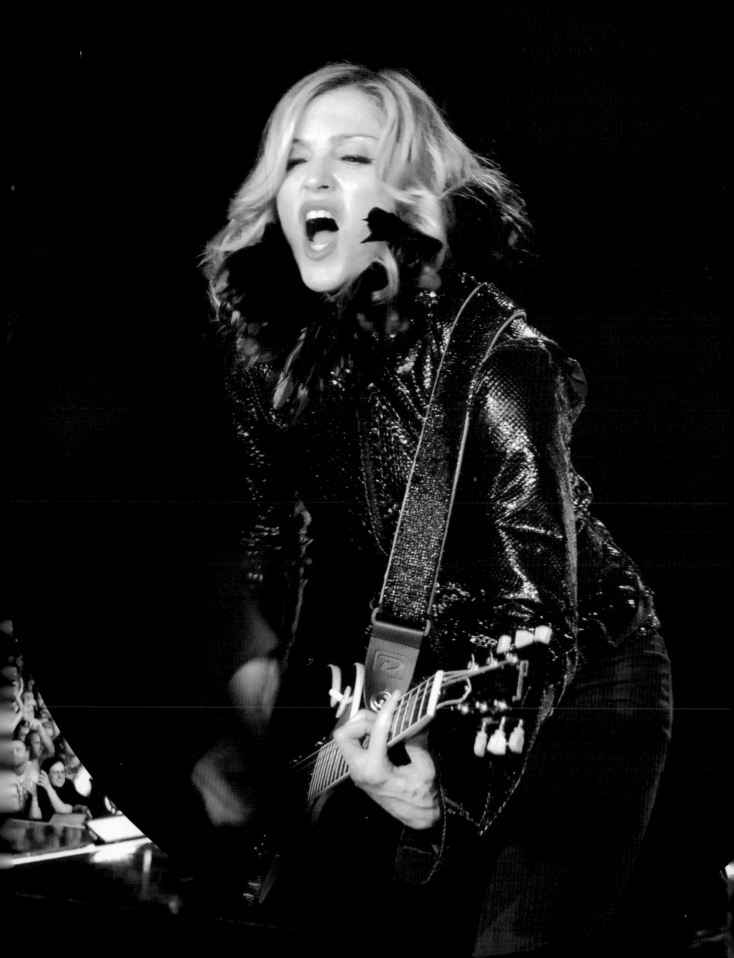

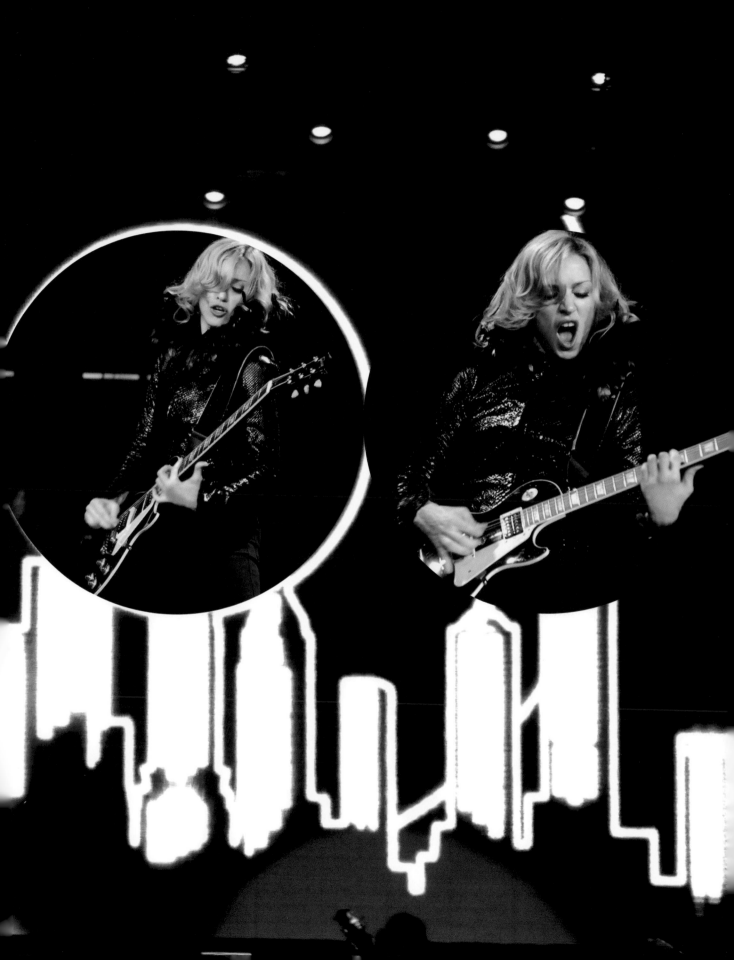

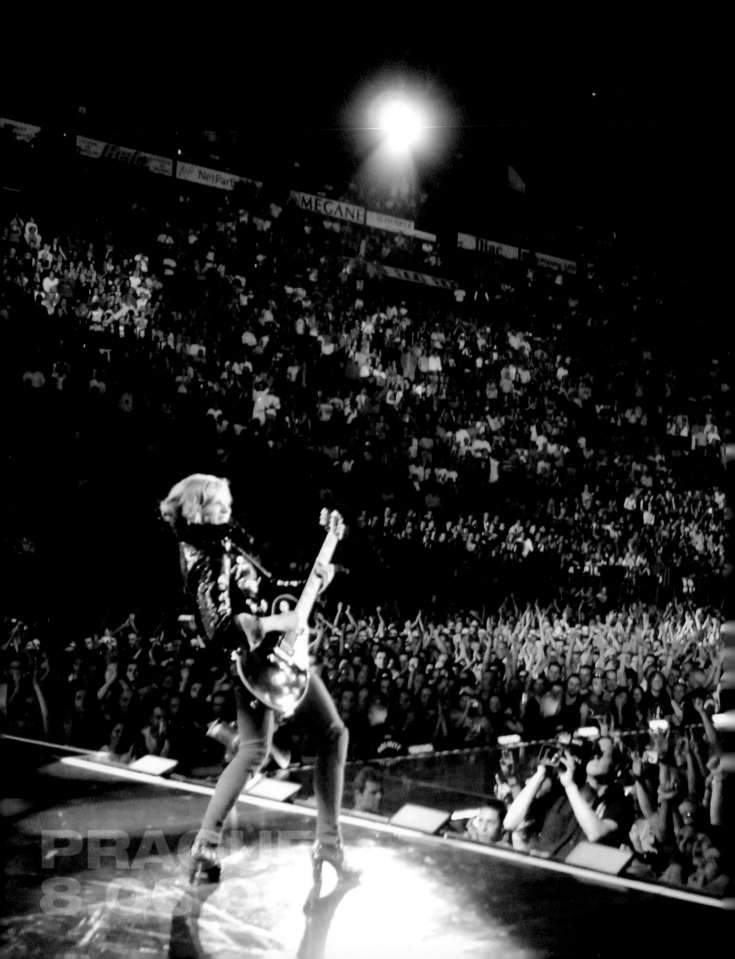

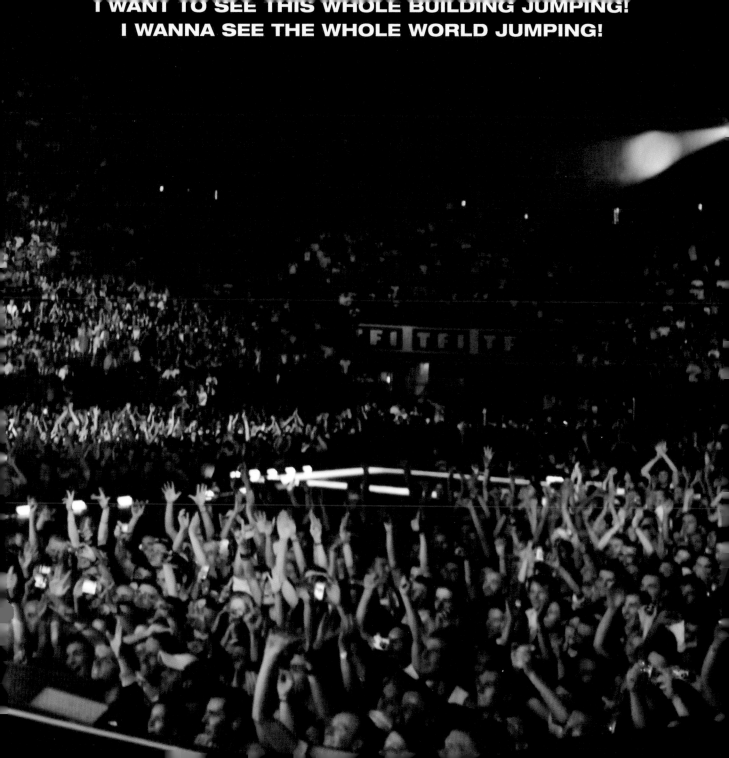

HANNOVER
8.22.06
PARIS
8.31.06

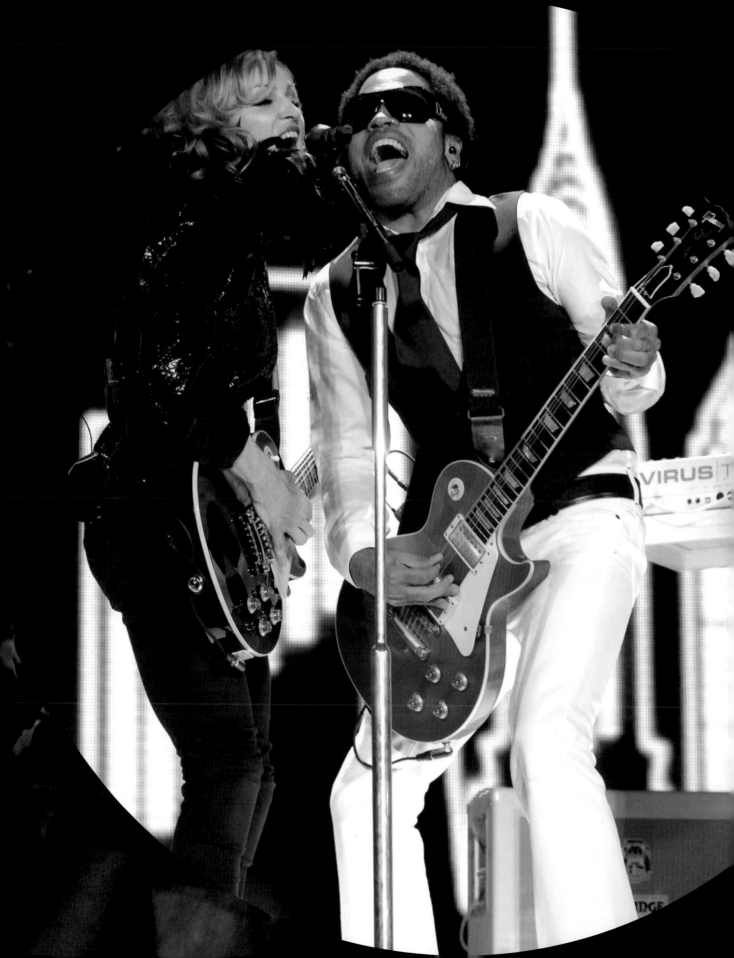

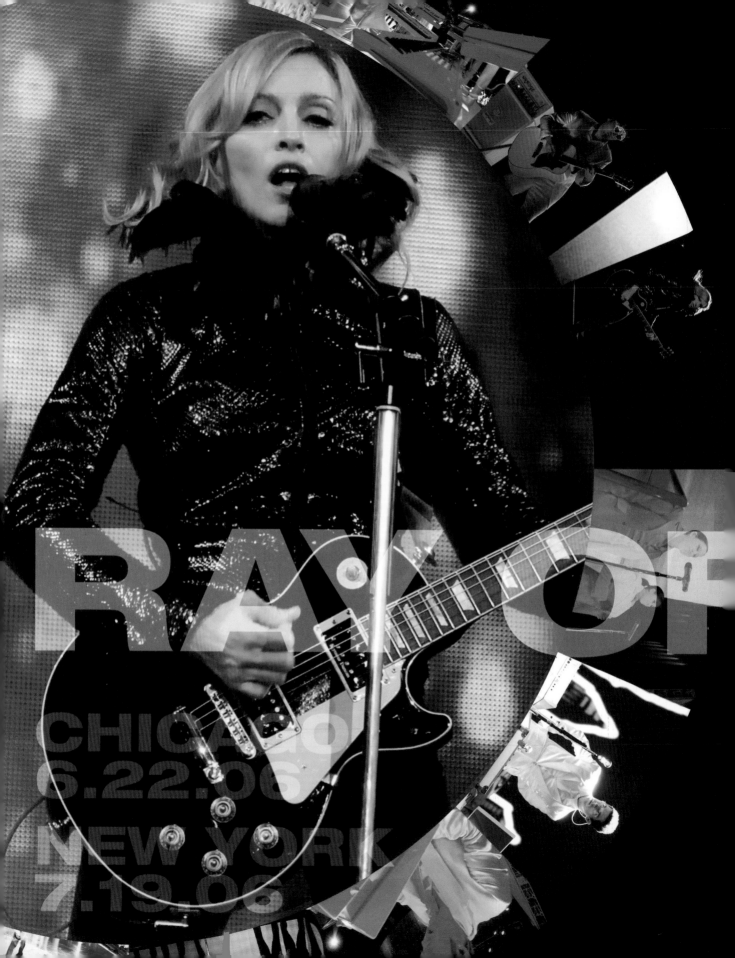

RAY OF

CHICAGO
6.22.06

NEW YORK
7.19.06

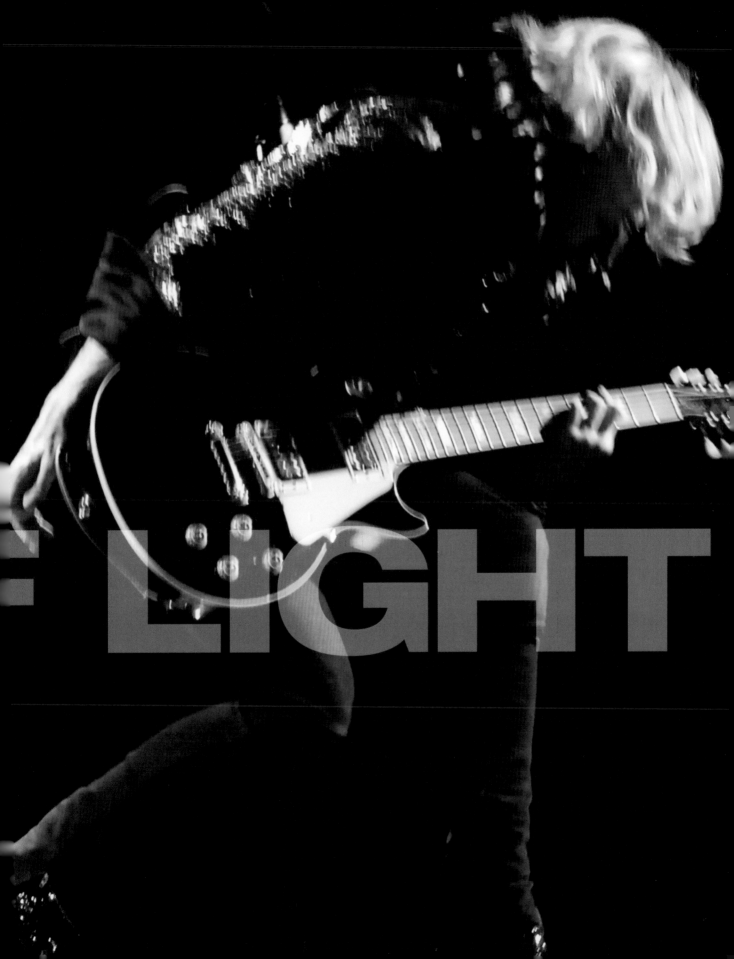

CARDIFF
7.29.06

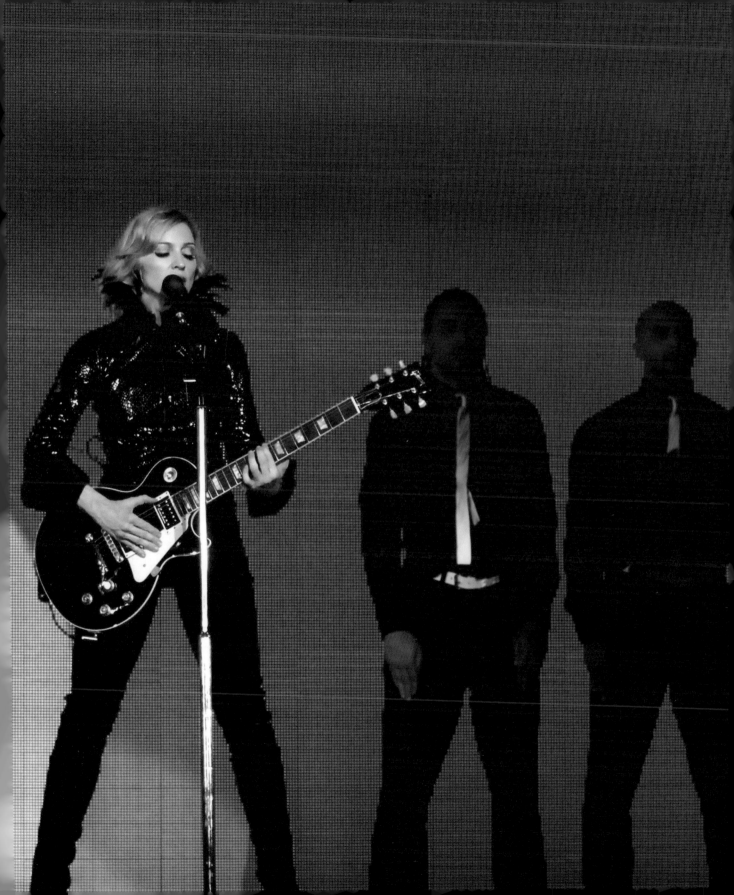

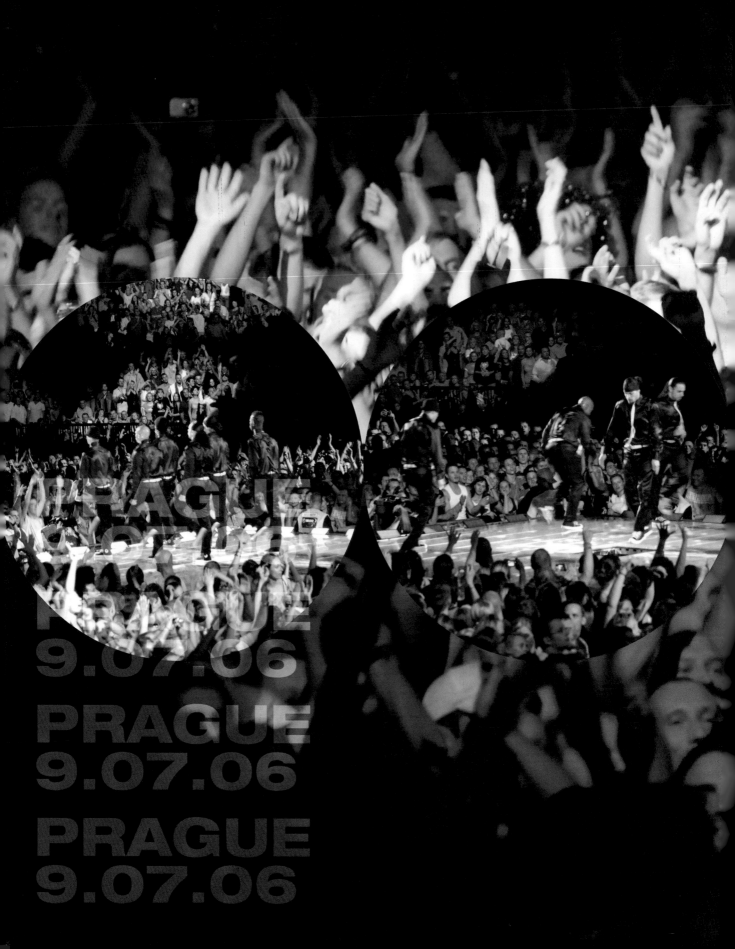

PRAGUE
9.07.06

PRAGUE
9.07.06

PRAGUE
9.07.06

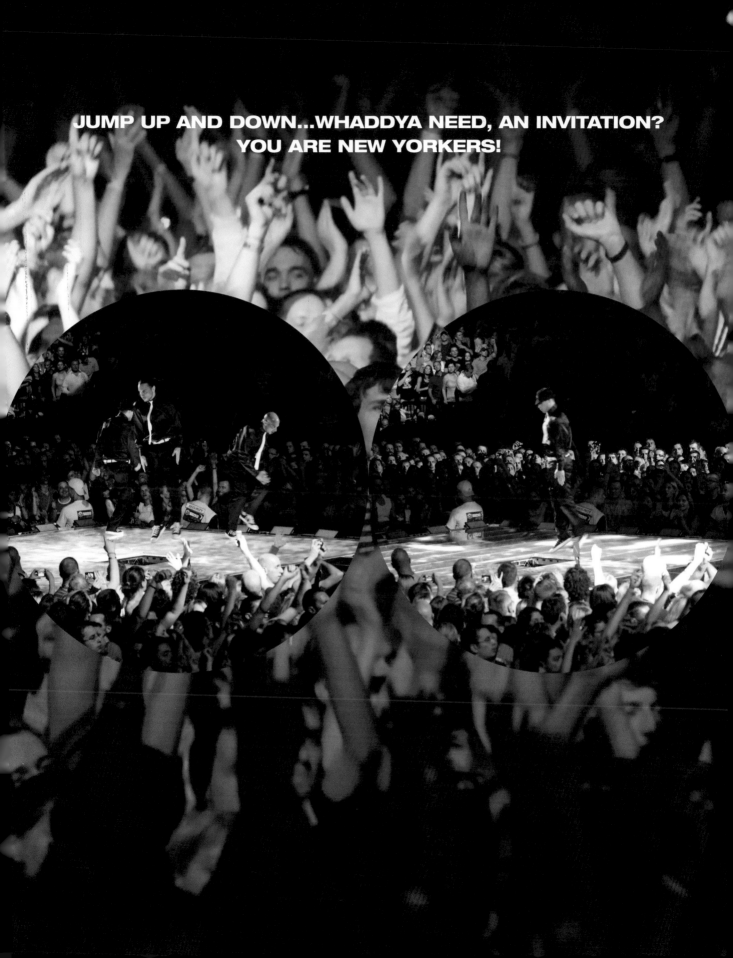

JUMP UP AND DOWN...WHADDYA NEED, AN INVITATION?
YOU ARE NEW YORKERS!

CARDIFF
29.06

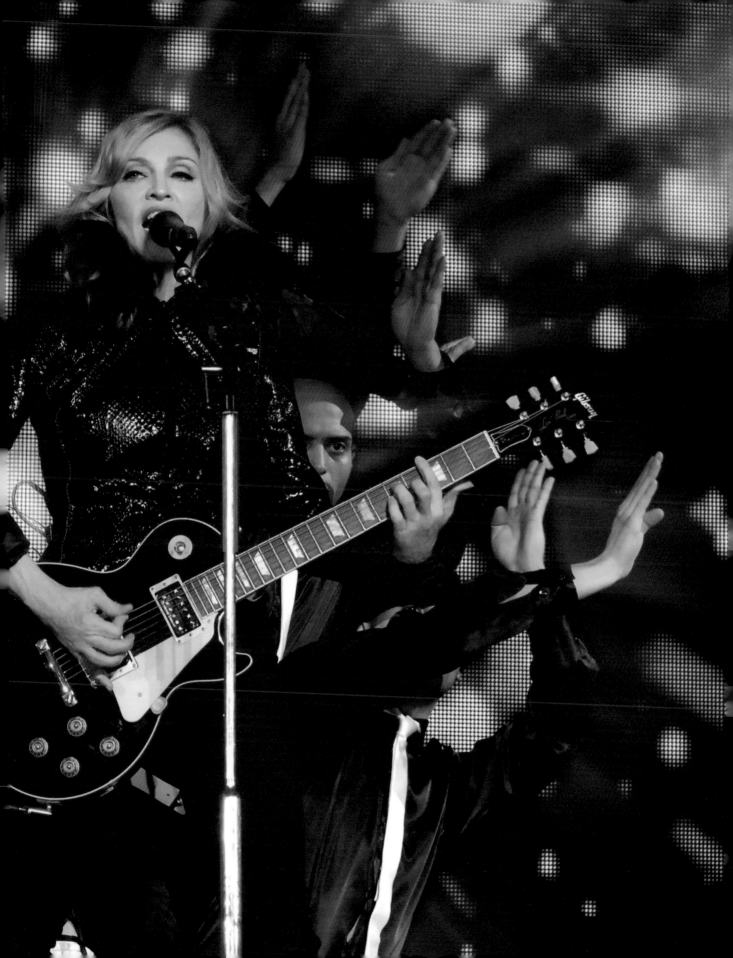

MIAMI
7.22

NEW YORK CITY
7.19

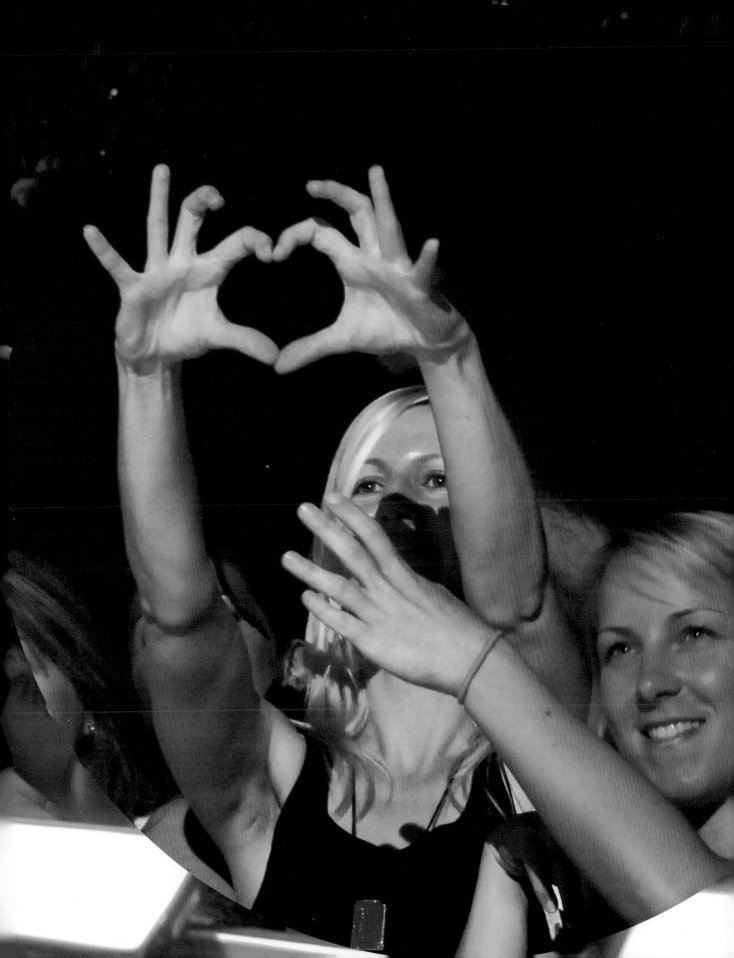

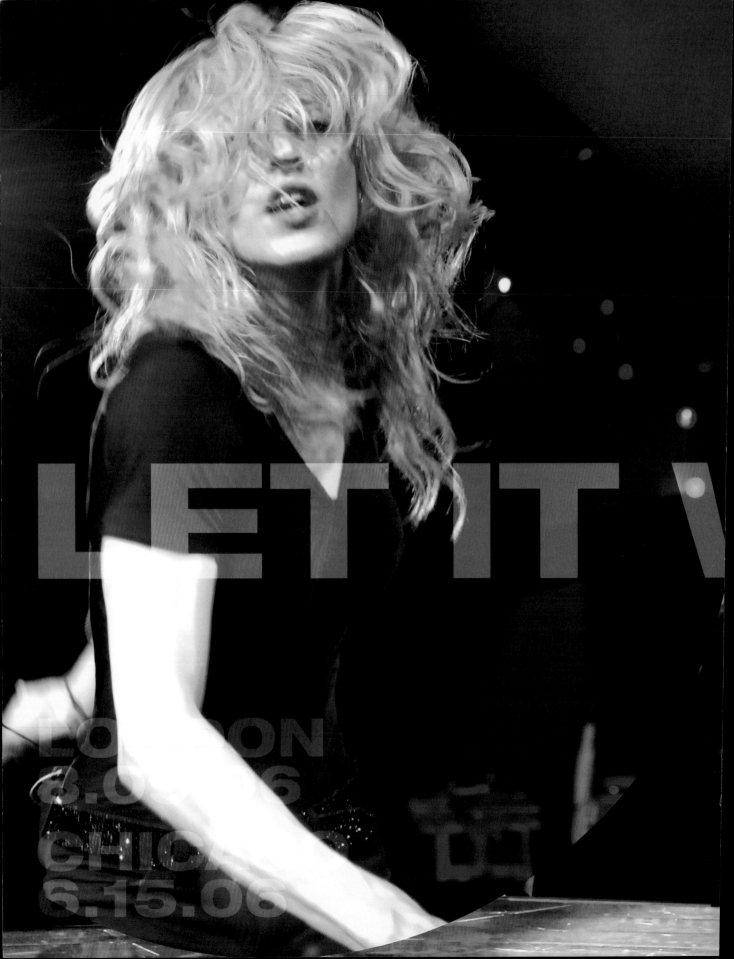

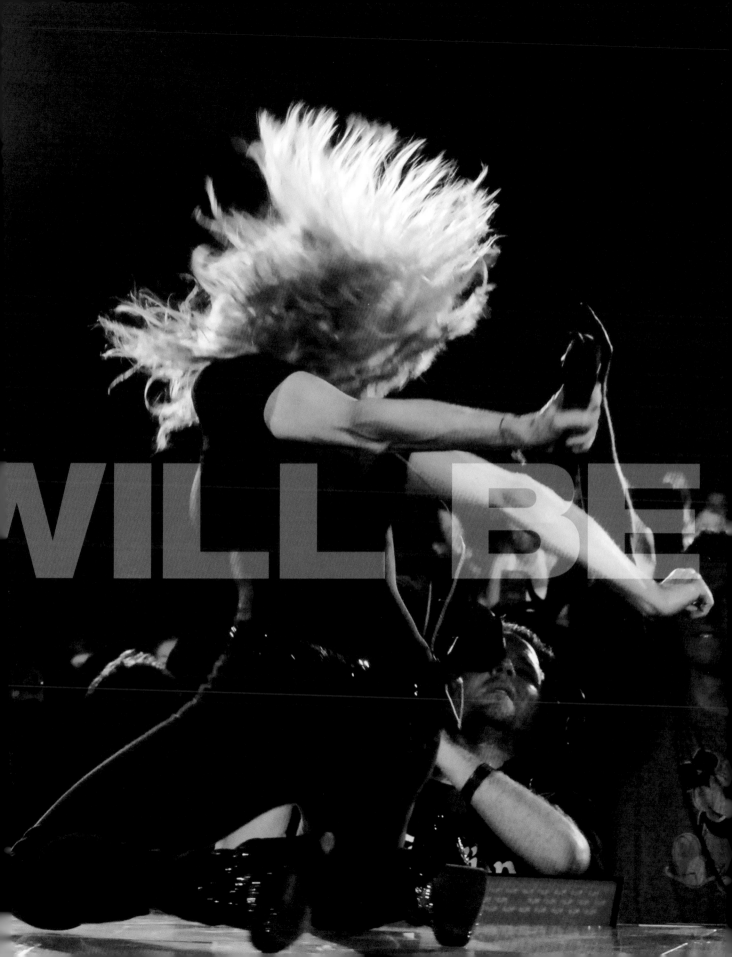

LONDON
8.09.06
LONDON
8.09.06

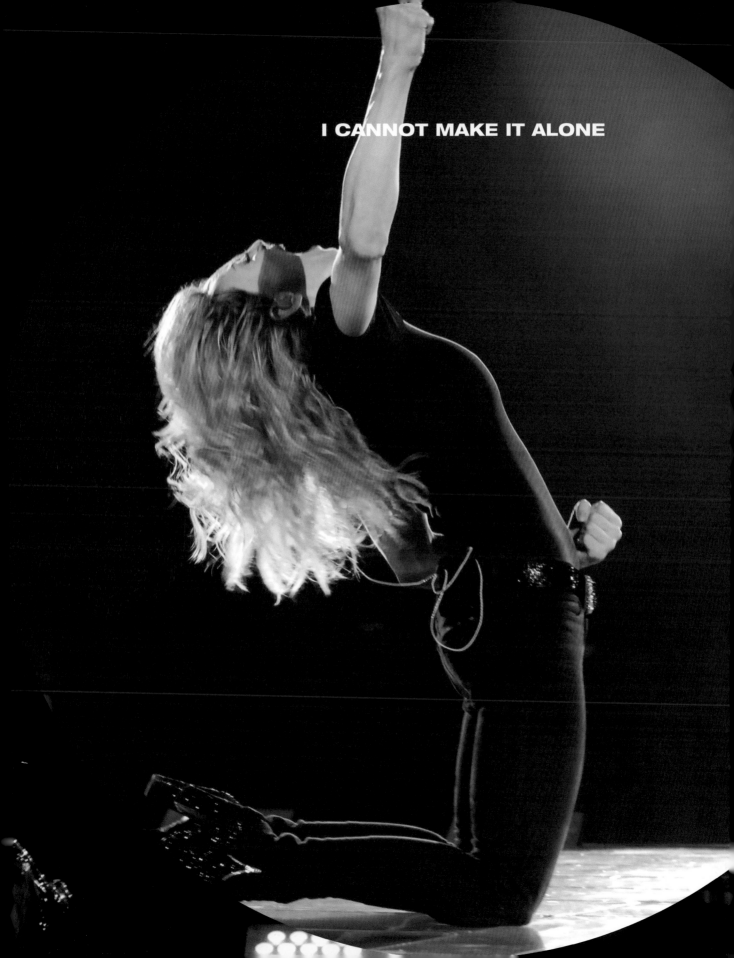

I CANNOT MAKE IT ALONE

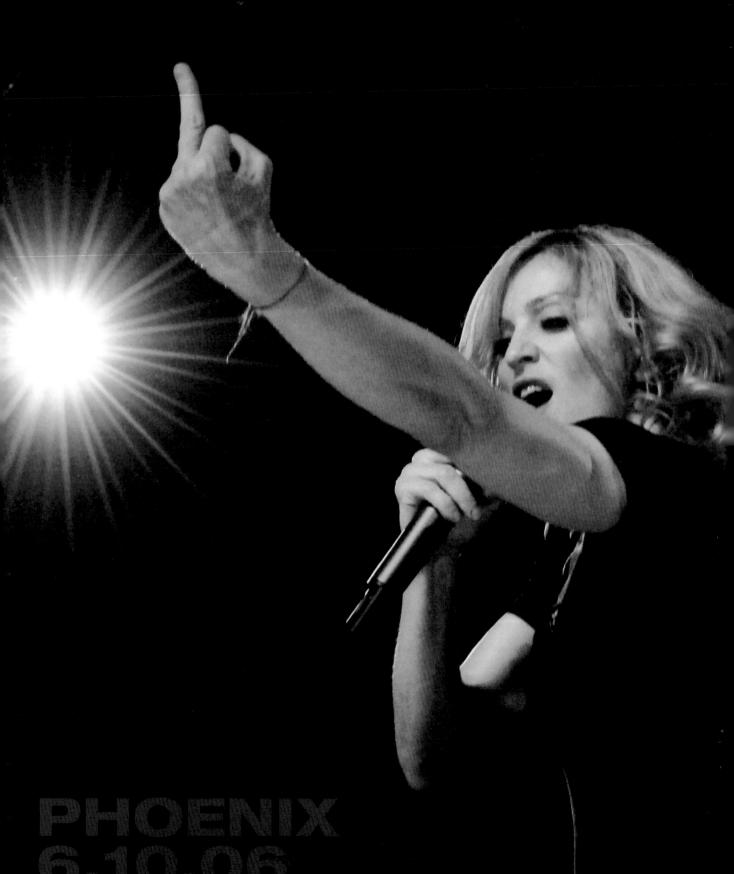

PHOENIX
6.10.06

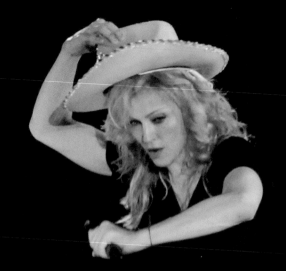
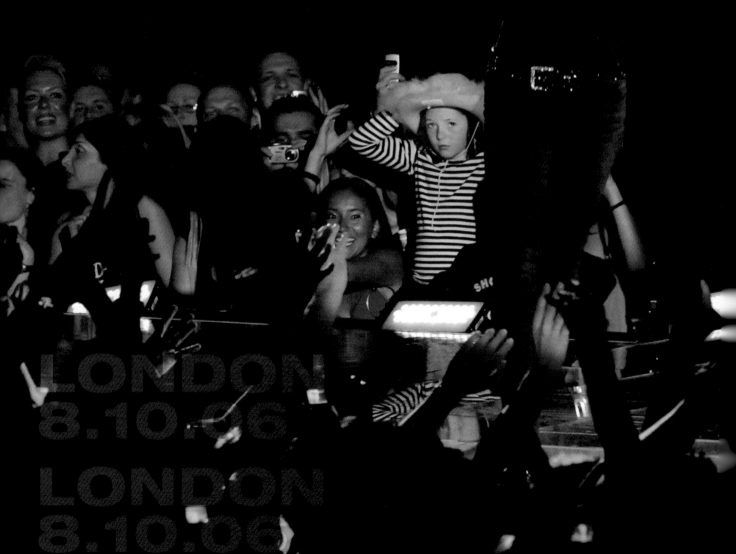

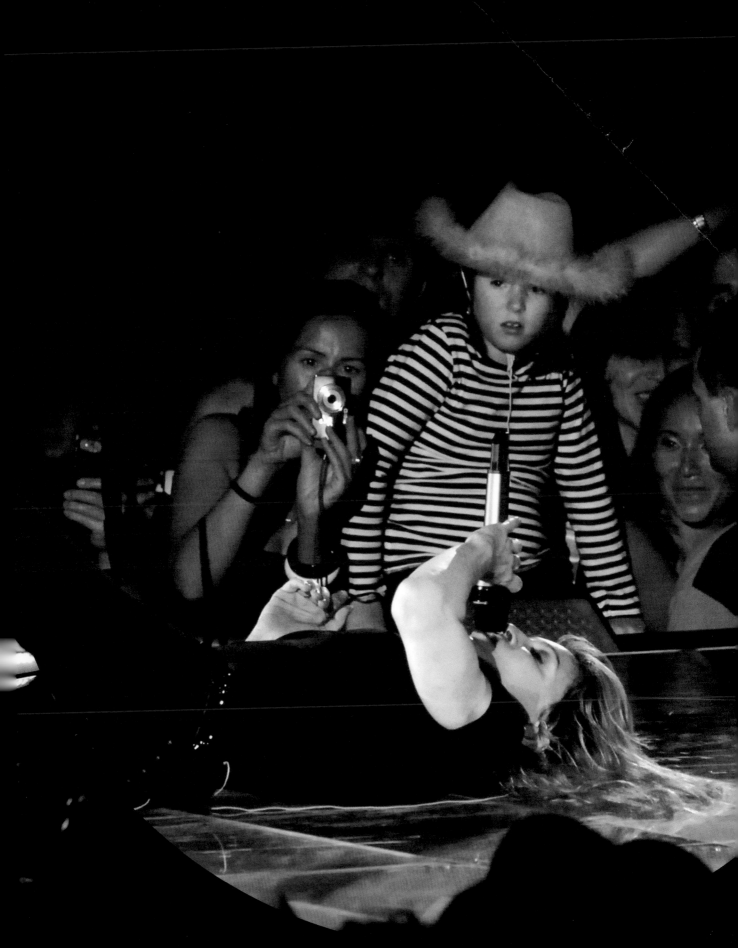

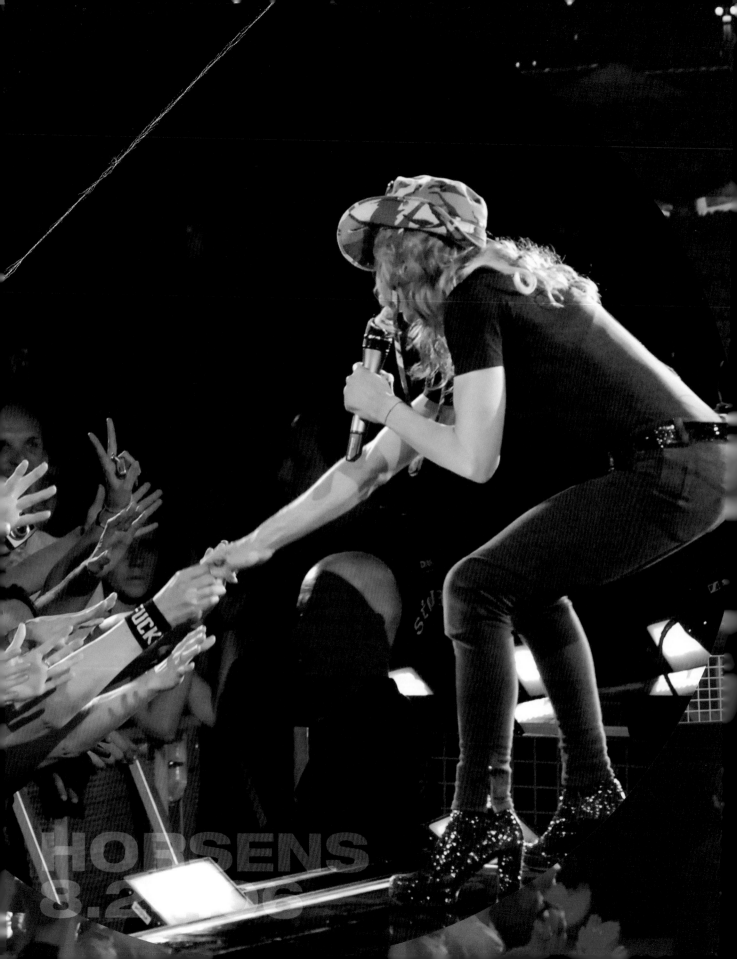

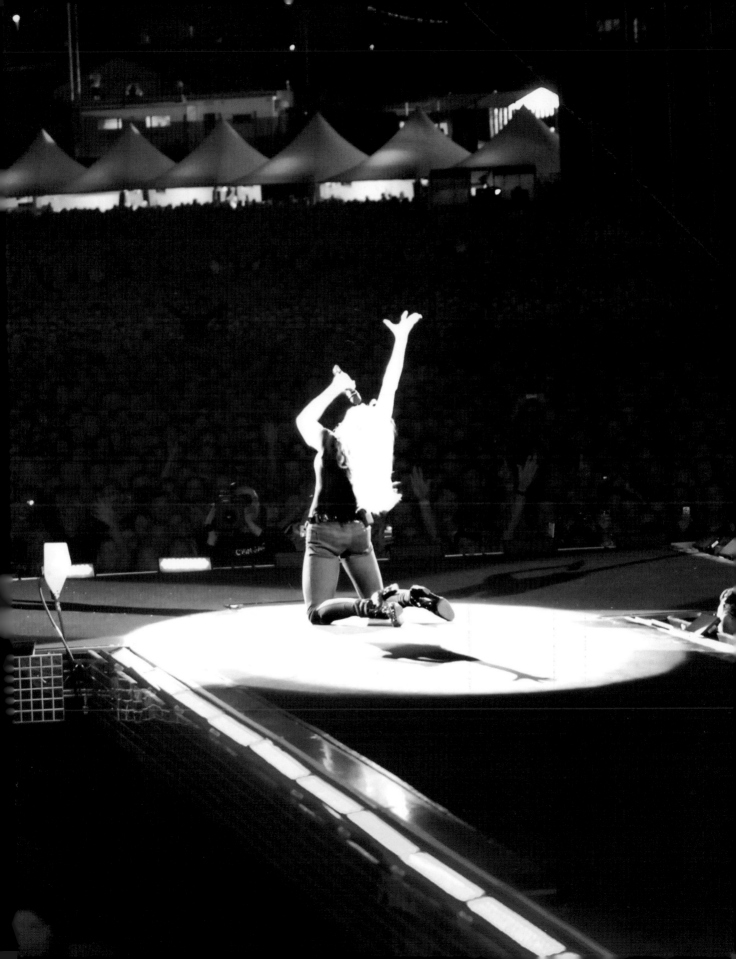

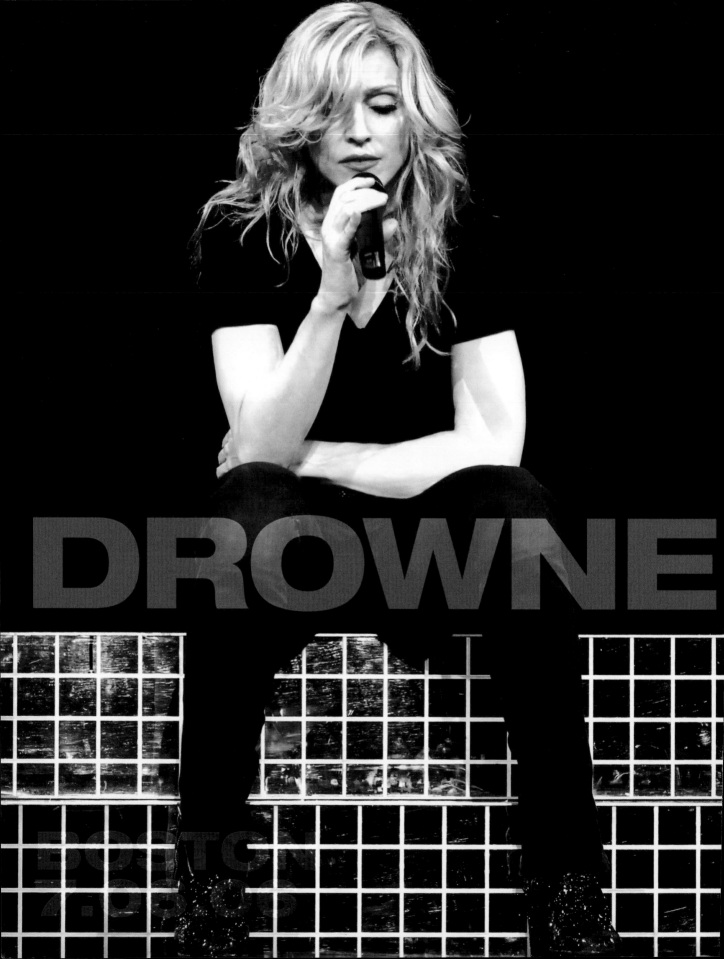

DROWNE

BOSTON
7.09.06

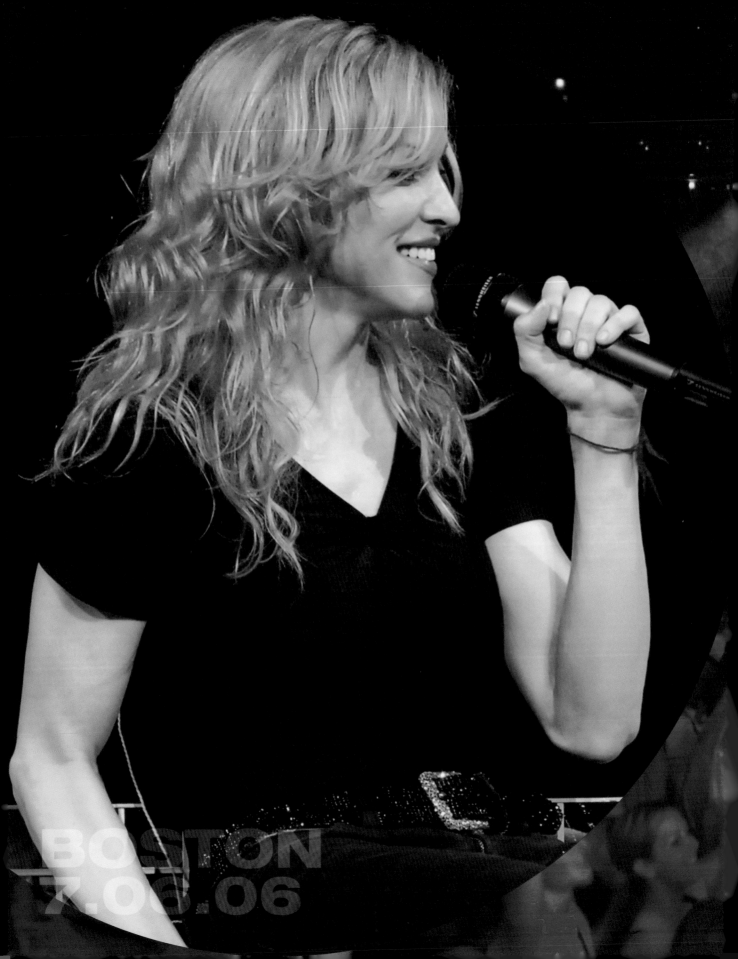
BOSTON
7.06.06

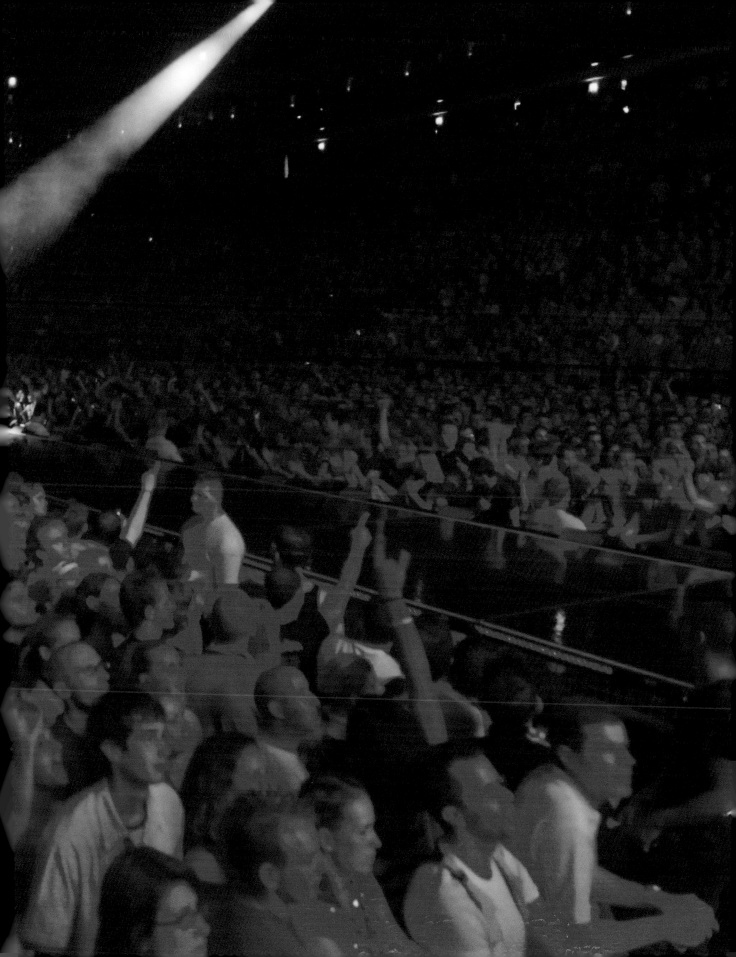

SUBST
FOR

BOSTON
7.06.06

PARA
(NOT F

TOKYO
9.20.06

JAPANESE
DO IT BETTER

IdD

ADISE
OR ME)

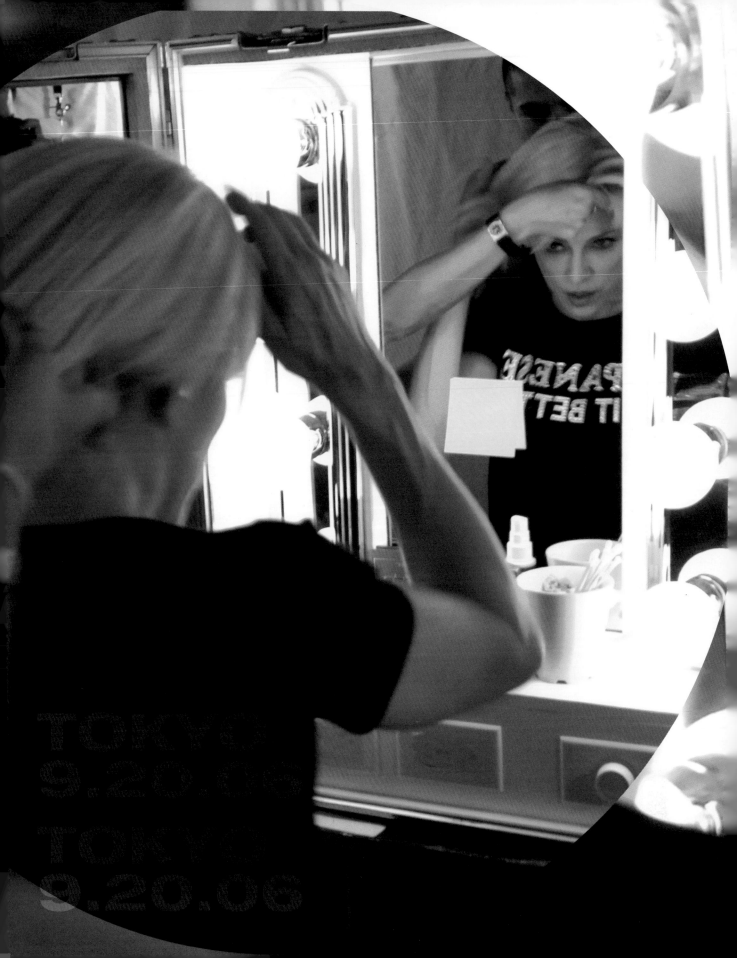

TOKYO
9.20.06
TOKYO
9.20.06

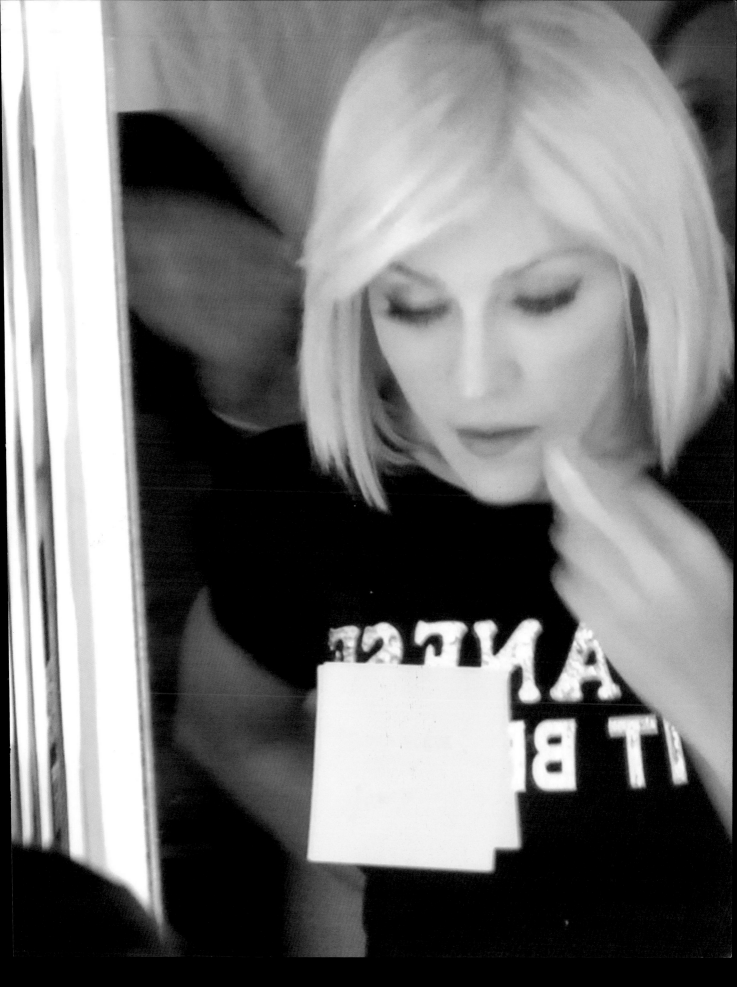

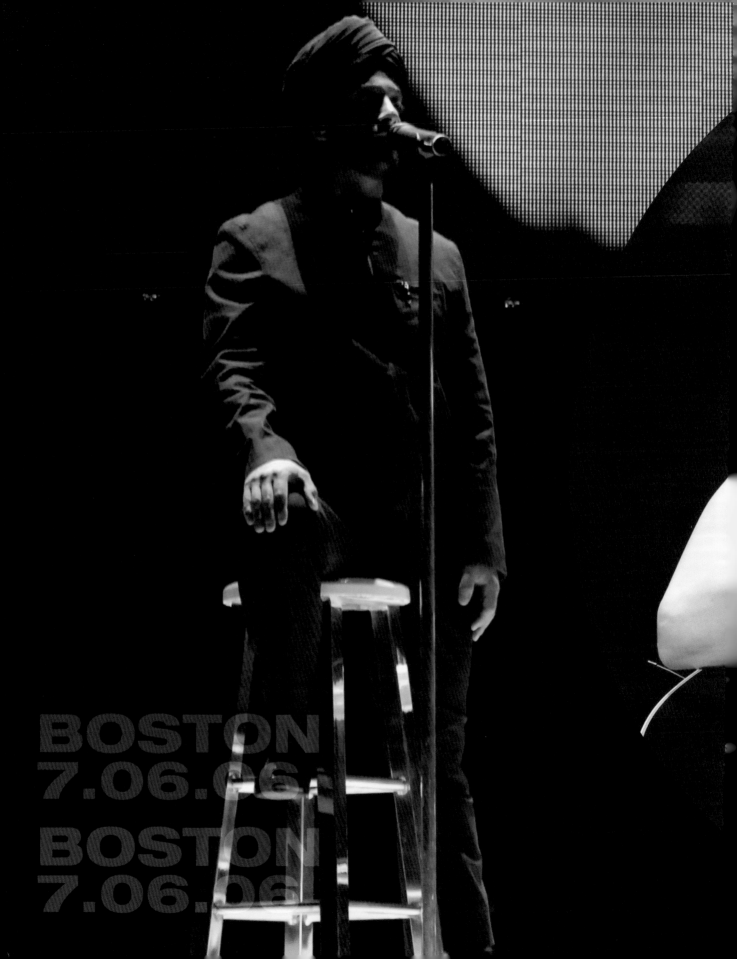

BOSTON
7.06.06

BOSTON
7.06.06

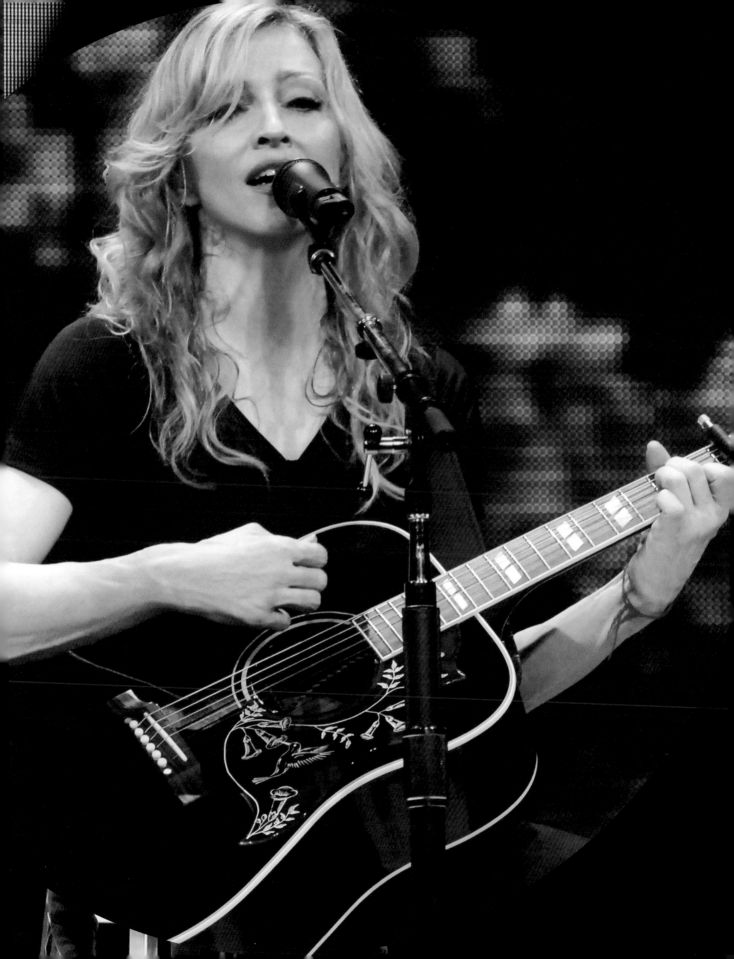

MUSIC II

OSAKA/
9.17.06

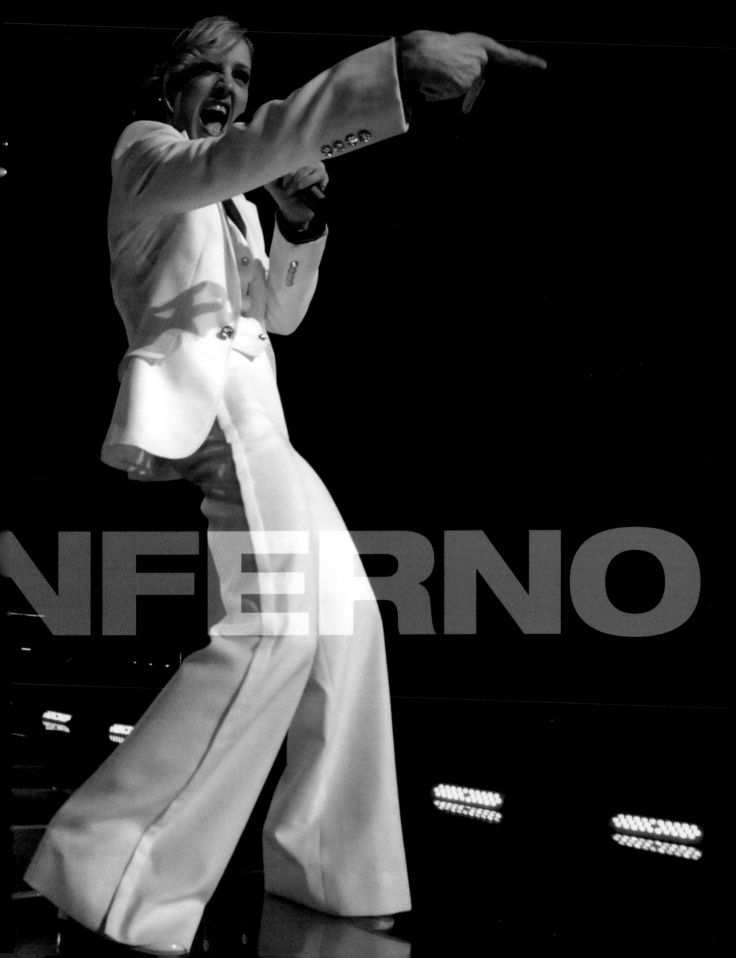

BOSTON
7.10.06

OSAKA
9.17.06

OSAKA
9.17.06

OSAKA
9.17.06

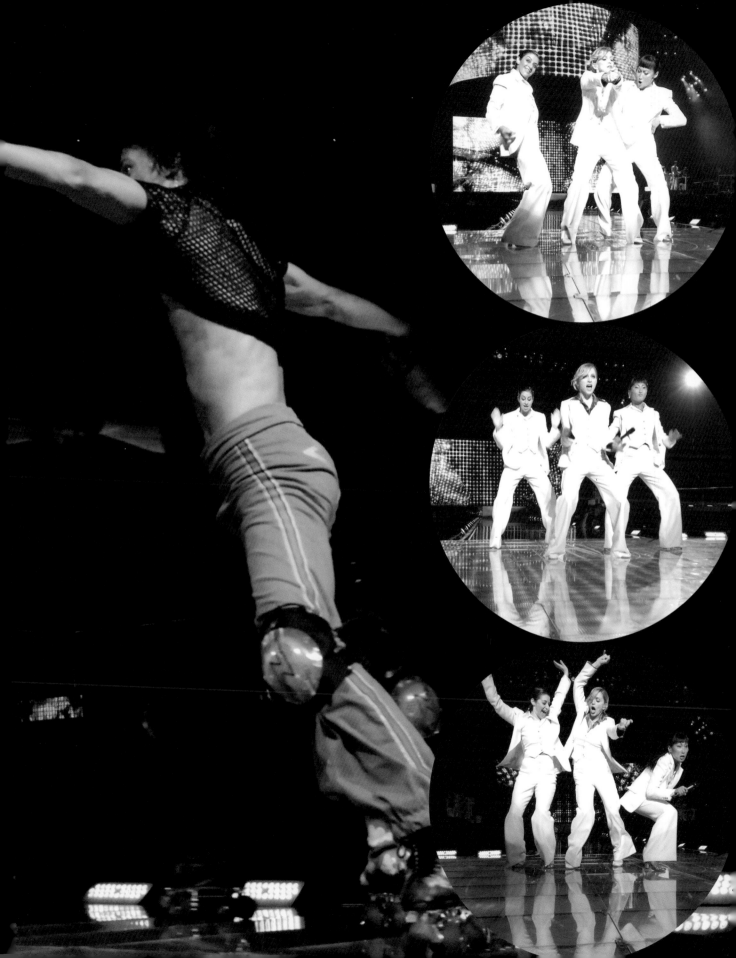

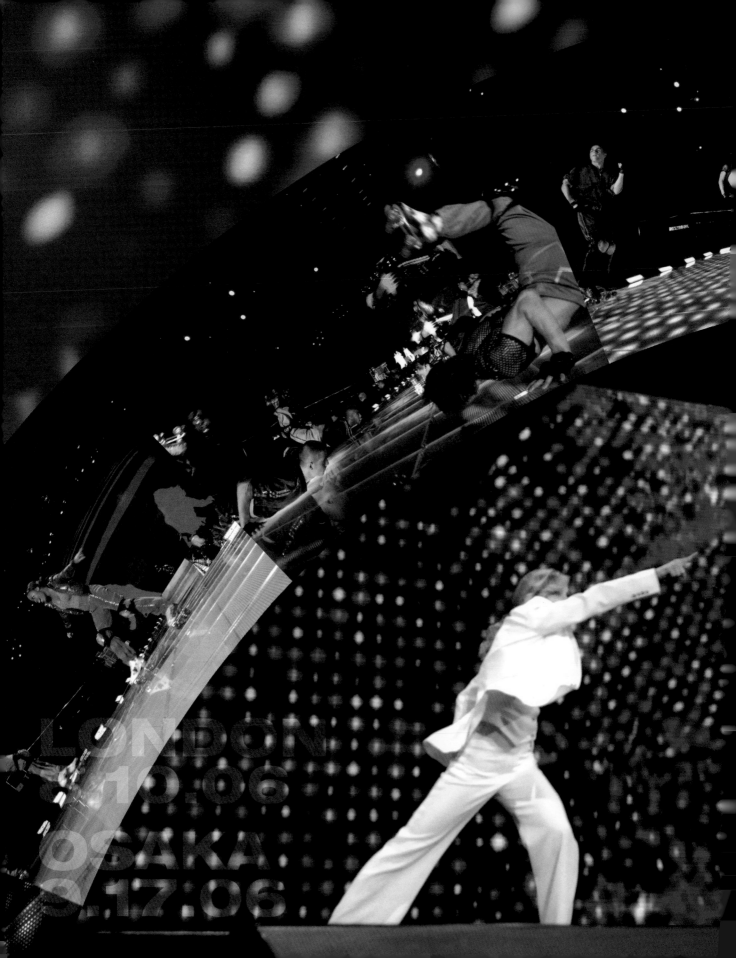

LONDON
10.06
OSAKA
9.17.06

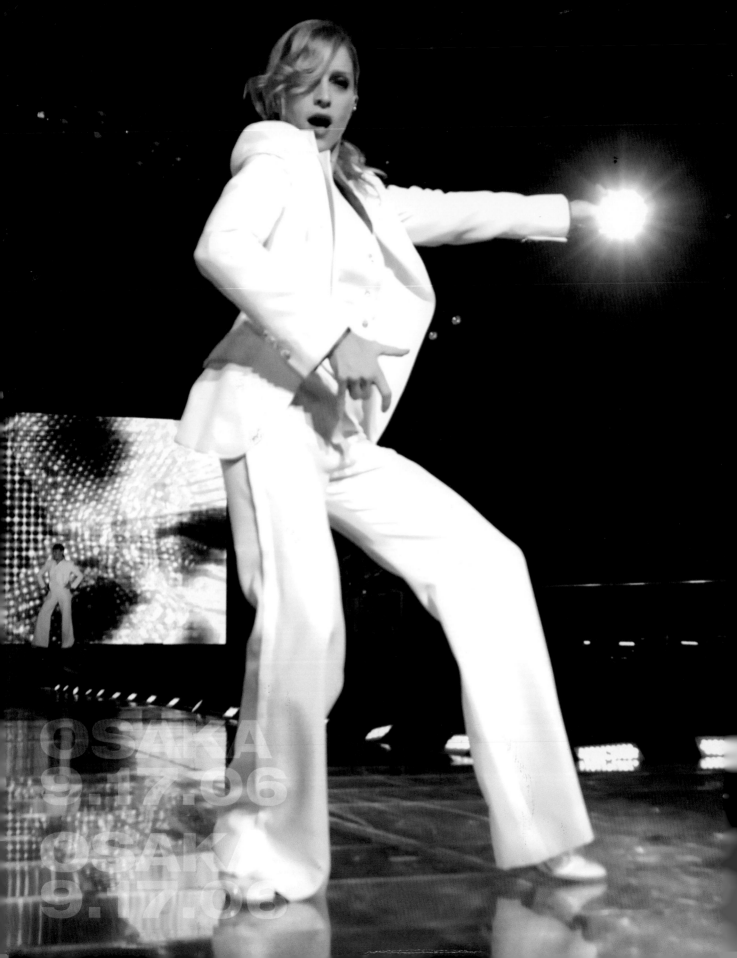

OSAKA
9.17.06
OSAKA
9.17.06

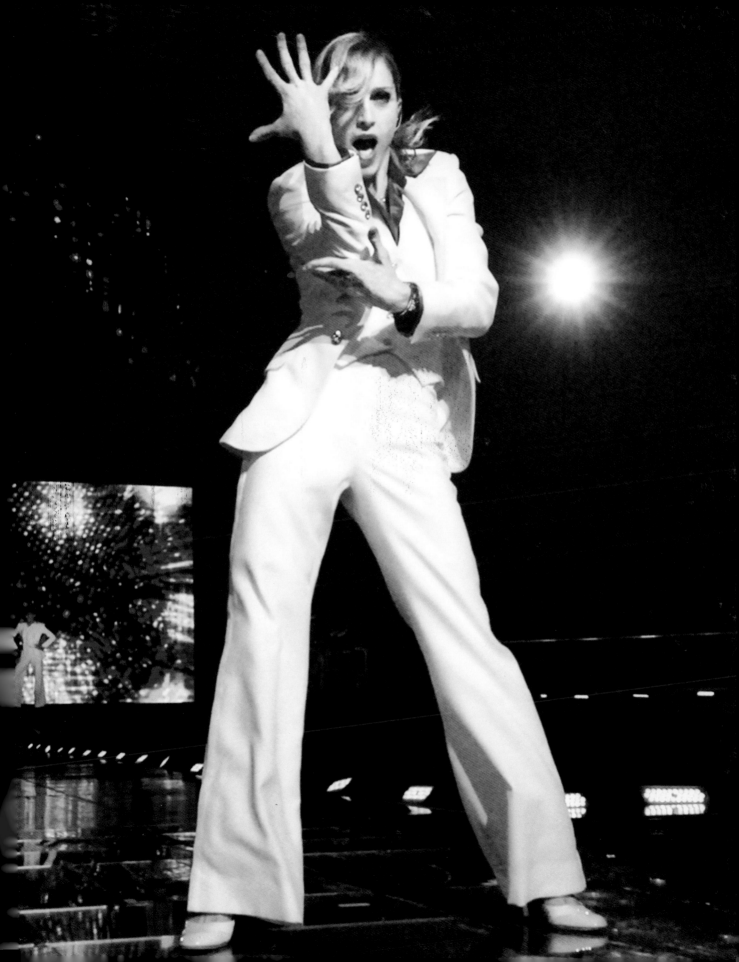

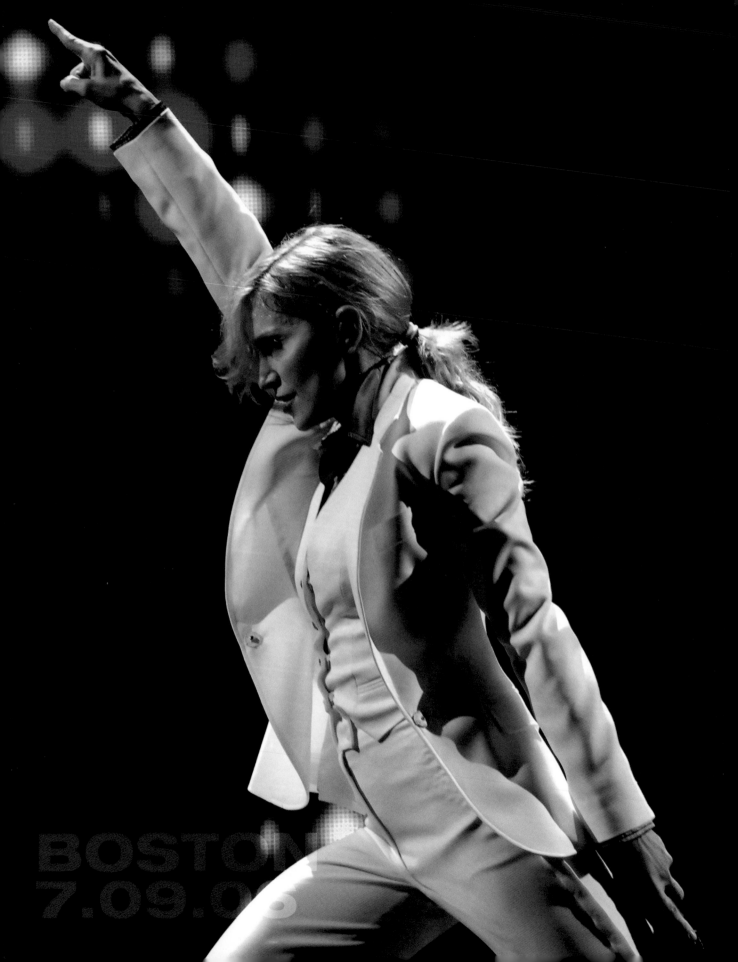

BOSTON
7.09.0

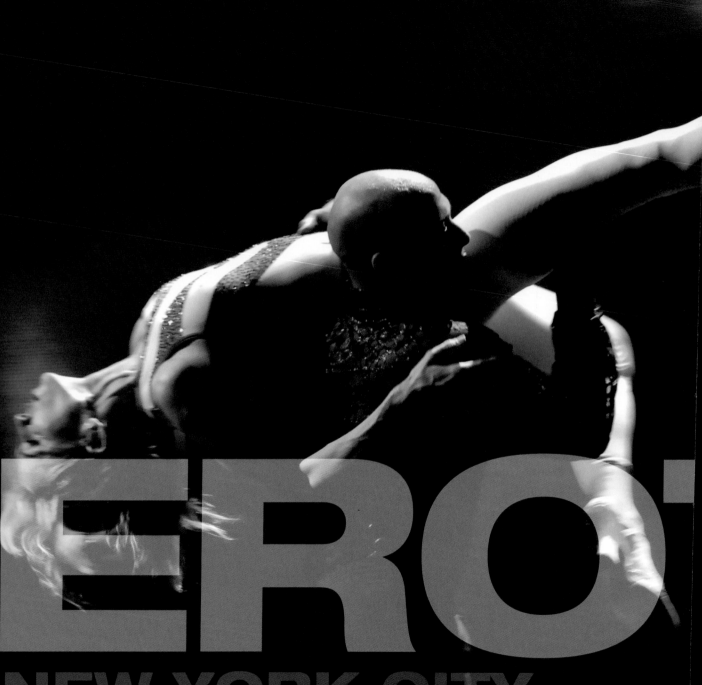

ERO

NEW YORK CITY
7.19.06

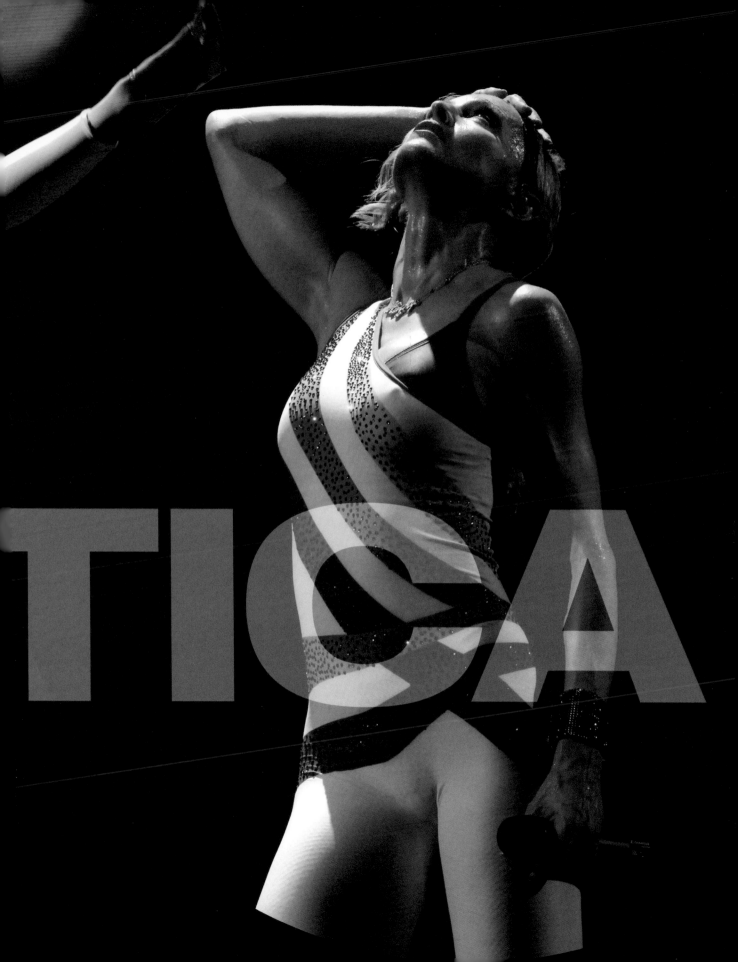

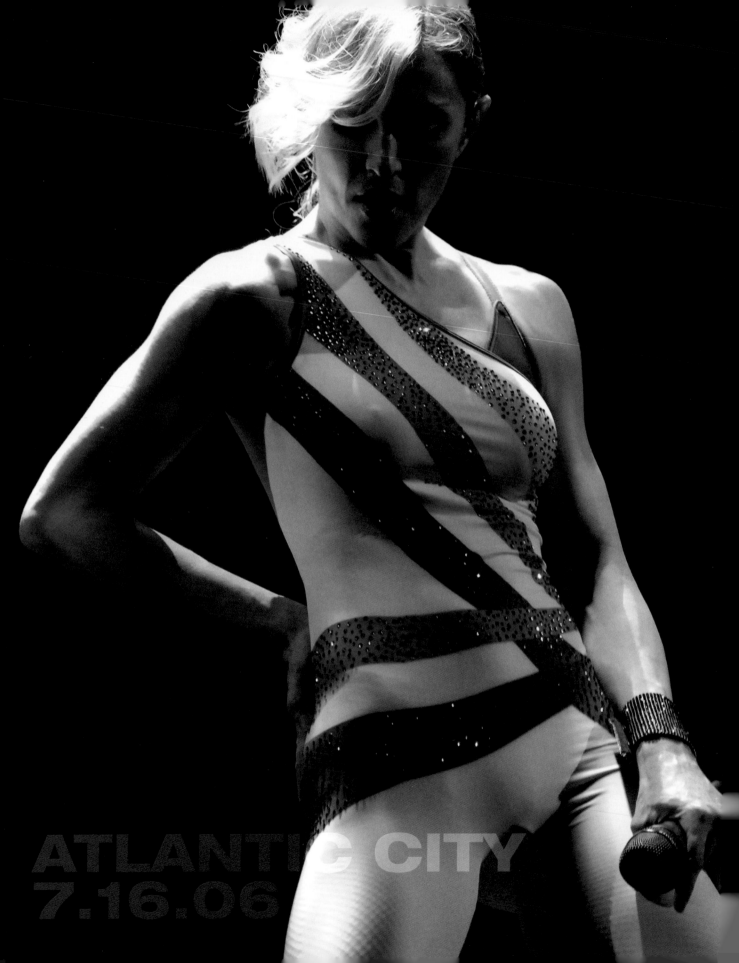

ATLANTIC CITY
7.16.06

WE CAN DO ANYTHING

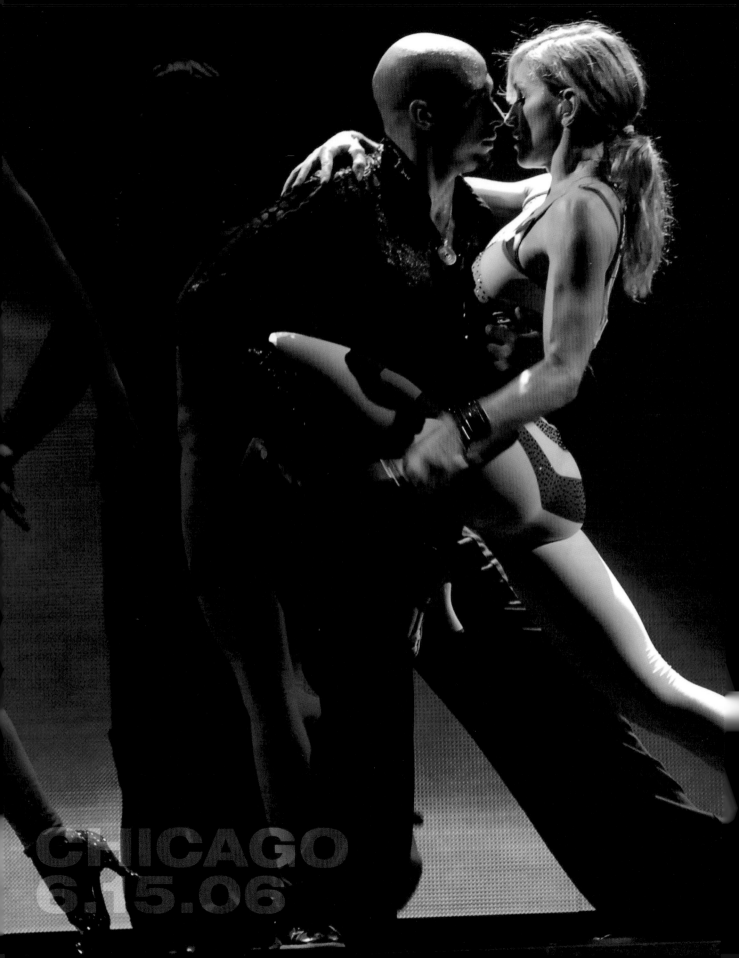

CHICAGO
6.15.06

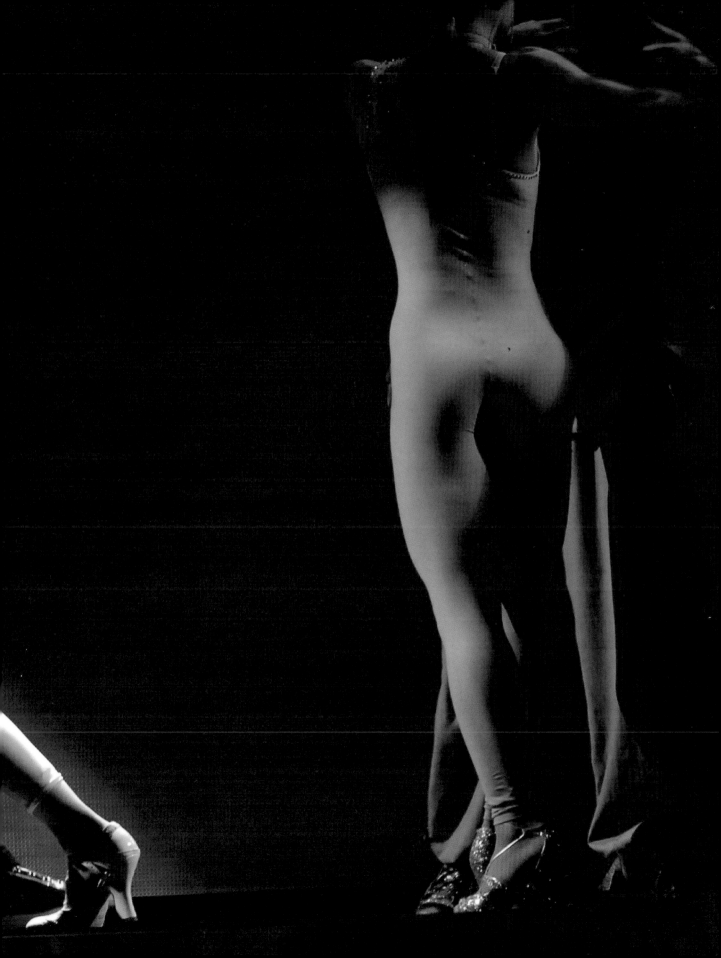

KYO
22.06
KYO
22.06
KYO
22.06
KYO
22.06

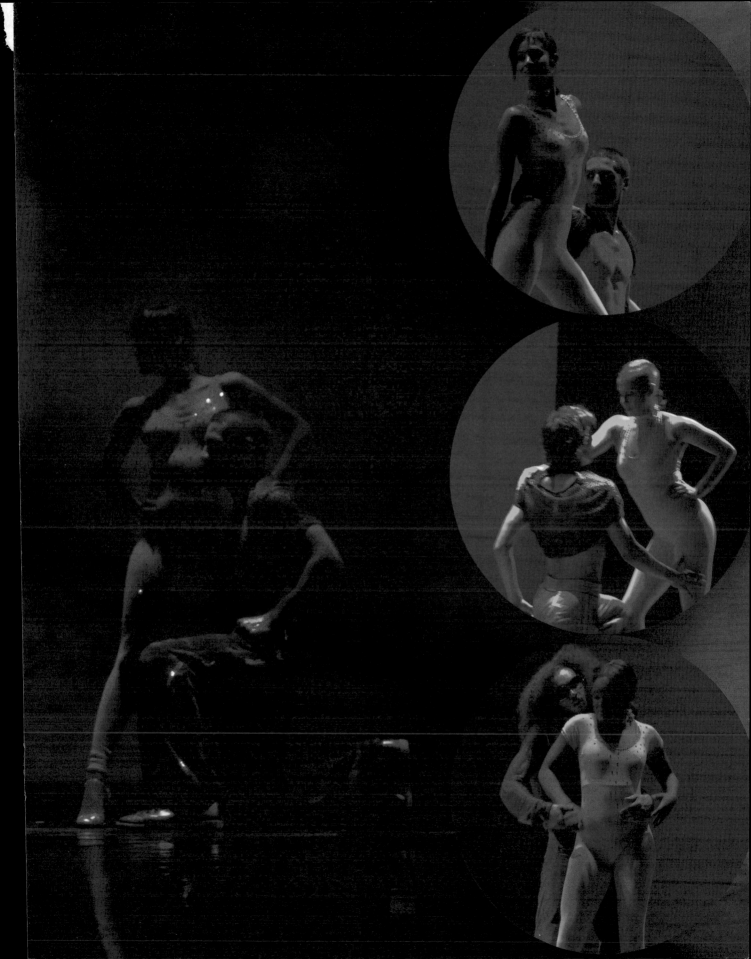

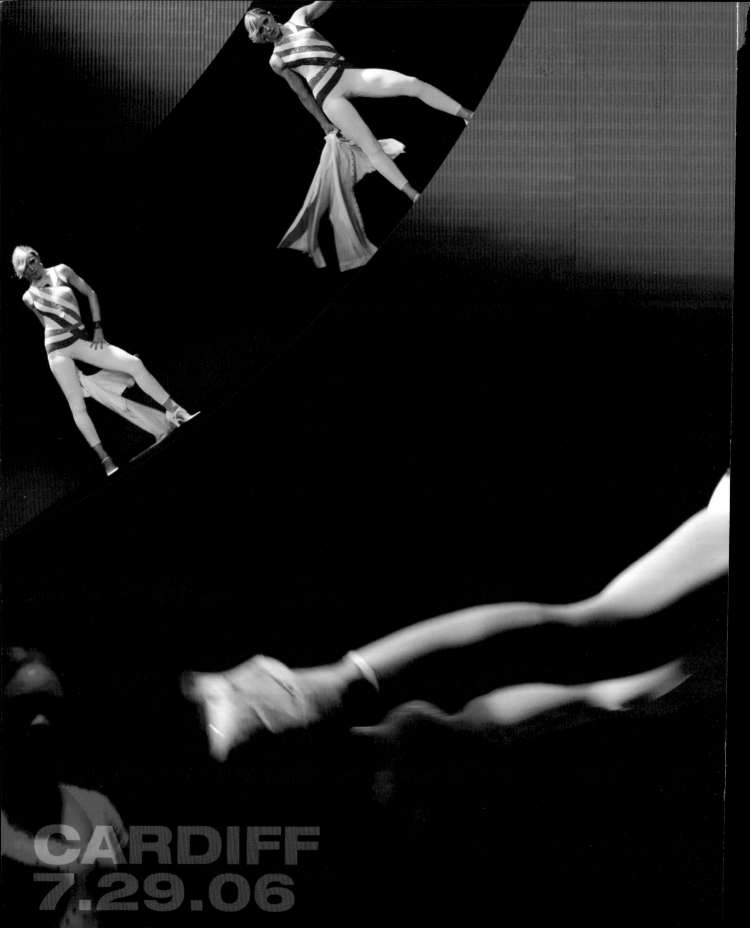

CARDIFF
7.29.06

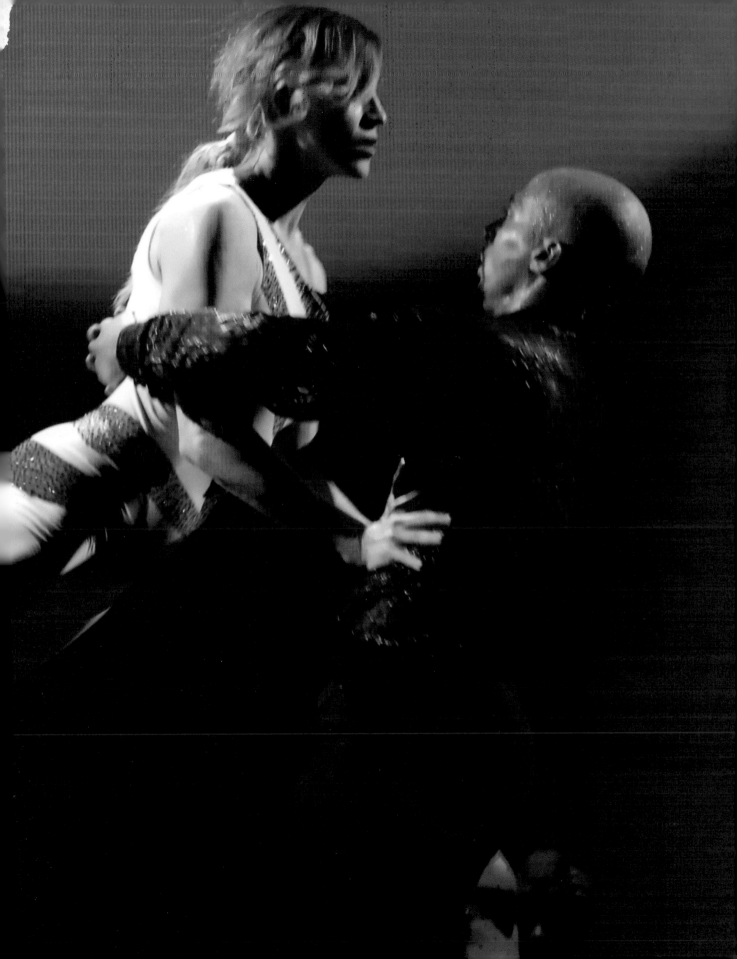

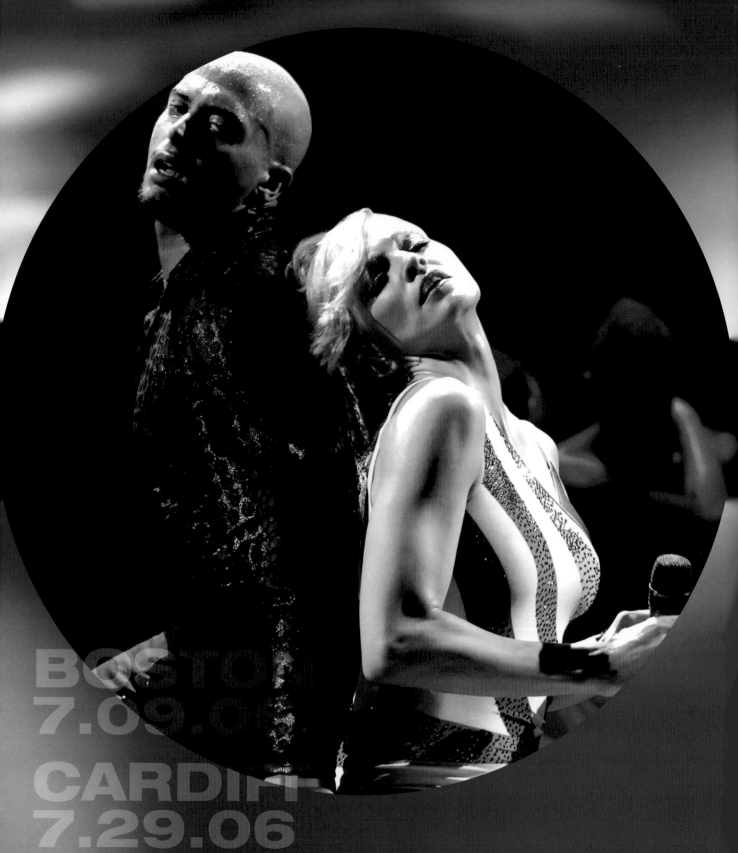

BOSTON
7.09.06

CARDIFF
7.29.06

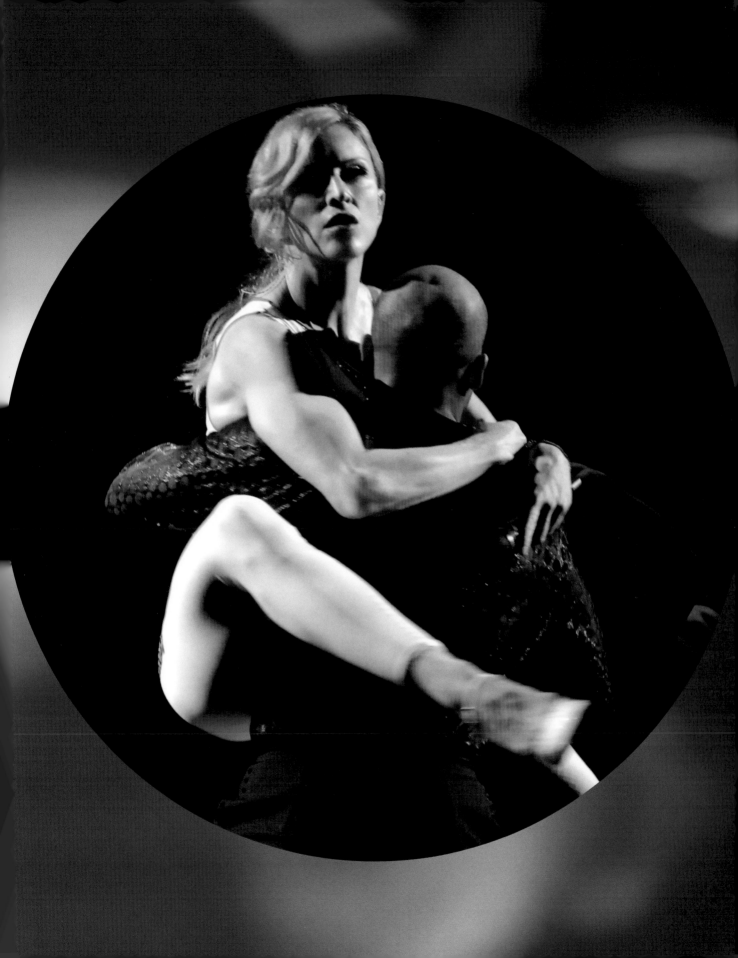

LA ISLA

OSAKA
9.17.06
LONDON
8.09.06

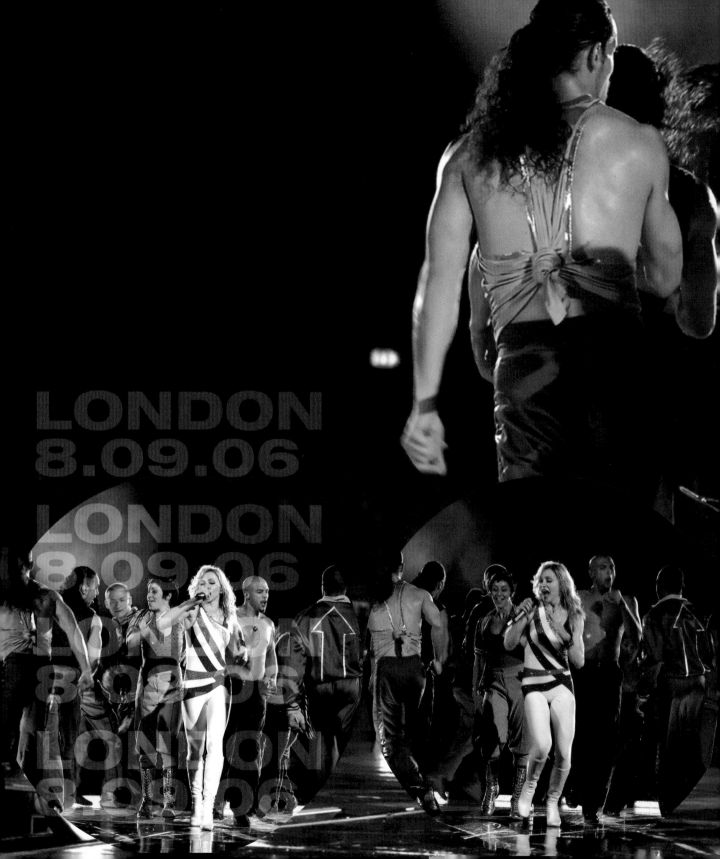

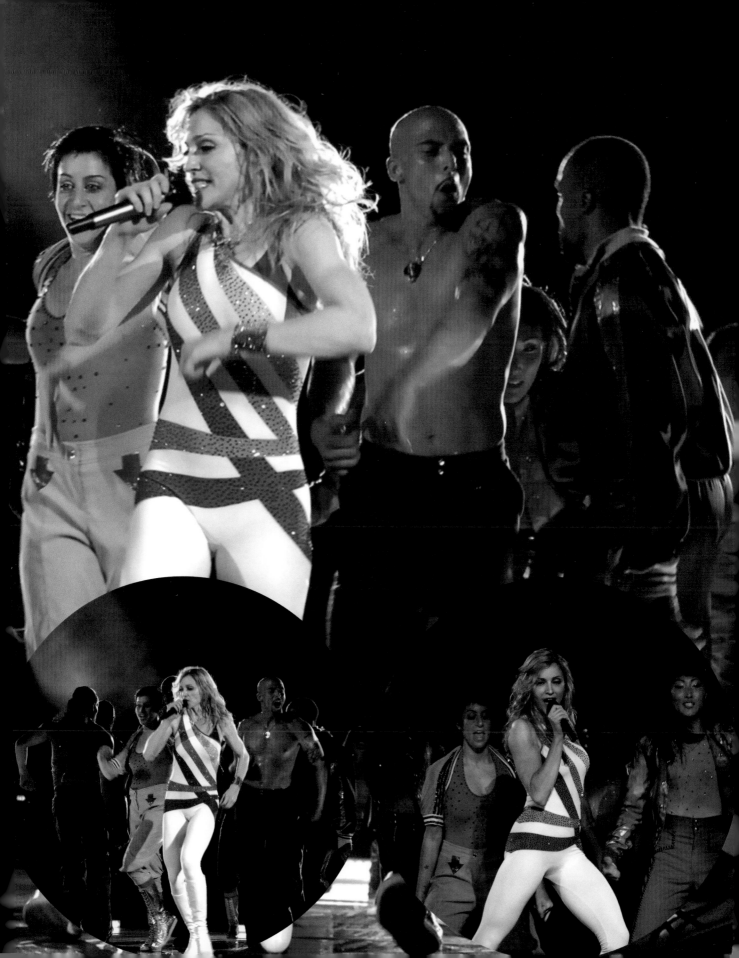

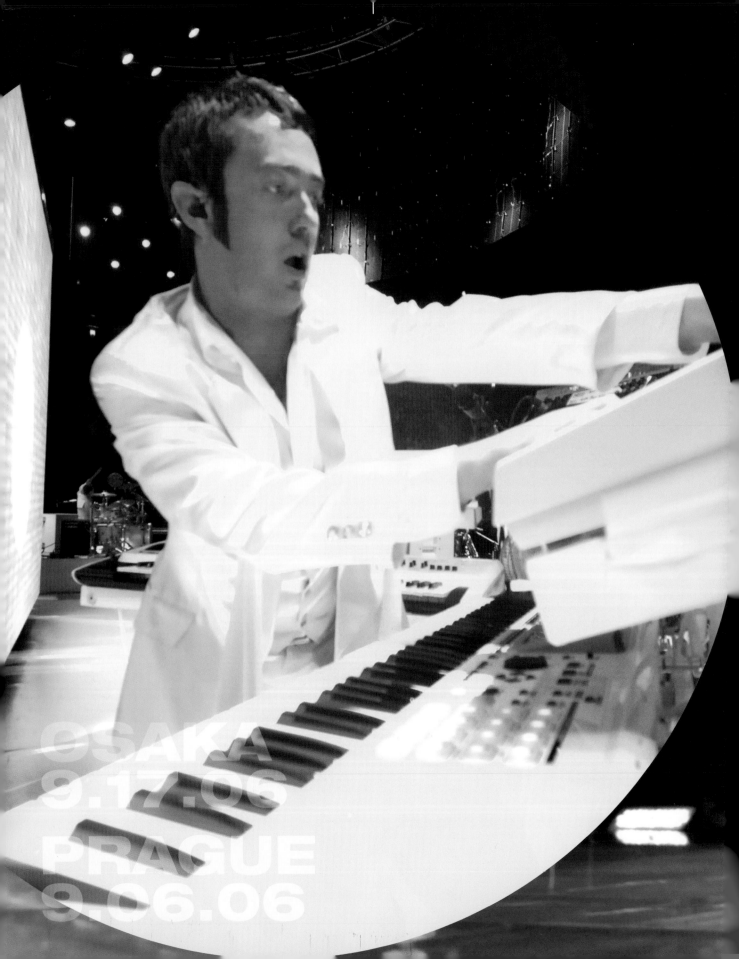

OSAKA
9.17.06
PRAGUE
9.06.06

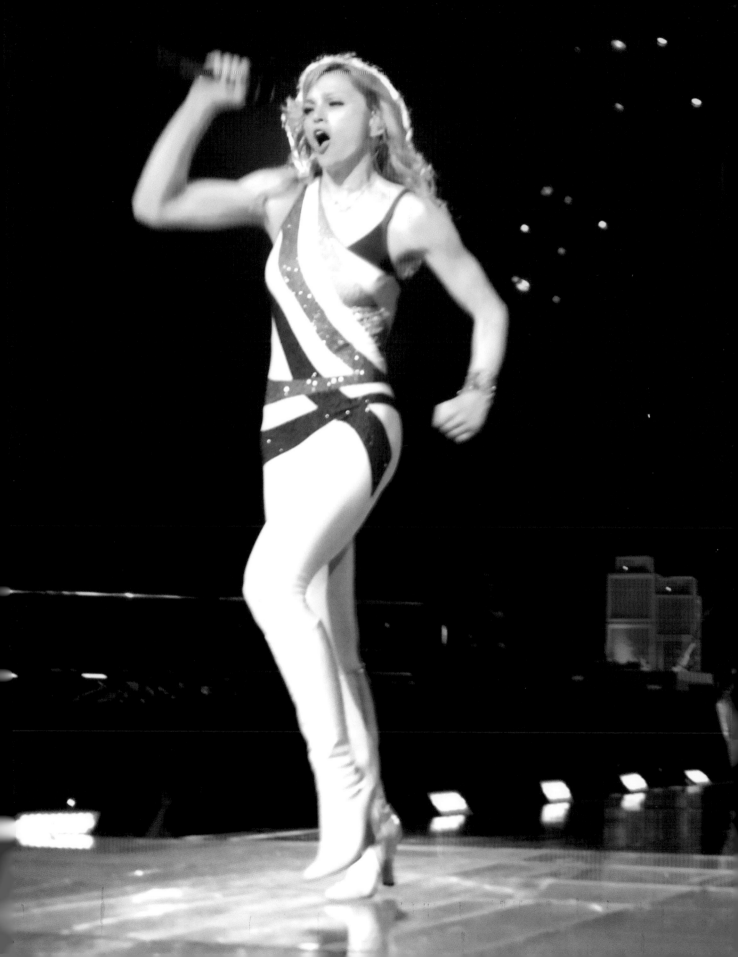

LUCKY

ATLANTIC CITY
7.16.06

Dancing Queen

ATLANTIC CITY
7.16.06
NEW YORK CITY
7.19.06

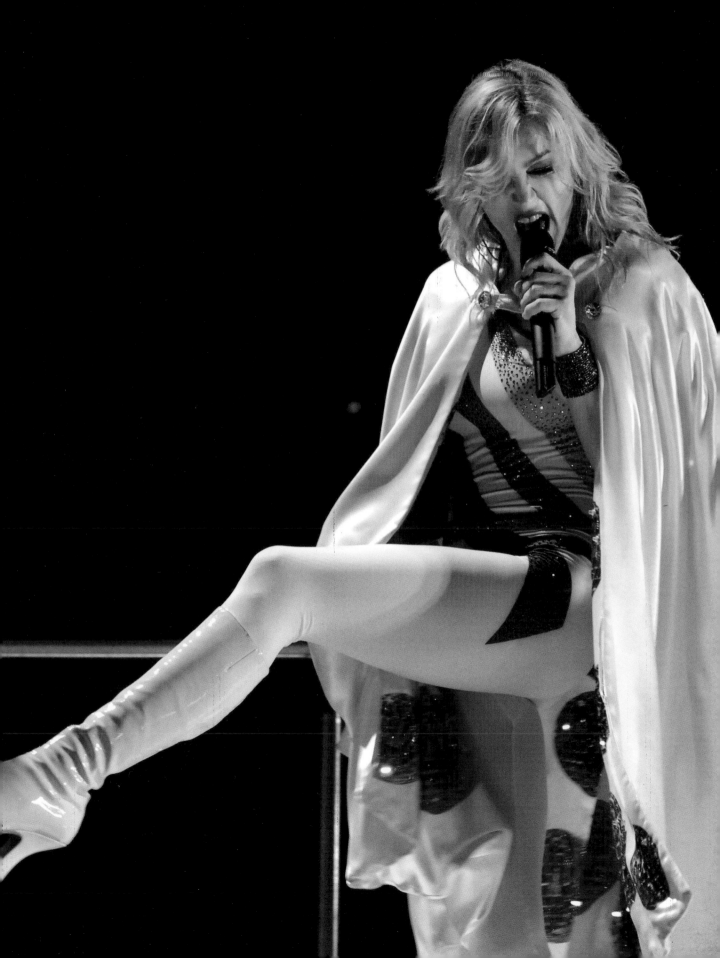

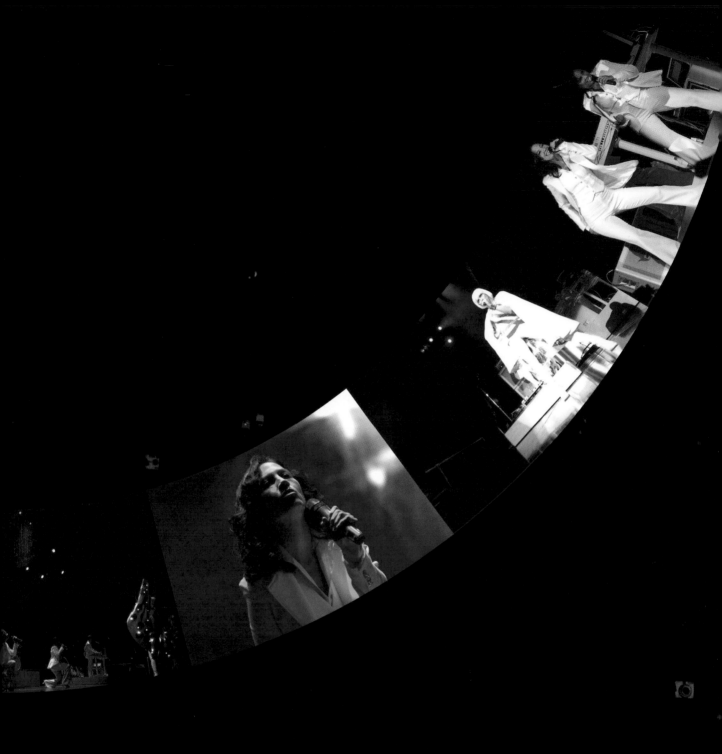

BOSTON
7.09.06

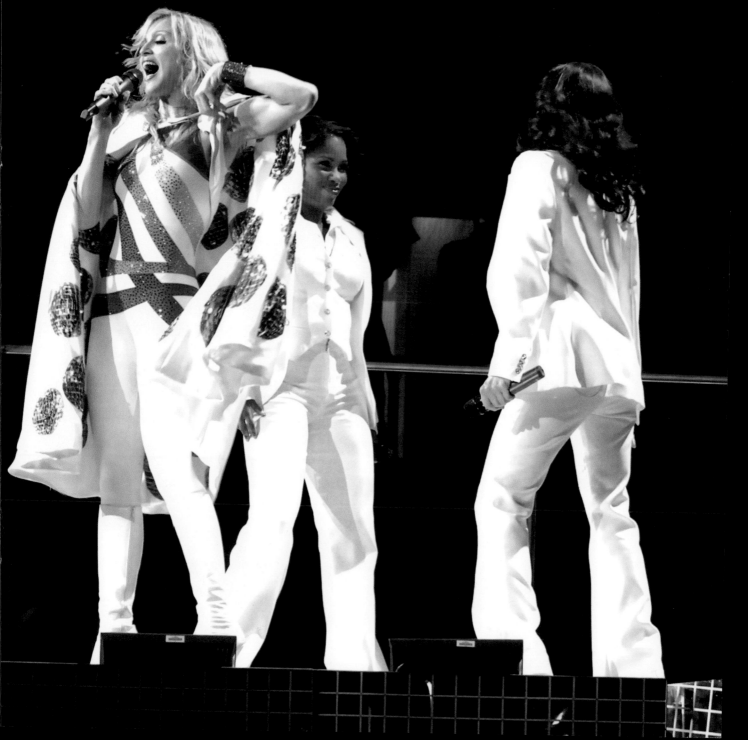

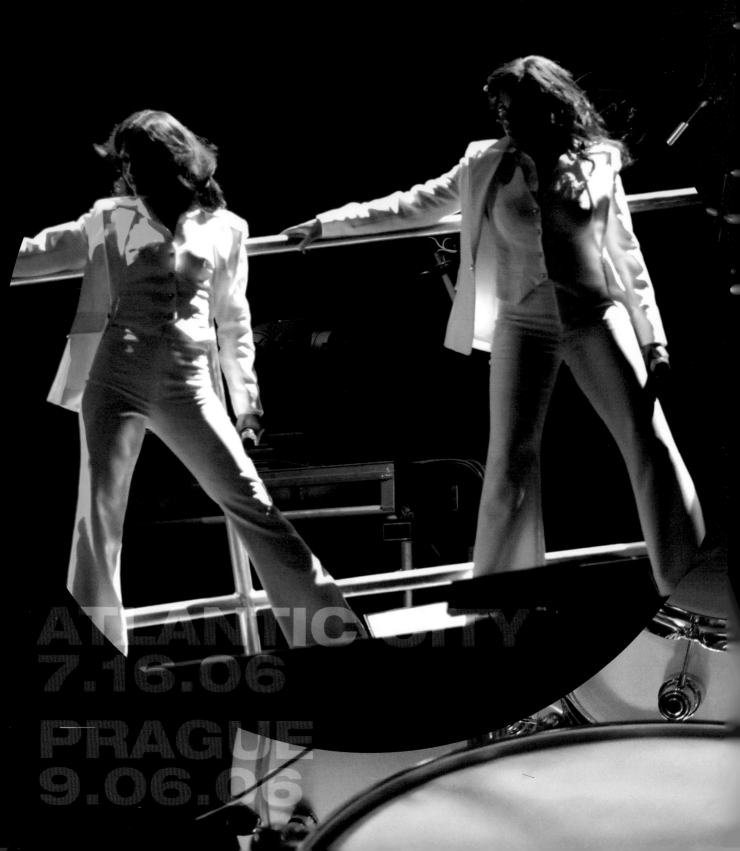

ATLANTIC CITY
7.16.06
PRAGUE
9.06.06

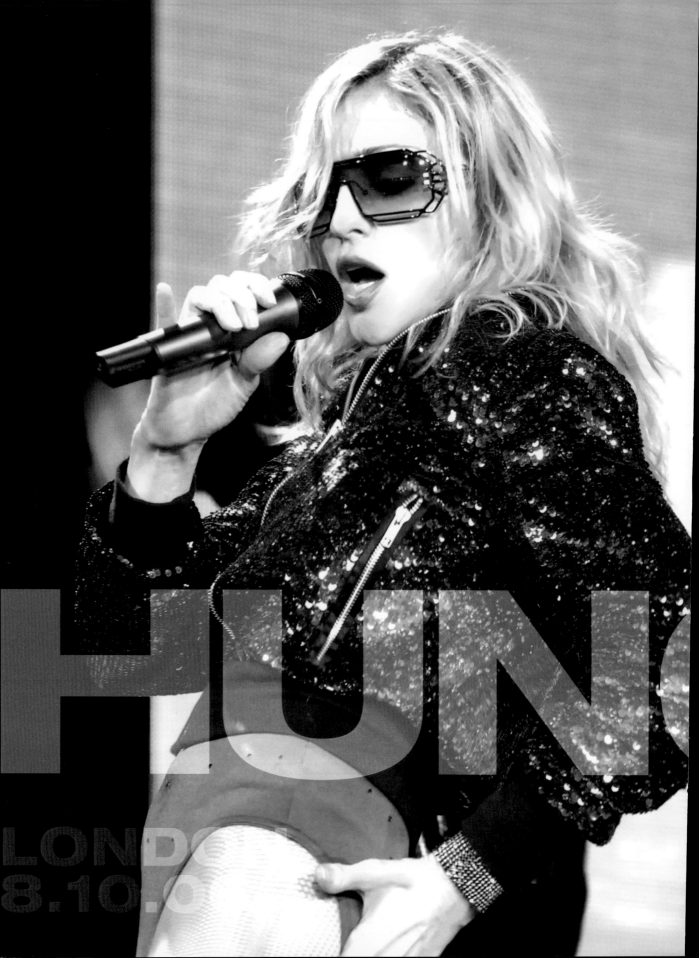

HUN

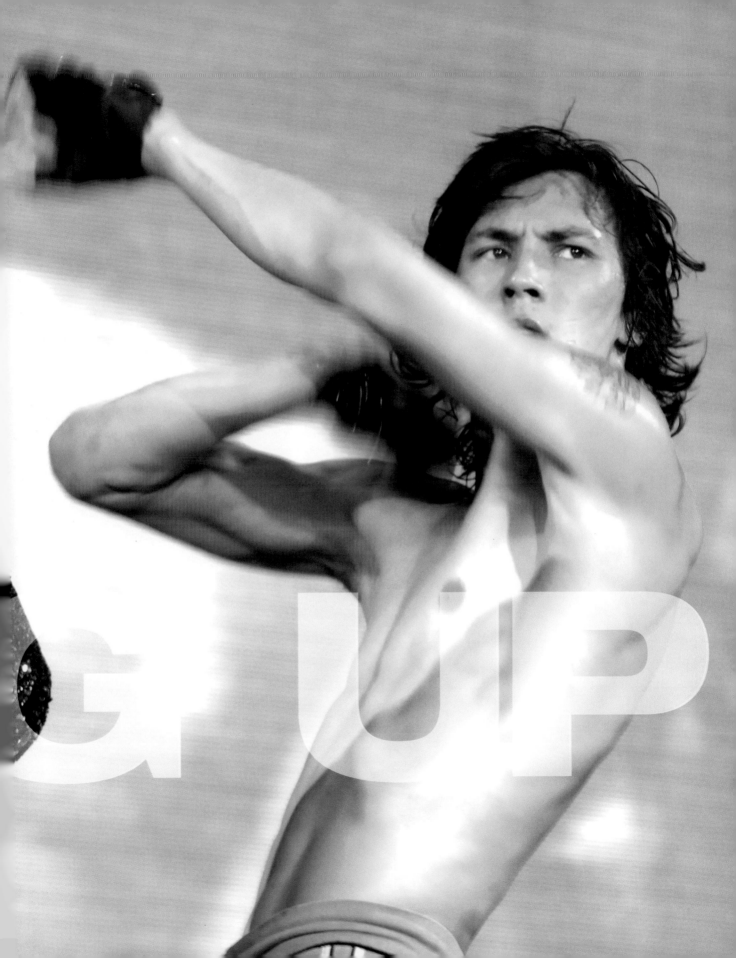

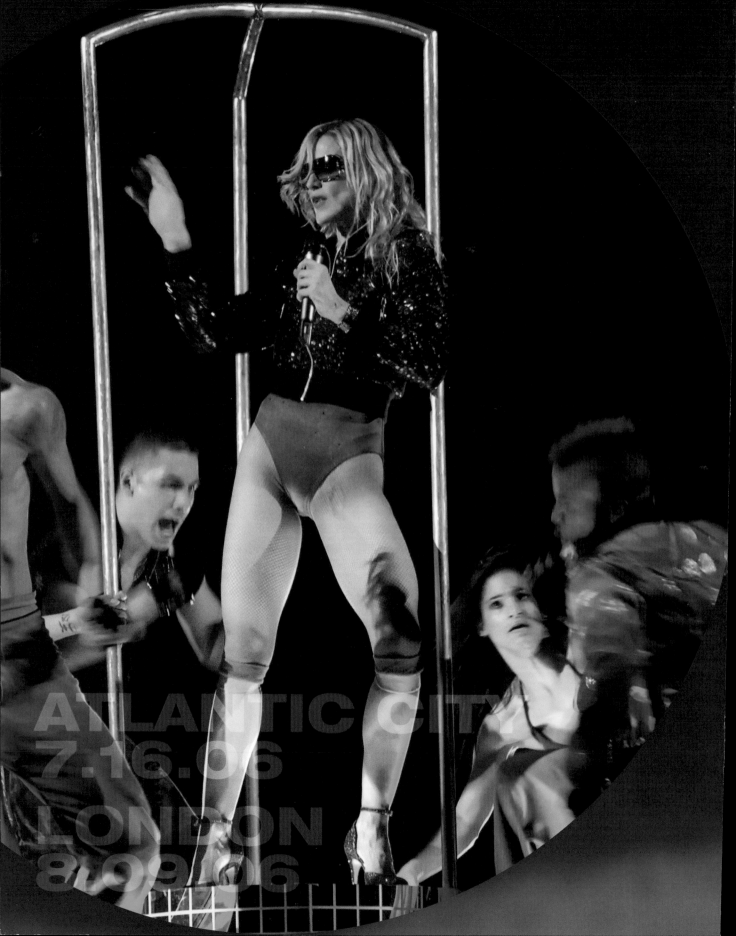

ATLANTIC CITY
7.16.06
LONDON
8.09.06

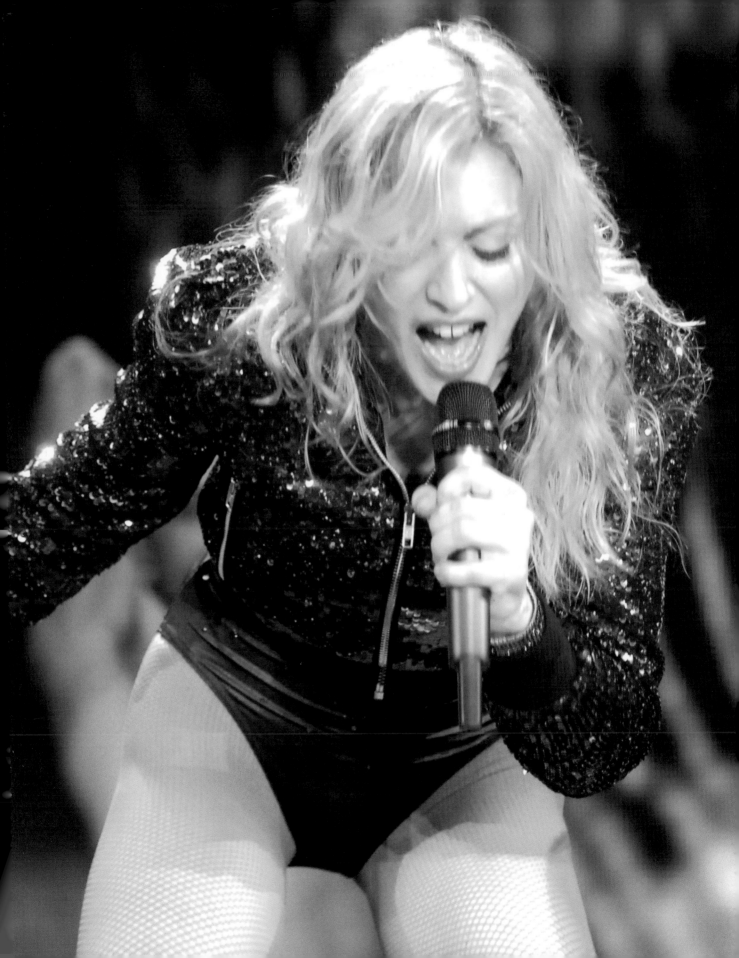

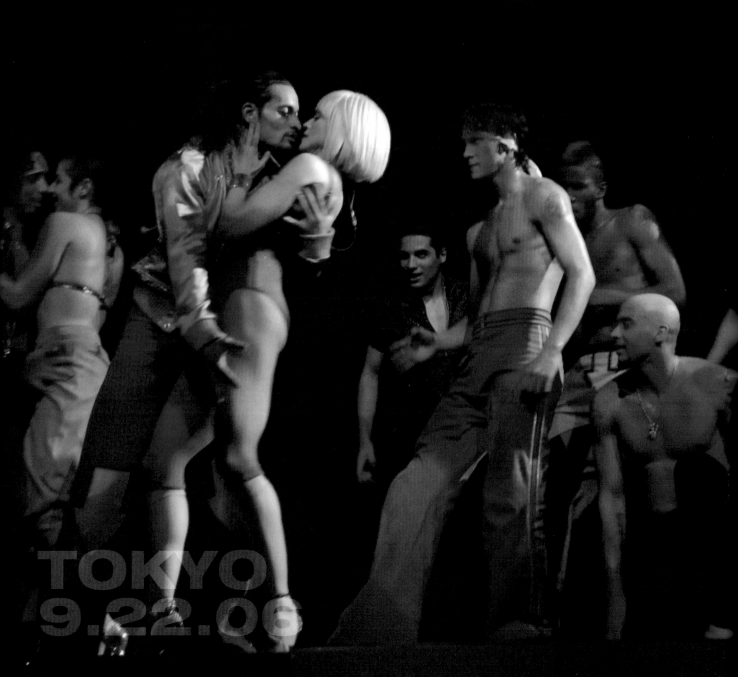

TOKYO
9.22.06

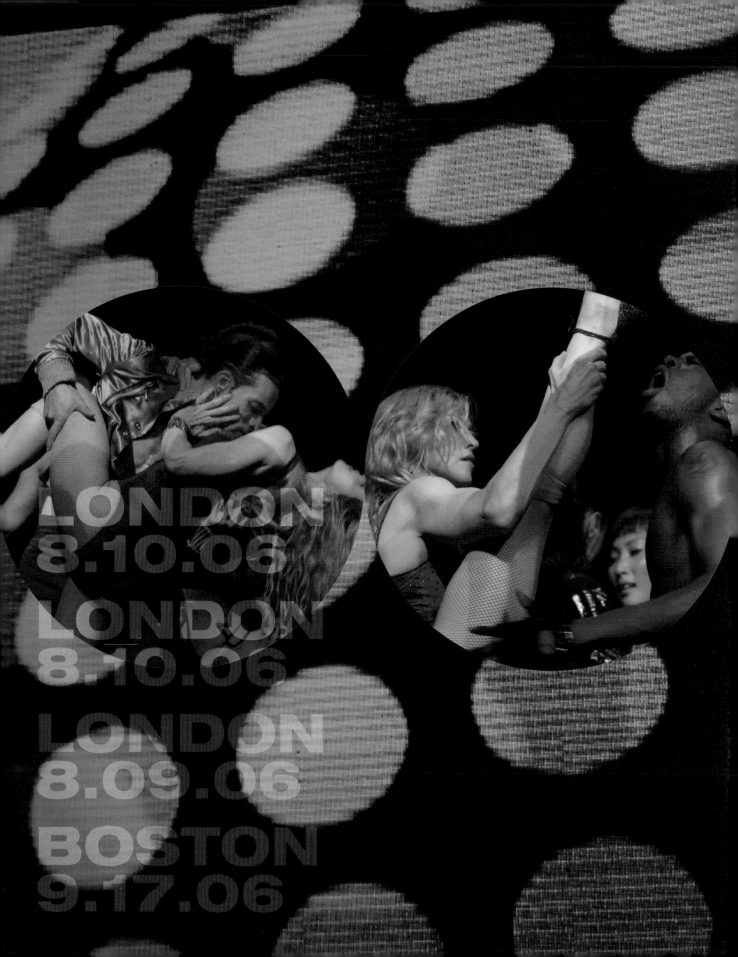

LONDON
8.10.06

LONDON
8.10.06

LONDON
8.09.06

BOSTON
9.17.06

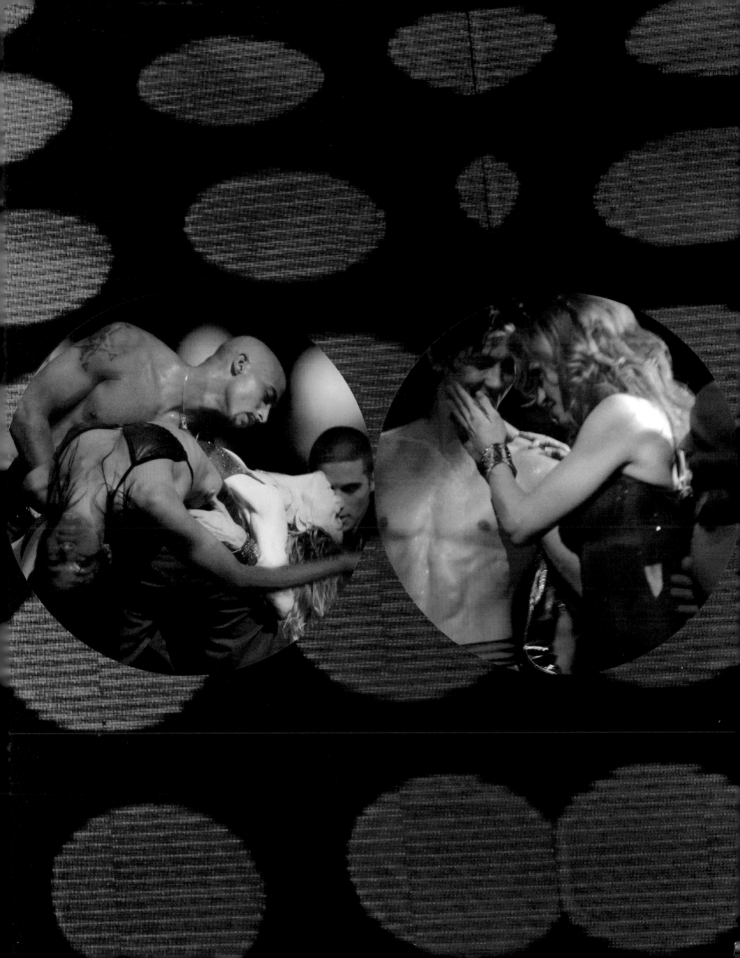